W9-ATO-699

RUTH FINNEGAN FBA is an anthropologist and creative writer with interdisciplinary interests, especially in classical studies, literature, sociolinguistics, modes of thought, and cultural history. She is renowned as the scholar who has made a generation of Africanists realise the singular importance of oral literature. She is Emeritus Professor at the Open University UK, a Fellow of the British Academy, International Fellow of the American Folklore Society, and an Honorary Fellow of Somerville College Oxford.

Born in Derry, Northern Ireland in 1933, she studied classics at Oxford, followed by social anthropology, then fieldwork and university teaching in Africa.

TIME FOR THE WORLD TO LEARN FROM

AFRICA

RUTH FINNEGAN

Hearing
Others'
Voices

BALESTIER PRESS
LONDON · SINGAPORE

Balestier Press
71-75 Shelton Street, London WC2H 9JQ
www.balestier.com

Time for the World to Learn From Africa
Copyright © Ruth Finnegan, 2018

First published by Balestier Press in 2018

A CIP catalogue record for this book
is available from the British Library.

ISBN 978 1 911221 21 0

CONTENTS

PREFACE

Normally I am an academic author. As such, it has always been my regret that I have, understandably I suppose, not been able to reach the wider, richer audience of school and college students, and general readers. This book is designed for all of them, of you—those wise, thinking and perceptive human beings eager for greater knowledge and understanding. My hope is that it will do something to feed that far-reaching sense of enquiry.

It builds on several generations of immersion in the study of Africa and the comparative literature that helps to put Africa in perspective. It is designed not just to give deeper knowledge of some aspects—only some—of that great continent but to correct certain long-entrenched misconceptions that are still, sadly, only too prevalent. The truth turns out to be more interesting—and more inspiring—than the mistakes! Like everywhere, Africa is the setting for tragedy and for evil. We do not need to learn about that—we know it too well already. This book is about the wealth that we can learn.

A quick background on my credentials for offering you this book: after a wonderful upbringing in Ireland surrounded by the wit of Ulster language and the skills of story-telling, I went to an open-minded and internationally inclined Quaker school, literature-and music-imbued; then furthered my study of literature during a degree in classics at Oxford, a period of school teaching, then a doctorate in anthropology—a mind-blowing, mind-opening experience. To prepare for that I had spent a year or so (1960–1; then, later, 1963–4) living in remote villages studying the rich art of story-telling among a people called

the Limba in northern Sierra Leone, West Africa. This was the followed by university teaching in Africa and, after that, many years at the Open University for distant students, both of which fired my determination to communicate more widely than just to the narrow circles of academe.

A fuller and more fully referenced version of much of this material can be found in my *Oral Literature in Africa* and of chapters 10 and 11 in *Storia delle Donne* (10/2014, Firenze University Press) and *International Journal of Play* (2014, 3:3, p.293-315, Taylor & Francis) respectively—my thanks to all of these. Also my thanks to many friends and colleagues for their help over the years and above all to the great scholars and practitioners of Africa—long may the flowns!

My best wishes for your studies of this and other things in our wonderful human world.

Ruth Finnegan
writing in Old Bletchley
(round the corner from the Code Breakers' Bletchley Park)
2018

1

INTRODUCTION:
AFRICA, WHAT IS AFRICA?

A common notion that many people still believe in today—one going back many centuries too—is that Africa is the same everywhere (or at least south of the Sahara): non-literate, primitive and pagan; and unchanging throughout the centuries. Most of all is the idea that Africa can have nothing to teach us enlightened westerners. This view still colours much of our thinking about Africa.

Such a notion is no longer tenable. In the late nineteenth or earlier twentieth centuries (and of course earlier too) the cultures and social forms of African societies were *far* from uniform. They ranged—and largely still do—from the small hunting bands of the Kalahari desert Bushmen, to the proud and independent pastoral peoples of the southern Sudan and (parts of) East Africa, or the elaborate and varied kingdoms found in many parts of the continent, above all in western Africa and round the Great Lakes in the east. Such kingdoms were the seed corn of elaborate court poetry and court poets, allowing other experts too to flourish.

In the economic field there is almost every gradation from the near self-sufficient life of some hunting or pastoral peoples to the engagement in far-reaching external trade based on a sophisticated division of labour and elaborate markets typical of much of West Africa and the Arab coast of East Africa. The degree of specialisation corresponding to these various forms has direct relevance to the position of native craftsmen and performers—in some cases leading to the establishment of

expert and professional practitioners, and of a relatively leisured and sometimes urban class to patronise the arts.

In religion too there are, and have long been, many forms: the naive pictures of Africa as uniformly given up to idol-worshipping and fetishes are now known to be totally inadequate. In North Africa, the northerly parts of the Sudan region and the east coast, Islam has a centuries-long history (and more); there are also the elaborate pantheons of West African deities with specialised cults and priests to match; the interest in "Spirit" issuing in a special form of monotheism among some of the Nilotic peoples; the blend between belief in the remote position of a far-off "High God" and the close power of dead ancestors in many Bantu areas—and so on and so on.

The image of Africa, furthermore, as a land without indigenous literary traditions, alas, retains its hold. Even now, it is still sometimes expressed in a form as crude as that satirized by Richard Burton more than a century ago:

> 'The savage custom of going naked', we are told, 'has denuded the mind, and destroyed all decorum in the language. Poetry there is none…There is no metre, no rhyme, nothing that interests or soothes the feelings, or arrests the passions.' (Burton 1865: xii)

And yet, as well as the by-now deeply embedded cases of alphabetic literacy, around in Africa for centuries, there is the long-established Arabic literacy of many parts of North and East Africa.

Even those who would immediately reject such views may still be influenced, unconsciously, by questionable assumptions about Africa. We still sometimes hear, even among educated people, of the "savage" reliance on the "magical power of the word", of "communal tribal creation", of the deep, strange, "mythic consciousness" imagined to be characteristic of non-literate

society—and thus, it is imagined, of Africa. All in all, there is still a popular myth of Africa as a continent devoid of literature and artistry until contact with "civilized" nations led to education and enlightenment in European written tongues and, for the first time in this static continent, "change".

The belief that Africa had no history was, quite simply, due to ignorance: African history had, a couple of generations ago, just not been studied by western scholars, and it has taken some time for general opinion to catch up. For Africa is no exception to the crowded sequence of historical events. The early impact and continuing spread of Islam, the rise and fall of empires and kingdoms throughout the centuries, diplomatic, commercial and cultural contacts within and beyond Africa, movement and communication between different peoples, economic and social changes, wars, rebellions, conquests—these are all the stuff of history. These are all in Africa. And there was the horrific slave trade too, with its radical effects on the population of the continent.

To one who thinks African society has remained static for, perhaps, thousands of years, recently induced changes must appear revolutionary. In fact, the experience since the late nineteenth century—colonial rule—important as it was, is merely one phase in a whole series of historical developments. It is true that these years have seen the imposition and then withdrawal of colonial rule, of new forms of administration and industry, new groups of men in power, and the introduction and spread of Western education accompanied, as with ourselves, by new economic forms and increased reliance on mass media, written communication and computerisation. But from the point of view of the local population, as a number of African scholars have convincingly shown, the changes over the last century or so probably did not seem so radical as they may appear to us.

For one thing, neither schools nor industrial or urban

development have been evenly spread over the continent; in some regions they are sparse. Bare literacy, furthermore, in what is often a foreign language (e.g. English or French) does not at all mean that school leavers always turn readily to writing as a form of communication, far less as a vehicle of literary expression. Literacy, a paid job, even an urban setting does not mean the death of oral forms—nor indeed does it in more (to us) familiar contexts. There is nothing to be surprised about in a continuing reliance on oral forms. Similarly there is nothing incongruous in a story being told about, say, struggling for political office or winning the football pools, or in candidates in a modern election campaign using songs to stir up and inform mass audiences with little direct access to written propaganda. Again, a traditional migration legend can perfectly well be seized upon and effectively exploited by nationalist elements to bring a sense of political unity among a disorganized population, or university lecturers seek to further their own standing by hiring praise singers and drummers to attend the parties given for their colleagues, uttering stirring praises by voice or drum for the hosts or guests. Such activities *may* appear odd to certain outside observers—as if having 'modern' competence in one sphere must necessarily involve an approximation to Western cultural modes in all others. The complexity of the facts contradicts this.

Africa furthermore has long been a continent of writing as well as of orality. The east coast and the Sahel areas in the west have seen many centuries of Koranic scholarship and of specialist Arabic scribes and writers using the written word as a tool for correspondence, religion and literature. To an extent only fairly recently being explored—some excuse then for earlier misunderstandings—these men were responsible for huge numbers of Arabic religious treatises, historical chronicles, and poetry.

Not only was Arabic itself a vehicle of communication and

literature, but many African languages in these areas came to adopt a *written* form using the Arabic script. In the east there was a long tradition of writing in Swahili, in the west in Hausa, Fulani, Mandingo, Kanuri and Songhai. The literary forms were largely adapted from Arabic literature, sometimes original, sometimes as paraphrases or translations, but in some cases there was a striking local literary culture, such as the well-established Swahili literature, influenced in a general way by Arabic genres and subject matter but not directly drawing from them. These written forms were probably little used for literary composition, but its existence gave rise to a small lettered class and the interplay between written and oral traditions. In addition there were other smaller-scale traditions of writing in Africa, including several using scripts invented—true sign of genius indeed—within the continent.

Even more remarkable you may think is the lengthy written tradition of Ethiopia—a complex and ancient civilization whose association with Christianity probably dates back to a the fourth century AD. Though probably never in general use, writing was used there from an early period, particularly in a Christian context, so that the history of Ethiopic written literature coincides pretty closely with Christian literature, much of it based on translation. There are chronicles (generally taking the Creation of the World as their starting point), lives of the saints and liturgical verse. In addition there are long and impressive royal chronicles which narrate the great deeds of various kings.

The common picture, then, of sub-Saharan Africa as totally without letters until the coming of the 'white man" is misleading. Above all it ignores the vast spread of Islamic and thus Arabic influences over many areas of Africa, profoundly affecting the culture, religion and literature. A word of warning, however. The picture we have tends to be of a split between learned (or written) and popular (or oral) literature. This is indeed

sometimes so. But in many other cases we find—as indeed with us—close interaction between oral and written forms. A poem first composed and written down, for instance, can become part of the oral tradition itself as we shall see, of greater complexity and value than often believed—and be transmitted by word of mouth, parallel to the written form. Initially oral forms, on the other hand, are sometimes preserved by being written down. In short, the borderline between oral and written in Africa, as elsewhere, was and is far from clear-cut.

In stressing the long literate tradition in parts of Africa, we should also note that this was the preserve of the specialist few. The vast majority, even of those peoples whose languages adopted the Arabic script, had little or no direct access to the written word. In so far as the writings of the scholars reached them at all, it could only be indirectly, by oral transmission. To some extent they did. Swahili religious poems were publicly intoned for the enlightenment of the masses. Fulani poems in northern Nigeria declaimed aloud, and, in the same area, Hausa compositions like the striking 'Song of Bagaudu' memorised in oral form. The situation was in fact very similar to what we now know to have been the case not so long ago in Europe, totally unlike the mass literacy of recent times which we take for granted.

Another obstacle to a realistic and up-to-date appraisal of African cultures is a tendency to think of two distinct and incompatible types of society ("traditional" and 'modern") and assume that the people move from one to the other by a sort of revolutionary leap. But individuals do not feel torn between two separate worlds; they exploit the situations in which they find themselves as best they can. There is nothing to be surprised at in a continuing reliance on oral forms—we all do this.

The point here—and it is surely for the younger generation to take the lead—is that the African world is not totally different from that of better-known cultures. It is true that much remains

to be studied. But the unfamiliarities are generally those of detail, not of principle. Far from being something mysterious or blindly subject to some strange force of "tradition", oral forms in fact bear the same kind of relation to their social background as do written ones.

One of the main points of this volume is to bring out the truth: that African cultures are not radically different from those of better-known ones (to us). The unfamiliarities are of detail, not of principle. Far from being something totally mysterious or blindly subject to some strange force of "tradition", the oral forms of Africa, as we shall see, in fact bear the same kind of relation to their social background as does written literature. It is a disservice to our understanding of human culture to suggest that knowledge of Africa is either totally simple (answered merely by some such term as "tribal mentality" or "tradition") or so unfamiliar and mysterious that the normal issues of scholarship and understanding cannot be explored.

All in all there is so much, here and now as in past centuries, that we can learn from Africa.

2

THE GLORY OF PERFORMANCE

In western contexts literature is pictured as, essentially, written: one-line, fixed, cold on the printed page. But the glory of African literature, sometimes written but often not, lies in its *performed* quality—in the miraculous properties of the human voice and of the astounding multi-sensory qualities of African performance from which we can learn so much. Here it is that we can best notice the choreographic, kinesic (conveyed by visible gesture or movement), sonic and musical dimensions of performance and the co-constructing role of the audience.

What then is literature? Certainly as you no doubt know, literature can be looked at from many viewpoints. Some look to its functions, its mythic or seemingly unconscious basis, or its famous authors; others to how particular genres have travelled across the world, its varying settings, or the specific ways it has been received in particular places. This chapter leaves those aspects—which you may be studying in other contexts—on one side to focus instead, as is especially fitting for Africa: on the features of *unwritten* literatures.

The concept of an "oral"—spoken, unwritten—literature is an unfamiliar one to those brought up in cultures which, like those of contemporary Europe, pride themselves on their mastery of literacy and written forms. For that reason this concept needs some direct discussion here.

In the popular view the notion of "oral" literature conveys on

the one hand the idea of mystery, on the other that of crude and artistically undeveloped formulations. In fact, neither of these assumptions is generally valid. Nevertheless, there are certain definite characteristics of this form of art that tie up with its oral nature. These need to be understood before we can fully appreciate the status and qualities of these African literary forms.

There is no mystery about the first and most basic characteristic of oral literature—even though it is constantly overlooked in collections and analyses. This is the significance of the actual performance. Oral literature is by definition dependent on a performer who formulates it in words on a specific occasion—there is no other way in which it can be realised as a literary product. In the case of written literature a literary work can be said to have, in at least some sense, an *independent and tangible existence in even one copy*, so that questions about, say, the format, number and publicizing of other written copies can, though not irrelevant, be treated to some extent as secondary; there is, that is, a distinction between the actual creation of a written literary form and its further transmission.

The case of *oral* literature is different. There questions about the *means of actual communication* are of the first importance—without its oral realization and direct rendition by singer or speaker, an unwritten literary piece cannot easily be said to have any continued or independent existence at all. In this respect the parallel is less to written literature than to music and dance; for these too are art forms that in the last analysis are actualized in and through their performance and depend on performance for their continued existence. This is not just a matter of definition: the *performance is the literature.*

This is obvious if we consider literary forms designed to be delivered to an audience even in more familiar—literate—cultures. If we think of a play, a sermon, jazz poetry, even something as trivial as an after-dinner anecdote—in all these

cases the actual delivery is a significant aspect of the whole. Even though it is true that these instances may also take a written form, they only attain their true fulfillment when actually performed. The same clearly applies to African oral literature. In, for example, the brief Akan dirge from Ghana

Amaago, won't you look?
Won't you look at my face?
When you are absent, we ask of you.
You have been away long: your children are waiting for you.
(Nketia 1955:184)

the printed words alone represent only a shadow of the full actualisation of the poem as an aesthetic experience for poet and audience. For, quite apart from the separate question of the overtones and symbolic associations of words and phrases, the actual enactment of the poem also involves the emotional situation of a funeral, the singer's beauty of voice, her sobs, facial expression, vocal expressiveness and movements (all indicating the sincerity of her grief) and, not least, the musical setting of the poem.

In fact, all the variegated aspects we think of as important in our familiar literary forms may also play their part in the delivery of unwritten pieces: expressive tone, gesture, facial expression, dramatic pause, rhythm, the interplay of passion, dignity or humour, receptivity to the audience, and so on and so forth. Such devices are not mere embellishments superadded to an already existent literary work—as we may think of them in regard to written literature—but an integral as well as flexible part of its full realization as an oral work of art.

Unfortunately it is precisely this dimension that is often overlooked in recording and interpreting instances of oral literature. This is partly due, no doubt, to practical difficulties;

but even more to the unconscious reference constantly made to the model of written text. This leads us to see the written element as the primary and thus somehow the fundamental material in every kind of literature—a concentration on the words to the exclusion of the vital and essential aspect of how they are performed. It cannot be too often emphasized that this insidious model is profoundly misleading in the case of oral literature.

This comes across clearly when we look at the resources available to the performer of African literary works. The linguistic basis of much African literature is treated in Chapter 3, but we must at least note in passing the striking consequences of the highly tonal nature of many African languages. Tone is sometimes a structural element in literary expression and can be exploited by the oral artist in ways somewhat analogous to the use of rhyme or rhythm in written European poetry. There are many instances of this African poetry, proverbs, and above all drum literature. This stylistic aspect is almost completely unrepresented in written versions or studies of oral literature, and yet is clearly one which can be manipulated in a subtle and effective way in the actual process of delivery

Music, instrumental or, especially, sung, also has a part, varying of course according to the artistic conventions of the particular genre. Most stories and proverbs are delivered as spoken prose. But the southern Bantu praise poems, for instance, and the Yoruba hunters' *ijala* poetry are chanted with a semi-musical framework. Other forms draw fully on music, with singing by soloist(s) or soloists and/or chorus, or in some cases instruments. Indeed, much of what is normally classed as poetry in African oral literature is designed to be performed in a musical setting, and the musical and verbal elements are thus interdependent. An appreciation, therefore, of these sung forms (and to some extent the chanted ones also) depends on at least some awareness of the musical material on which the artist draws, and we cannot hope

fully to understand their impact or subtlety if we consider only the bare words on a printed page.

In addition performers have various visual resources at their disposal. They are typically face to face with their audience and can take advantage of this to enhance the impact, sometimes the verbal content. too. In stories the characterization of both leading and secondary figures may appear slight in *verbal* terms; but what in literate cultures must be written into the text can in orally delivered forms be conveyed by more visible means— by the speaker's gestures, expression and mimicry. A particular atmosphere—dignity for a king's official poet, light-hearted enjoyment for an evening story-teller, grief for a woman dirge singer—can be conveyed not only by a verbal evocation of mood but also by the dress, accoutrements, or bearing of the performer.

This visual aspect is sometimes expressed in dance, often joined by members of the audience (as chorus). In these cases the verbal content is now just one element in a complete opera-like performance which combines words, music and dance. This extreme type is not that uncommon; and even in cases where the verbal element seems to predominate, the delivery and movements of the performer may partake of something of the element of dancing in a way that to both performer and audience enhances the aesthetic effectiveness of the whole.

Oral performers can thus marshal a multiplicity of resources to project their literary products—vivid 'ideophones' for example (explained in the next chapter), dramatized dialogue, or the manipulation of the audience's sense of humour or susceptibility (when played on by a skilled performer) to be amazed, shocked, moved, or enthralled at appropriate moments.

The detailed way in which the performer enacts the literary product of his art naturally varies both from culture to culture and according to its literary genre. Not all types of performance involve the extremes of dramatization. Sometimes indeed the

artistic conventions demand the exact opposite—a dignified, aloof bearing, and emphasis on continuity of delivery rather than on studied and receptive style in the exact choice of words. This was so, for instance, with the professional reciter of historical Rwanda poetry, an official conscious of his intellectual superiority over amateurs and audience alike, who conventionally relied on a stance of superior detachment.

To this kind of austere delivery we can contrast the highly emotional atmosphere in which the southern Sotho praise poet is expected to pour out his panegyric:

> Out of the background of song by solo and chorus, working up to a pitch of excitement and highly charged emotion, the chorus increases in its loudness to be brought to a sudden stop with shrills of whistles and a voice (of the praise poet) is heard: '*Ka-mo-hopola mor'a-Nyeo!*' (I remember the son of so-and-so!) Behind that sentence lurk all the stored up emotions and, without pausing, the name...is followed by an outburst of uninterrupted praises, save perhaps by a shout from one of the listeners: '*Ke-ne ke-le teng*' (I was present), as if to lend authenticity to the narration. The praiser continues his recitation working himself to a pitch, till he jumps this way and that way while his mates cheer him...and finally when his emotion has subsided he looks at his mates and shouts: '*Ntjeng, Banna*' (lit. Eat me, you men). After this he may burst again into another ecstasy to be stopped by a shout from him or from his friends: '*Ha e nye bolokoe kaofela!*' or '*Ha e nye lesolanka!*', a sign that he should stop. (Mofokeng 1945:137)

Different again are the styles adopted by story-tellers: normally less of this sort of emotional intensity, but dramatic vividness and, often, humour can add drama and meaning to relatively simple wording. The Lamba narrator has been particularly well described:

It would need a combination of phonograph and kinematograph to reproduce a tale as it is told…Every muscle of face and body spoke, a swift gesture often supplying the place of a whole sentence…The animals spoke each in its own tone: the deep rumbling voice of Momba, the ground hornbill, for example, contrasting vividly with the piping accents of Sulwe, the hare… (Smith and Dale ii, 1920:336)

Many other cases, and not just in Africa, could also be cited where the mode of performance is as significant for the local critic as actual content or structure.

There is a further, related, characteristic of oral literature. This is the question of improvisation and original composition in general. In other words, something more may be involved in the delivery of an oral piece than the fact of its actualization and re-creation in and through the performance, for performers quite often introduce variations on older pieces or even totally new forms in wording, structure or content.

The extent of innovation, of course, varies with both genre and individual performer, and the question of original composition is a difficult one. It is by no means the same everywhere, and between the extremes of totally new creation and memorized reproduction of set pieces there is scope for many different theories and practices of composition. There are, for instance, the long-considered and rehearsed compositions of Chopi singers in Mozambique, the improvisation of a leader in a boat- or dance-song, the combination and recombination of known motifs into a single unique performance among Limba story-tellers. There are also cases, like the Rwanda poets just mentioned, where participants stress the accuracy and authenticity of the wording (at least in outline) so that memorization rather than creation is the expected thing.

But in general a striking characteristic of oral as distinct from

written literature is its *verbal variability*. What might be called the 'same' poem or prose piece may vary in detail to such an extent that, going beyond the techniques of delivery, one has to take some account at least of the originality of the artist who is actualizing it.

Take for instance the case of Ankole praise poems in East-Central Africa. Since the ideas expressed in these poems are stereotyped and repetitive, the *omwevugi* (poet/reciter) often changes the wording to obtain variety:

> He has to rely to a great extent upon the manner in which he expresses these ideas in order to give beauty and interest to his poem. Herein lies the art of the accomplished *omwevugi* who, by the ingenious choice of his vocabulary, can repeat identical themes time and time again, always with a different and startling turn of phrase. (Morris 1964:25)

Or take story-telling among the Thonga. It is worth quoting a perceptive observer's close description. Having postulated the "antiquity" of Thonga tales, he goes on:

> This antiquity is only relative: that is to say they are constantly transformed by the narrators and their transformations go much further than is generally supposed, further even than the Natives themselves are aware of. After having heard the same stories told by different story-tellers, I must confess that I never met with exactly the same version. First of all words differ. Each narrator has his own style, speaks freely and does not feel in any way bound by the expressions used by the person who taught him the tale. It would be a great error to think that, writing a story at the dictation of a Native, we possess the recognized standard form of the tale. There is no standard at all!...
>
> The same can be said with regard to the sequence of the episodes;

although these often form definite cycles, it is rare to hear two narrators follow exactly the same order. They arrange their material as they like, sometimes in a very awkward way...

I go further: New elements are also introduced, owing to the tendency of Native story-tellers always to apply circumstances of their environment to the narration. This is one of the charms of Native tales. They are living, viz., they are not told as if they were past and remote events, in an abstract pattern, but considered as happening amongst the hearers themselves... So all the new objects brought by civilisation are, without the slightest difficulty, made use of by the narrator...

Lastly, my experience leads me to think that, in certain cases, the contents of the stories themselves are changed by oral transmission, this giving birth to numerous versions of a tale, often very different from each other and sometimes hardly recognizable. (Junod 1913, ii:198-200)

The artist's scope to improvise or create may vary, but there is almost always some opportunity for 'composition'. It comes out in the choice of word and phrase, stylistic devices like the use of ideophones, asides, or repetitions, the ordering of episodes or verses, new twists to familiar plots or the introduction of completely new ones, improvisation or variation of solo lines even All this naturally takes place within the current conventions— but what is involved, nevertheless, is some degree of individual creativity. This process is likely to enter into the actualization of just about any piece of oral literature, which thus has to be regarded as in one sense a unique literary work—the work on that particular occasion.

This *variability of oral literary forms* is regularly overlooked. This is largely because of certain theoretical assumptions held in the past about the verbatim handing down of oral tradition supposedly typical of non-literate societies. The model of written

literature is misleading in this context too, with its presumption of transmission (exact) through manuscripts or printing press. It must therefore be stressed yet again that characteristics we now associate with a written literary tradition do not always apply to oral art. There is not necessarily any concept of an 'authentic' version, and when a particular literary piece is being transmitted to an audience the processes of extemporization or elaboration are more likely to be to the fore than that of memorization. There is likely to be little of the split, familiar from written forms, between composition and performance or between creation and transmission.

A further factor, not in the same way applicable with written texts, is *the audience*: often directly and actively involved. According to convention, genre and personality, the artist may be more or less receptive to his listeners' reactions—but, with few exceptions, an audience of some kind is normally an essential part of the whole literary situation. As all performers, past and present, west or east, know well, there is no escape from a face-to-face confrontation with the audience, and this is something which they can exploit as well as be influenced by. Sometimes she or, more often, he, chooses to involve listeners directly, as in story-telling situations where it is common for the narrator to open with a formula which explicitly arouses his audience's attention; they are also often expected to participate actively in the narration and, in particular, to join in the choruses of songs introduced by the narrator.

The audience may participate in the performance of poetry too, where the lead poet often sings the verse line, maybe a new one, while the audience performs as a chorus keeping up the burden of the song, sometimes to the accompaniment of dancing or instrumental music. In such cases the artist and audience in a way become a single identity. Even in less formalized relationships the actual literary expression can be greatly

affected by the presence and reactions of the audience. The *type* of audience can affect the presentation—the artist may try, for instance, to omit obscenities, certain types of jokes or complex forms, in the presence of, say, children or missionaries (or foreign students) that would be included in other contexts. References to the characteristics, behaviour, or fortunes of particular listeners can also be brought in in a subtle and flexible way not usually open to written literature—whether negative or positive or just witty these can be enormously effective with the listeners.

Members of the audience need not confine their participation to silent listening or a mere acceptance of an invitation to participate—they sometimes break into the performance with additions, queries, or criticisms. This is common not only in the typical and expected case of story-telling but even in formalized performances like the complex Yoruba hunters' chants (*ijala*) in Nigeria. The artist is critically listened to by other experts present, and if one of them thinks the performer has made a mistake he cuts in with such words as

> I beg to differ; that is not correct.
> You have deviated from the path of accuracy ...
> Ire was not Ogun's home town.
> Ogun only called there to drink palm-wine ...

on which performer defends himself by suggesting that others should respect his integrity:

> Let not the civet-cat trespass on the cane rat's track.
> Let the cane rat avoid trespassing on the civet-cat's path.
> Let each animal follow the smooth path of its own road.
> (Babalola 1966: 64, 62)

The possibility of clarification and challenge from members of

the audience and their effect on the performance is indeed one of the main distinctions between oral and written literary pieces. As Plato put it long ago:

> It is the same with written words [as with painting]. You would think they were speaking as if they were intelligent, but if you ask them about what they are saying and want to learn [more], they just go on saying one and the same thing for ever.
> (Plato, Phaedrus 275 d)

A further, related, characteristic of oral literature is the performance *occasion*. This can directly affect the detailed content and form of the piece being performed. Oral pieces are not composed in the study and later transmitted through the impersonal and detached medium of print, but tend to be directly involved in the occasions of their actual utterance. Some poetry is specifically 'occasional' in being designed for, say, funerals, weddings, celebrations of victory, soothing a baby, accompanying work, and so on; again, with certain prose forms (like proverbs), appropriateness to the occasion may be more highly valued than the verbal content itself. But for other poetry too such factors as the general purpose and atmosphere of the gathering at which it is rendered, recent episodes in the minds of performer and audience play a part, or the time of year and propinquity of the harvest.

All this has consequences for the nature for oral literature and how to approach it. Details of performance, audience, and occasion are central in a way that would be irrelevant in most approaches to written literature. Ignoring these for an oral work would be to miss much of the subtlety, flexibility and individual originality of its creator and, furthermore, to fail to give consideration to the aesthetic canons of those intimately concerned in its production.

This is easy enough to state, but difficult to pursue in practical terms. The *words* are relatively easy to capture—by dictation, texts written by assistants, audio recordings. But the *performance*— how is one to record this? Even more difficult, how is one to convey it to readers not themselves acquainted with this art form? In the days before the availability of the portable audio or video recorder this problem was practically insuperable. The general tendency was thus to rely only on written records, often second-hand without a sight of the original performance–clearly inadequate..

This in itself goes a long way to account for the simplified impression of African oral literature we often receive from published collections or summaries. Further, such publications encouraged others to follow the same pattern even when it became open to them to use new media for recording. By now, however, there is increasing use of audio and video recording giving a much better grasp of the original product with some hint, perhaps not of the audience interaction, at least of the verbal subtlety of the piece, its stylistic structure and content, but also of the various detailed devices which performers have at their disposal to impress and communicate with their audiences, and the ways these are used by different individuals. Difficult or not, without some attention to such aspects we have scarcely started to understand its aesthetic development or literary artistry.

A series of highly questionable assumptions about the nature of oral tradition and so-called 'folk art' among non-literate people have not made matters any easier, among them such ideas as that 'oral tradition' (including what we should now call oral literature) is passed down word for word from generation to generation and thus reproduced verbatim from memory throughout the centuries; or, alternatively, that oral literature is something that arises communally, from the people or the 'folk' as a whole, so that there can be no question of individual authorship or originality.

Such assumptions have inevitably discouraged interest in the actual contemporaneous performance, variations, and the role of the individual poet or narrator in the final literary product. A related assumption was that oral literature (in this context usually kown as 'folklore') was undeveloped and 'primitive'; and this derogatory interpretation was applied to oral literature both in completely non-literate societies and when, in the past, it coexisted with written literary forms in 'civilized' cultures. The bare prose texts in translation or synopsis of most publications left little apparent need for any more profound analysis about, say, the overtones and artistic conventions underlying these texts, far less the individual contribution of performer and composer.

For oral literature, far more extremely than for written forms, *the bare words cannot be left to speak for themselves* for the simple reason that in the actual literary work so much else is necessarily and intimately involved.

There is a final point to consider. Even in a society apparently dominated by the printed word, the oral aspect is far less absent than is often supposed—think of the lyrics of rock songs, of sermons, political speeches, funny stories. Perhaps because of the common idea that written literature is somehow the highest form of the arts, the current significance of oral elements often tends to be played down, if not overlooked completely. But remember the importance of performance and production in a play, the idea held by some at least that much poetry can only attain its full flavour when spoken aloud, or the increasing but often underestimated significance of the oral reproduction and dissemination of classic literary forms (as well as wholly new compositions) through radio and television. Add to this the interplay between the oral and the written—the constant interaction in any tradition between the written word and, at the least, the common diction of everyday speech (an interaction which may well be heightened by the spreading reliance on radio

and television channels of transmission), as well as the largely oral forms like speeches, sermons, children's rhymes, satires depending in part on improvisation, or many current pop songs, all of which have both literary and oral elements: in view of all this it becomes clear that even in a fully literate culture oral formulations can play a real part, however unrecognized, in the literary scene as a whole.

What is more, the distinction between oral and written forms is by no means as rigid or profound as is often thought. It is already widely accepted that these two media can each draw on the products of the other, for orally transmitted forms have frequently been adopted or adapted in written literature, and oral literature too is prepared to draw on any source, including the written word. To this interplay we can now add that when looked at comparatively, the two forms, oral and written, are far from mutually exclusive. Even if we picture them as two independent extremes there are many possibilities and many different stages between the two poles; the facile assumption of a profound and unbridgeable chasm between oral and written forms is a misleading one.

A final point that has sometimes deterred people from the recognition of oral forms as a type of literature has been the idea that they have only resulted in trivial formulations without any depth of meaning or association. This impression has, it is true, been given by the selection and presentation of much of the African verbal art that reaches the public—the emphasis on animal tales and other light-hearted stories (relatively easy to record)—rather than the more elaborate creations of specialist poets, and the publication of unannotated texts which give the reader little or no idea of the social and literary background which lies behind them, let alone the arts of the performer.

Quite apart from mere problems of translation, the difficulties of appreciating the genres of unfamiliar cultures without

help are well known. We need only consider (to take just one example) how much our appreciation of the opening lines of a Shakespeare's sonnet,

> Like as the waves make towards the pebbled shore,
> So do our minutes hasten to their end…

depends, among other things, on our knowledge of the particular art form used, its whole literary setting, the rhythm, phrasing, and music of the line, and, not least, on the emotive overtones of such familiar words as 'waves', 'minutes', 'end' which bring us a whole realm of associations, sounds, and pictures, all of which can be said to form an essential part of the meaning of the line. This is obvious—but it is often forgotten that exactly the same thing applies in oral literature.

> *Nana Gyima abasateaa a adoes wo mu*
> (Grandsire Gyima with a slim but generous arm).
> (Nketia 1955: 195, 245)

is the first line of an Akan funeral poem which of itself seems to have little of poetry about it. It is very different when we know the overtones of the concept of generosity, metaphorically expressed here through the familiar concept of the dead man's 'arm'; the particular style and structure, so pleasing and acceptable to the audience; the rhythm and the musical setting of the line; the familiarity and associations of the phrasing; the fact that this is a mother singing for her dead son whom she is calling her 'grandsire' in the verse; and the grief-laden and emotional atmosphere in which these dirges are performed and received— all this makes such a line, and the poem that follows and builds on it, something far from trivial to its Akan listeners. And so on with other African genres.

Building on this background, these crafted oral literary forms fall, I believe, within most definitions of 'literature' (save only for the point about writing as a medium, not always included in such definitions). In other words, though I am not venturing any one particular definition of 'literature', it seems that the elements out of which such definitions tend, variously, to be constructed are also recognizable in oral forms, often with exactly the same range of ambiguities. The basic medium is words, though in both cases this verbal element may be supplemented by visual or musical elements. Beyond this, literature, we are often told, is expressive rather than instrumental, is aesthetic and characterized by a lack of practical purpose—a description equally applicable to much oral art. The exploitation of form, heightening of style, and interest in the medium for its own sake as well as for its descriptive function can clearly be found in oral literary forms. So too can the idea of accepted literary conventions of style, structure and genre laid down by tradition, which are followed by the second-rate and exploited by the original author.

The sense in which literature is set at one remove from reality is another familiar element: this too is recognisable in oral literature, not merely in such obvious ways as in the use of fiction, satire or parable, but also through the very conventionality of the literary forms allied to the imaginative formulation in actual words.

If we prefer to rely on an ostensive type of definition (looking at *examples* of what we mean) and list the kind of genres we would include under the heading of 'literature" this gives us many analogies in oral literature (though we may find that we have to add a few not familiar in recent European literature). Among African oral genres, for instance, there are forms analogous to European elegies, panegyric poetry, lyric, religious poetry, fictional prose, rhetoric, topical epigram, and perhaps drama.

Whichever approach we take will run into some difficulties

and unclear cases—in the case of oral literature the problem of delimiting literary from everyday spoken forms is a peculiarly difficult one which I do not think I have solved successfully here—but the point I want to stress is that these difficulties are no different from those that crop up to puzzle us in the study of *any* kind of literature. In fact there is no good reason to deny the title of "literature" to literary-type forms just because they happen to be unwritten.

The consequence is, that if we do treat African oral forms as fundamentally different, we deny ourselves a wider perspective on the general subject of comparative literature. We need of course to remember that oral literature is only one type of literature, a type characterized by particular features to do with performance, transmission, and social context, with the various implications these have for its study. But for all these differences, there is surely no essential chasm between this type of literature and the more familiar written forms.

And for this point, and for leading us to appreciate more fully the oral and multisensory qualities of the world's word-based art forms, including those nearer home, we have Africa and its study to thank.

3

THE BEAUTY OF LANGUAGE

Performance is, indeed, crucial. But we are after all, within this, dealing with *words*. To understand here more fully we need to say something about the linguistic context and resources of these performances.

First, it must be said, Africa is, with New Guinea, linguistically one of the most complex areas in the world. The exact number of languages to be found is a matter of dispute, but certainly in the high hundreds, more likely thousands. These, let it be stressed, are *languages* in the full sense of the term, not just 'dialects' as foreigners tended, in derogatory terms, to label them.

They can, however, be grouped together into larger language families. The exact composition and relationships of these are, again, a matter of controversy, but the overall picture is clear.

The best-known group is that of the Bantu languages (languages like Zulu, Swahili and Luba), which extend over practically all of south and central Africa. In the opinion of some recent scholars, even this large Bantu group is only one subdivision within a much larger family, the 'Niger-Congo' group, which includes most of the languages of West Africa. Another vast family is the Afro-Asiatic (also called Hamito-Semitic), a huge language group which not only includes Arabic but also, in the form of one language or another, covers most of North Africa, the Horn of East Africa (including Ethiopia), and an extensive area near Lake Chad (the well-known and widely spoken example of Hausa). The Central

Saharan and Macro-Sudanic families are two further groupings, the former covering a large but mostly sparsely inhabited region north and east of Lake Chad, the latter the Sudanic languages around the Nile/Congo divide and the Nilotic and Great Lakes region of East Africa. And then there is the remarkable and unusual 'Click' (or Khoisan) family covering the Bushman and Hottentot languages which, in the south-west of Africa, form a separate island in an otherwise Bantu-dominated area. Finally we should also mention the more recently arrived languages like English, French or Afrikaans, by now well dug-in *African* languages: they too are part of the equation.

Across these contrasting language families, there are nevertheless certain distinctive features. These no doubt come from contacts among these languages within the continent (a familiar linguistic process), on a vast scale and over a long period. Though many of these features exist singly elsewhere, their combination gives a definite enough characterization for an expert to be able to spot any one of these languages as being African.

Contrary to earlier views, then—based essentially on nothing else but either ignorance or speculation about the supposed 'primitive nature' of non-literate language—it is now known that African languages are neither simple in structure nor deficient in vocabulary. They can, indeed, be exceedingly complex. Many, for instance, make complicated and subtle use of varying tones to express different lexical and grammatical forms—a widespread element in African languages is *tone* (pitch), especially but not exclusively in West African languages. In these languages tone is significant for grammatical form and, as in Chinese, for meaning. In Yoruba, Igbo or Ewe, for instance, the meaning of words with exactly the same phonetic form in other respects may be completely different depending on their tone—it is in fact a different word. The tense of a verb, case of a noun, even

the difference between affirmative and negative can also depend on tonal differentiation. In poetry too tone can be important, sometimes taking on the role that in other languages is played by rhythm or rhyme. So too in tonal riddles, where the art is to reply with a word or phrase with the same tones as the question. Tonal patterning is something of which speakers of such languages are very aware, and it has even been said of Yoruba that a native speaker finds it easier to understand someone who gets the sounds wrong than someone speaking with incorrect tones.

Other languages have a system of affixes comparable in scope to those of Russian, Hungarian, or ancient Greek. In some, multiple complex derivations can be built on the verb to express such concepts as causative, reciprocal, reflexive, passive or applicative action. Complex noun-classifications are also found; somewhat analogous to the simpler gender assignment of European languages, there is also the remarkable system of classes, characterized by prefixes, most notably the system by which all nouns are divided in the Bantu languages, but similar forms are also to be found elsewhere.

In these and many other ways each language has its individual resources of structure and vocabulary on which the native speaker can draw for both everyday communication and literary expression. A full appreciation of these points can naturally only be gained through a detailed study and knowledge of a particular language and its various forms of expression. But a general discussion of the Bantu group of languages can illustrate better than mere assertion the kinds of factors that can be present— literary-linguistic resources have been vividly described by the eminent South African scholar Clement Doke:

> Great literary languages have a heritage of oral tradition which has influenced the form of the earliest literary efforts: in many cases this early heritage has had to a great extent to be deduced; but we are in

the fortunate position of being able to observe the Bantu languages at a stage in which their literature is still, in the vast majority of cases, entirely oral. (Doke 1948:284)

The linguistic basis within which Bantu speech and literature are set and on which written forms are built emerges clearly from his description. In the first place, the literary potentialities of these languages include their remarkably rich vocabularies. Languages like Zulu or Xhosa, for instance, are known to have a vocabulary of over 30,000 words (excluding all automatic derivatives), the standard southern Sotho dictionary (20,000 words) is definitely not exhaustive, and Laman's great Kongo dictionary gives 50,000–60,000 entries. A large percentage of vocabulary, furthermore, is employed in daily use by 'ordinary people'. This naturally did not, in earlier years, include words for objects and ideas outside the cultures at the time. African languages have always shown themselves peculiarly adaptable in assimilating foreign terms; and in 'the fields of experience with which Bantu thought is familiar, the extent of Bantu vocabulary tends to be rather larger than that of the average European language'.

Vocabulary, however, is not just a matter of the *number* of words. It is also how they are used. The picturesque and imaginative forms of expression of many Bantu languages can be, and are, applied to even the commonest actions, objects and descriptions. The highly figurative quality of Bantu speech comes out in some of these terms—*molalatladi*, the rainbow, is literally 'the sleeping-place of the lightning'; *mojalefa*, the son and heir of a household, is 'the eater of the inheritance'; *bohlaba-tsatsi*, the east, is 'where the sun pierces'. This also comes out in compound nouns. In the Kongo language, for instance, *kikolwa-malavu*, a drunken person is 'stiff with wine'; *kilangula-nsangu*, a slanderer, is 'uprooting reputations', while in Bemba *icikata-nsoka*, a courageous person, is 'handling a snake', and *umuleka-ciwa*, ricochet, is, nicely,

'the devil aims it'. Besides the praise forms to be explained in a later chapter, figurative expression is also commonly used to convey abstract ideas in a vivid and imaginative way. The idea of 'conservatism' for instance is expressed in the Zulu phrase meaning 'to eat with an old-fashioned spoon', 'dissimulation' by 'he spoke with two mouths', while in southern Sotho the idea of 'bribery' is 'the hand in the cloak'.

The flexible way this vocabulary is deployed can only be explained with some reference to the characteristics of Bantu morphology (language structure). One of the most striking features is the wealth of derivative forms that can be built on a few roots through the affixes, agglutination and internal vowel changes to express the most delicate shades of meaning. The verb system in particular is extraordinarily elaborate. There are of course the normal forms of conjugation of the type we might expect—though these forms are complex enough and exhibit a great variety of moods, implications, aspects and tenses. Zulu, for instance, has, apart from imperative and infinitive forms, five moods, three implications (simple, progressive and exclusive), three aspects, and a large number of tenses built up on verbal roots. There are also multiple derivative verbal forms—an even more fertile resource for speakers: stereotyped monotony is easily avoided.

The extent of these derivative verbal forms can be illustrated from Lamba, a Bantu language from Central Africa. For this one language, Doke lists seventeen different formations of the verb, each expressing a different aspect. These comprise:

1. Passive (suffix -*wa*).
2. Neuter (intransitive state or condition, suffix -*ika* or -*eka*).
3. Applied (action applied on behalf of, towards or with regard to some object; suffix -*ila*, -*ina*, et al.), e.g. *ima* (rise) > *imina* (rise up against).

4. Causative (various suffixes), e.g. *lala* (lie down) > *lalika* (lay down).
5. Intensive (intensity or quickness of action, suffix *-isya* or *-esya*), e.g. *pama* (beat) > *pamisya* (beat hard).
6. Reciprocal (indicating action done to one another, suffix *-ana* or (complex form) *-ansyanya*, e.g. *ipaya* (kill) > *ipayansyanya* (engage in killing each other).
7. Associative (indicating action in association, suffix *-akana* or *-ankana*), e.g. *sika* (bury) > sikakana (be buried together).
8. Reversive (indicating reversal of the action, various suffixes with different meanings), e.g. *longa* (pack) > *longoloka* (come unpacked), *longolọla* (unpack), and *longolosya* (cause to be in an unpacked state).
9. Extensive (indicating an action extended in time or space, various suffixes), e.g. *pama* (strike) > *i* (beat).
10. Perfective (of action carried to completion or perfection, various suffixes), e.g. *i* (leave) > *i* (leave quite alone).
11. Stative (state, condition, or posture, in *-ama*) .
12. Contactive (indicating contact, touch, in *-ata*) .
13. Frequentative (by reduplicating the stem), e.g. *-ya* (go) > *-yayaya* (go on and on and on).

A few other forms occur sporadically:
1. Excessive (in *-asika*) , e.g. *pema* (breathe) > *pemasika* (pant).
2. Contrary (in *-ngana*) , e.g. *selengana* (be in confusion).
3. Reference to displacement, violent movement (*-muka* and various other suffixes), e.g. *cilimuka* (rush off).
4. Reference to extension, spreading out (suffix *-alala*) , e.g. *andalala* (spread out at work)

Lamba is particularly rich in these verbal derivatives, but

similar formations are found in all Bantu languages. In Mongo, for instance, a linguist can list eighty different forms of the verb in his table of verbal 'conjugation', each with its characteristic format. Another scholar sums up the 'extraordinary richness' of the Bantu verb:

> Any verb stem... can be made the base of some twenty or thirty others, all reflecting the root idea in various lights, sometimes curiously limited by usage to a particular aspect and limited significance, mostly quite free and unrestrained in growth, and each bearing the whole luxuriant super-growth of voices, moods, tenses, and person-forms, to the utmost limits of its powers of logical extension. (Madan 1911: 53)

A second subtle linguistic instrument is the system of nouns and noun-formation. The basic structure is built up on a kind of grammatical class-gender, with concordial agreement. In Bantu languages, that is, there are a number of different classes, varying from twelve or thirteen to as many as twenty-two (in Luganda), into one or other of which all nouns fall. Each class has a typical prefix which, in one or another form, is repeated throughout the sentence in which the noun occurs (concordial agreement: similar to the more limited gender concordance of French or Latin).

A simple example will make this clear. The Zulu term for horses, *amahhashi*, is characterized by the prefix *ama-* which reappears (*a-*, *ama-*) in any phrase referring to them. Thus 'his big horses ran away' must be expressed as 'horses they-his they-big they-ran-away' (*amahhashi akhe amakhulu abalekile*). The precision of reference achieved through this grammatical form dispels the vagueness and ambiguity sometimes found in equivalent English forms, and at the same time provides possibilities—which are exploited—for alliteration and balance in literary formulations.

Each of these noun classes tends to cover one main type of

referent (with variations between different languages). People and personal names predominate in classes 1 and 2, names of trees in 3 and 4, of animals in classes 9 and 10, abstract terms in class 14, verb infinitives in class 15, and locatives in classes 16, 17 and 18.

There are effective ways of using this system. Changing the prefix (and thus class) of a particular word can put it into a new class and thus startle listeners or put a new construction on it by altering its meaning or connotation. In Tswana, for instance, *mo/nna*, man (class 1) takes on new meaning when transferred to other classes, as se/nna, manliness, bojnna, manhood, while in Venda we have *tshi/thu*, thing, *ku/thu*, tiny thing, and *di/thu*, huge thing.

Besides such straightforward instances, the transference of noun class is sometimes exploited in a vivid and less predictable way in the actual delivery of an oral piece. *AnNilyamba*, a story about a hare's wicked exploits, ends up with the narrator vividly and economically drawing his conclusion by putting the hare no longer in his own noun class but, by a mere change of prefix, into that normally used for monsters!

Personification is very popular. It can be economically effected by transferring an ordinary noun from its usual class to that of persons, as in the Zulu personified form *uNtaba* (Mountain) from the common noun for mountain, *intaba*; and *uSikhotha*, from the ordinary *isikhotha*, long grass. This kind of personification is sometimes found in stories where the name of an animal is transferred to the personal class and thus, as it were, invested with human character. A further way of achieving personification is by formations based, among other things, on special prefixes, derivations from verbs or ideophones, reduplication or the rich resources of compounding. Several of these bases can be used to form special impersonal nouns, like, say, a verb stem modified by a class 4 prefix to indicate 'method of action' (e.g. the Kikuyu *muthiire*, manner of walking, from *thii*, walk), or by a class 7

prefix (I like this!) suggesting an action done carelessly or badly (e.g. Lamba *icendeende*, aimless walking about, from *enda*, walk, or the Lulua *tshiakulakula*, gibberish, from *akula*, talk).

Then there are the special suffixes or prefixes that can transform a root noun into a diminutive, into a masculine or feminine form, or into a term meaning the in-law, the father, the mother, the daughter, and so on of the referent. Reduplication is also often used in noun formation. In Zulu for example the ordinary form *izinhlobo*, kinds, can be lengthened into *izinhlobonhlobo*, variety of species, and *imimoya*, winds, into *imimoyamoya*, constantly changing winds. Compound nouns above all exhibit the rich flexibilithy of expression open to Bantu speakes. These use combinations of verbs (compounded with e.g. subject, object or descriptive) or nouns (compounded with other nouns, with a qualitative, or with an ideophone (on which below)—hence the Lamba *umwenda-nandu*, a deep ford ('where the crocodile travels'), *icikoka-mabwe*, the klipspringer antelope (lit. 'rock-blunter'); Xhosa *indlulamthi*, giraffe (lit. 'surpasser of trees'), or *amabona-ndenzile*, attempts ('see what I have done'); or the Ila name for God, Ipaokubozha, 'He that gives and rots'.

To this can be added the special 'praise names' described in a later chapter. These add yet a further figurative aspect to those already mentioned.

As well a the actual vocabulary in use in each language there is also the style and syntax. These vary with the particular literary genre chosen by the speaker. In general, apart from the rhetorical praise poems of the southern areas, Bantu syntax gives the impression of being relatively simple and direct. This is misleading: the syntactical relationships of sentences are more complex than they appear. What seems like co-ordination of simple sentences in narrative in fact often conceals subtle forms of subordination through the use of subjunctive, sequences of historic tenses, or conditionals. A fluent speaker can thus avoid the monotony of

a lengthy series of parallel and conjunctive sentences—though this is the form in which such passages tend to appear in English translations.

Further, Bantu expression generally is not limited, as is English, by a more or less rigid word-order: because of its structure there are many possible ways in which, by changes in word-order or terminology, delicate shades of meaning can be precisely expressed which in English would have to depend on the sometimes ambiguous form of emphatic stress. All in all, Doke concludes, 'Bantu languages are capable of remarkable fluency…They provide a vehicle for wonderful handling by the expert speaker or writer.' (Doke 1948: 285)

Besides the basic structure of Bantu languages, other features add to its resources for speech or writing. The most striking is the *ideophone* (also called 'mimic noun', 'intensive noun'—though it isn't really a noun—or, better, 'indeclinable verbal particle'). It conveys most immediately a kind of a idea-in-sound and is commonly used to add emotion or vividness to a description or recitation. Ideophones are sometimes onomatopoeic, but the acoustic impression often conveys other aspects, ones that in English culture at least are not normally associated with sound at all—manner, colour, taste, smell, silence, action, condition, texture, gait, posture or intensity. To some extent they resemble adverbs in function, but in grammatical form seem more like interjections, demonstrating the richness and elasticity of the language, with new ones constantly being invented.

These always serve to heighten a narrative and add drama. They come in continually to create a particularly lively style or vivid description and are used with considerable rhetorical effect to express emotion or excitement. An account, say, of a rescue from a crocodile or a burning house, of the complicated and excited interaction at a communal hunt or a football match—these are the kinds of contexts made vivid, almost brought directly before

the listener's eyes, by the plentiful use of ideophones: They are used by accomplished speakers with an artistic sense for the right word. To be used skilfully, I have been told, they must arise from the speaker's inner feeling.

The graphic effect of these ideophones is not easy to describe in writing, but it is worth illustrating some of the kinds of terms involved. The Rhodesian Shona ideophones include k'we—sound of striking a match, *gwengwendere*, sound of dropping enamel plates; *nyiri nyiri nyiri nyiri*, flickering of light on a cinema screen; *dhdbhu dhdbhu dhdbhu*, of an eagle flying slowly; *tsvukururu*, of millet turning red; go, go, go, *ngondo ngondo ngondo*, *pxaka pxaka pxaka pxaka pxaka*, the chopping down of a tree, its fall, and the splintering of the branches. In Zulu there is *khwi*, turning around suddenly; *dwi*, dawning, coming consciousness, returning sobriety, easing of pain, relief; *ntrr*, flying high with upward sweep, aeroplane or missile flying; *bekebe*, flickering faintly and disappearing; *khwibishi*, sudden recoil, forceful springing back; *fafalazi*, doing a thing, carelessly or superficially; *ya*, perfection, completion.

Ideophones are often in a reduplicated form. In Thonga they can give a vivid impression of gait and manner of movement: A tortoise is moving laboriously—*khwanya-khwanya-khwanya!* A butterfly in the air—*pha-pha-pha-pha*. A frog jumps into a pond, after three little jumps on the ground—*noni-noni-noni-djamaaa*. A man runs very slowly—*wahle-wahle-wahle*; with little hurried steps—*nyakwi-nyakwi-nyakwi*; at full speed—*nyu-nyu-nyu-nyu-nyuuu*. Walking drunkenly—*tlikwi-tlikwi*. A tired dog—*fambifa-fambifa-fambifa*. A lady with high-heeled shoes—*peswa-peswa*. Thus a Thonga writer can describe vividly and economically how a man was seized, thrown on the thatched roof of a hut, came down violently and fell on the ground: *Vo nwi! tshuku-tshuku! O tlhela a ku: shulululuuu! a wa hi matimba a ku: pyakavakaa.* In Thonga, this form expresses, in a little word, a movement,

a sound, an impression of fear, joy or amazement. Sensation is immediate and is immediately translated into a word or a sound, a sound-sensation so appropriate, so fitting, that one sees the animal moving, hears the sound produced, or feels oneself the very sensation expressed.

In the ideophone, therefore, speakers of Bantu languages have a rhetorical and emotive tool whose effectiveness cannot be overemphasized. In vivid and dramatic passages to use it is to be graphic; to omit it is to be prosaic, and

> In descriptive narration in which emotions are highly wrought upon…the vivid descriptive power of *kuti* [ideophone] is seen, and the-human appeal is made, and the depths of pathos are stirred by this medium of expression of intensely-wrought emotion without parallel in any other language. The ideophone is the key to Native descriptive oratory. I can't imagine a Native speaking in public with intense feeling without using it. (Burbridge, quoted in Doke 1948: 287)

There are a few additional features to mention. One is the sound system in which strongly marked dynamic stresses, occurring in more or less regular positions in all words of the same language, and the incidence of long syllables also usually in the same positions, give a rhythmic quality and a measured and balanced flow not met with in languages with irregular stresses and more staccato delivery. The type of verse used exploits the grammatical and syntactical possibilities of the language, which is not, as in English, bound by a fixed word order, and alliterative parallelism is common. Thus in the Zulu proverb *Kuhlwile / phambili // kusile / emuva* (It is dark / in front // it is light / behind—'it is easy to be wise after the event') there is perfect parallelism, idea contrasting to idea in corresponding position, identical parts of speech paralleling each other (verb for verb, and

adverb for adverb), and, finally, number of syllables and dynamic stress exactly matching each other. Similar effects are produced by 'cross-parallelism' (chiasmus) where the correspondence is to be found crosswise and not directly, and by linking the repetition of a prominent word or phrase in a previous line in the first half of the next one. The balance may extend to tonal correspondence and this , though very different from more familiar 'metrical' forms, is felt to provide perfect balance and rhythm by native speakers of the language

And then there is the local literary tradition and spirit of criticism as a whole. The long interest in oratory and in literary criticism is in their very blood, so that discussions of words and idioms, and plays on tone, word, and syllable length 'provide hours of entertainment around the hearth or camp fire in Central Africa'. There are the metaphorical praise names, the established literary genres—recognized in Africa as elsewhere—and the rich fund of proverbs, often in metrical form that can ornament both everyday and literary expression with their figurative and elliptical forms.

Other languages in Africa have yet other resources of structure or vocabulary, but a similar kind of analysis could no doubt be made in each case. There is no reason, in short, to accept the once common supposition that African languages, unlike those of Europe, provide only an inadequate vehicle for the expression of speech, thought and literature.

4

THE POWER OF PRAISE

Panegyric (praise poetry) is the most prized and elaborate poetic genre of Africa. It often goes with a particular ethos: a stress on royal or aristocratic power, and an admiration for military achievement. Praises (including self-praises) also occur among non-centralized peoples, particularly those who lay stress on the significance of personal achievement in war or hunting. The use of "praise names" is nearly universal. The most specialized forms, however, and those to be first considered here, are the formalized praises directed publicly to kings, chiefs, and leaders, composed and recited by members of a king's official entourage.

First, then, the "praise names", a striking feature in many African cultures (more fully considered in a later chapter). These are most often given to people but may also describe clans, animals, or inanimate objects. Usually explicitly laudatory, they are commonly the basis of formal praise poetry. The Zulu king Shaka's praise is focused on one of his many names as, "The Ever-ready-to-meet-any-challenge", a West African Hausa chief as "Fearful and terrible son of Jato who turns a town into ashes", an Ankole warrior as "He who Does Not Fear Black Steel". Such phrases occur frequently within complete poems. The stock praise name of the Huasa *molo* (three-stringed guitar) is "*Molo*, the drum of intrigue; if it has not begun it is being arranged" (the *molo* is often associated with immorality); of the wind "O wind, you have no weight, but you cut down the biggest trees." Similar stock praises are used of people or animals: a butterfly is "O Glistening One, O Book of God, O Learned One open your

book" (i.e. the wings, compared to the Koran); a lion "O Strong One, Elder Brother of the Forest"; an old woman is addressed as "O Old Thing, you are thin everywhere except at the knee, of flesh you have but a handful, though your bones would fill a basket."

Other "praise" names are negative or concerned more with insight into inherent qualities than with praise in the direct sense Derogatory "praise" names are in fact common in West Africa and can be used in proverbs and riddles as well as conversation. They do not replace the more laudatory comments, however, for, also among the Hausa, every celebrated man has his own praise name, used in prolonged praises by what might be termed "professional flatterers". Among the Yoruba *oriki* (praise names) are like permanent titles held by individuals, given to them by friends or, most often, by the drummers. Some individuals have several names, so a collection of them, recited together, resembles a loosely constructed poem (also called *oriki*) about the person praised. In east and south Africa cattle are a popular subject in praise poetry, and inanimate things like divining implements or even a train or bicycle are also praised. Although normally addressed to distinguished human beings or to animals, praise poems can be concerned with almost anything—divining bones, beer, birds, clans. Even a stick can be apostrophized in high-sounding terms, as in the Zulu:

Guardsman of the river fords,
Joy of adventurers reckless! (Dhlomo 1947:6)

Among the pastoral Zulu cattle are particularly popular, but wild animals appear too. The lion is the "stone-smasher", or "awe-inspirer", or "darkness", the crocodile

Cruel one, killer whilst laughing.
The Crocodile is the laughing teeth that kill. (Lekgothoane 1938: 201)

In West Africa formal praises are also addressed to supernatural beings. When a spirit is to be called, its praise songs are played through one after another until it takes possession of one of its worshippers. Yoruba praise poems to deities in Nigeria and Dahomey (as well as in Brazil where Africans were transported in the slave trade) are particularly famous. Each of the many Yoruba deities (*orisha*) has a series of praises expressed in figurative and obscure language, sung by a priest. Here, for instance, is a praise poem to, and about, Ogun, the god of iron and warfare, one of the most powerful deities, worshipped particularly by warriors, hunters and blacksmiths:

Ogun kills on the right and destroys on the right.
Ogun kills on the left and destroys on the left.
Ogun kills suddenly in the house and suddenly in the field.
Ogun kills the child with the iron with which it plays.
Ogun kills in silence.

Ogun kills the thief and the owner of the stolen goods.
Ogun kills the owner of the slave—and the slave runs away.
Ogun kills the owner of thirty *iwofa* [pawns]—and his money, wealth and children disappear
Ogun kills the owner of the house and paints the hearth with his blood.
Ogun is the death who pursues a child until it runs into the bush.
Ogun is the needle that pricks at both ends.
Ogun has water but he washes in blood.
Ogun do not fight me. I belong only to you.

The wife of Ogun is like a *tim tim* [decorated leather cushion].
She does not like two people to rest on her.

Ogun has many gowns. He gives them all to the beggars.

He gives one to the woodcock—the woodcock dyes it indigo.
He gives one to the coucal—the coucal dyes it in camwood.
He gives one to the cattle egret—the cattle egret leaves it white.

Ogun is not like pounded yam:
Do you think you can knead him in your hand
And eat of him until you are satisfied?
Ogun is not like maize gruel:
Do you think you can knead him in your hand
And eat of him until you are satisfied?
Ogun is not like something you can throw in your cap:
Do you think you can put on your cap and walk away with him?

Ogun scatters his enemies.
When the butterflies arrive at the place where the cheetah excretes, they scatter in all directions.

The light shining on Ogun's face is not easy to behold
Ogun, let me not see the red of your eye.
Ogun sacrifices an elephant to his head.
Master of iron, head of warriors,
Ogun, great chief of robbers.
Ogun wears a bloody cap.
Ogun has four hundred wives and one thousand four hundred children.
Ogun, the fire that sweeps the forest.
Ogun's laughter is no joke.
Ogun eats two hundred earthworms and does not vomit.

Ogun is a crazy *orisha* [deity] who still asks questions after 780 years.
Whether I can reply, or whether I cannot reply,
Ogun, please don't ask me anything.
The lion never allows anybody to play with his cub.

Ogun will never allow his child to be punished.

Ogun do not reject me!
Does the woman who spins ever reject a spindle?
Does the woman who dyes ever reject a cloth?
Does the eye that sees ever reject a sight?
Ogun, do not reject me!
(Gbadamosi and Beier 1959: 21-2)

Despite these elaborate religious praises, however, the most frequent subjects for panegyric are humans, especially great warriors and chiefs. Praises of kings are the most formal and public of all, ranging from the relatively simple Ganda praise of the powerful nineteenth-century king Mutesa

Thy feet are hammers,
Son of the forest [a comparison with a lion];
Great is the fear of thee;
Great is thy wrath;
Great is thy peace;
Great is thy power.
(Chadwick 1940, iii, 579)

to the allusive praise of another powerful ruler, a man who had seized power for himself in Zaria and was deposed by the British when they occupied northern Nigeria:

Mahama causer of happiness,
Mahama slab of salt who handles it tastes pleasure,
though thou hatest a man thou givest him a thousand cowries;
thou hatest a naked man's blood but if thou dost not get his garment
thou slayest him.
Mahama the rolling flight of the crow,

O boy, cease gazing and seeing first white then black . . .

the wall of silver that reaches the breast of the horseman
the tying up that is like
son of Audu thy help (is) God
son of Audu, the support of God which is more than the man with
the quiver,
yea more than his chief on his horse
hammer of Audu,
salt of Kakanda that is both sweet and bitter,
son of Audu, O sun, thou dost not look askance and slightingly,
storm on the land, medicine for the man with the mat-cover,
elephant with the red loins, medicine for the standing grass,
with thy trunk thou spiest into every man's house;
the beating of the rain does not stop the jingling of the bell
the swelling of the palm-stem that fills the embrace of the (climbing)
boy
black dafara tree there is labour before thou breakest.
(Fletcher 1912: 38-9)

The frank assessment of the emir's character that accompanies
the praise of his power and achievements is not unparalleled.
Thus the praises of two Hausa emirs of Zazzau run

Look not with too friendly eyes upon the world,
Pass your hand over your face in meditation,
Not from the heat of the sun.
The bull elephant is wise and lives long.

Be patient, and listen not to idle tales
Poisoned chaff attracts the silly sheep—and kills them.
(Heath 1962: 27, 32)

Self-praises, created and performed by the subject him- or (less often) herself, are not uncommon. Among the Sotho all adult men are expected to be able to compose and perform self-praises, and the composition of formalized praise poetry among the Ankole is expected to be within the capacity of every nobleman: he must find inspiration in a particular episode, compose a personal and topical praise poem based on it, and add it to his repertoire. Among the Nigerian Igbo taking a title is followed by a string of self-praises. Or again the personal recitations of the Hima noble class of Ankole celebrate a man's military achievements, building up a sequence of praise names:

> I Who Am Praised thus held out in battle among foreigners along with The Overthrower;
> I Who Ravish Spear In Each Hand stood resplendent in my cotton cloth;
> I Who Am Quick was drawn from afar by lust for the fight...
> (Morris 1964: 42)

Praises by women occur too. In the kingdom of Dahomey choruses of wives performed in praise of the king and nobles, and there is a professional Nupe women's group. The most formal praises, however, are usually by official male bards. Every Zulu king had one or more specialists who both recited the praises of previous rulers and composed new ones for the current king. There were specialist praise poets, ranging from the Ashanti state drummers and singers to Rwandan dynastic poets. Whole teams, with the obligatory musicians, were sometimes responsible for official praises; among the northern Nigerian Hausa a District Head's *maroka* (praise) team normally contained several drummers on different types of drum, eulogists, two or more pipers, and sometimes a horn-blower. Lesser chiefs had bards who were less skilled and less specialized, modelled on the king's

but performing in a less complex and more limited way.

The *style* of recitation varied between the unaccompanied forms characteristic of the Southern Bantu praises, those with minimal string accompaniment on some stringed instrument, and those where the music was to some regular rhythmic beat (usually percussion or wind). This last is widespread in West African states and its precise form often significant. Among the Hausa the amount or type of musical accompaniment is clearly laid down for each grade of ruler in the hierarchy; wooden gongs, for instance, could not be used to praise anyone below a certain level and certain instruments could only be used for rulers.

Most praise poetry, above all the official type, is in a relatively obscure and allusive style. The language is generally archaic and lofty, there are often references to historical events or people which may need interpretation even to local listeners, and figurative forms of expression are common. Especially frequent are comparisons of the person praised to an animal or animals. He is as a lion, rhinoceros or elephant in strength; and, particularly in southern Bantu praise poetry, his actions and qualities are often almost completely conveyed in metaphorical terms, only the animals to which the hero is implicitly compared being depicted in action. Comparisons to natural phenomena are common too—the hero is a storm, a rock, a downpour of rain.

Other figurative forms of expression are used too, sometimes reaching a high degree of complexity. In one Rwanda poem the royal name, "Ntare" suggests *intare*, lion to the bard; he "veils" the royal lion by emphasising the animal"s qualities: "Hunter of zebras", "Clamour of the forests", "Mane-carrier". Praise is not something to be expressed in bald or straightforward language.

Much panegyric, highly formalized, is less variable than other types of oral literature. Unlike self-praises and the more informal and topical praise poems the state praises of present and. particularly. past rulers are often handed down in a more

or less received version. Word and stanza order is, indeed, sometimes varied from recitation to recitation, or follows the particular version approved by an individual bard but the changes are minor; stress is laid on conformity to tradition. In Rwanda, with its powerful corporation of bards, the exactness of wording is even more close. In one case there were only very slight variations in four versions by four different bards of a 365-line praise poem attributed to a poet from the early nineteenth century.

Animal praises tend to be light-hearted and humorous. Here is a Southern Sotho praise for a pig:

Pig that runs about fussily,
Above the narrow places, above the ground;
Up above the sun shines, the pig grows fat,
The animal which grows fat when it has dawned.

Pig that runs about fussily,
With little horns in its mouth.
(Lestrade 1935: 9)

But even these can be solemn. Indeed there is often an intentional ambiguity between animal and person, and some poems are really sustained metaphors. The following extract from a Northern Sotho poem appears to be about a leopard; but the allusion is to the chiefs of the Tlokwa, whose symbol was a leopard:

It is the yellow leopard with the spots,
The yellow leopard of the cliffs.
It is the leopard of the broad cheeks,
Yellow leopard of the broad face, I-do-not-fear
The black and white one, I-get-into-a-small-tree,

I tear off the eyebrows,
Clawer am I, I dig in my claws
My people (adversaries) I leave behind
Saying: this was not one leopard, there were ten.

Mr Claws, scratch for yourself.
Even for a big man it's no disgrace to yell if scratched.
Leopards of the Tlokwa country
Of Bolea, where the Tlokwa came from,

Wild cat with the broad face,
Both impala buck we eat and cattle,
Yellow leopard of the clan Maloba the great,
Yellow spotted one,
Poor nobody, active smart fellow that summons together a huge
gathering,
My victim goes away with his scalp hanging down over his eyes

Leopard of the many spots
Leopard of the very dark spots
Leopard grand old man (formidable one)
Even when it can no longer bite, it still butts its adversaries out of the
way with its forehead.
(Lekgothoane 1938: 193-5)

Most ambitious and elaborate of all are the praises composed
and recited by the professional bards surrounding a king or chief.
The following extract from one of the many long praises of the
famous Zulu king, Shaka, illustrates the use of allusion, metaphor
and praise name combined with an element of narrative to convey
the fearsomeness of the king as he defeated his enemy Zwide:

His spear is terrible.
The Ever-ready-to-meet-any-challenge!
The first-born sons of their mothers who were called for many years!
He is like the cluster of stones of Nkandhla,
Which sheltered the elephants when it had rained.
The hawk which I saw sweeping down from Mangcengeza;
When he came to Pungashe he disappeared.

He invades, the forests echo, saying, in echoing,
He paid a fine of the duiker and the doe.
He is seen by the hunters who trap the flying ants;
He was hindered by a cock in front,
By the people of Ntombazi and Langa [mother and father of Zwide],
He devoured Nomahlanjana son of Zwide;
He devoured Mdandalazi son of Gaqa of the amaPela;
He was lop-eared. He devoured Mdandalazi son of Gaqa of the
amaPela;
He was lop-eared.
The Driver-away of the old man born of Langa's daughter!
The Ever-ready-to-meet-any-challenge!
Shaka!

The Eagle-which-beats-its-wings-where-herds-graze!
He drove away Zwide son of Langa,
Until he caused him to disappear in the Ubani;
Until he crossed above Johannesburg and disappeared;
He crossed the Limpopo where it was rocky;
Even though he left Pretoria with tears.
He killed the snake, he did not kill it in summer,
He killed it when the winter had come.
(Grant 1927: 211-3)

The convention is to focus on the praisee's military success whether against neighbouring peoples in pitched battle or more mobile cattle raiding. Wars against European invaders also often came into praise poems—one may wonder whether the exploits of the conquerors were celebrated in as poetic and elevated a manner as some of those of the conquered! Given this focus it is scarcely surprising that even more peaceful exploits were expressed in military terms. There are also references to acts of generosity and to skill and achievement in hunting. Comments on personality and criticism can provide social pressure on an unpopular chief. sometimes, counter-intuitively sarcastic, even insulting, remarks are conventionally taken, as among the Ngoni at least, as high praise—comments are so ludicrous that they could not possibly be literally true! Recently composed praises speak of such topics as winning a case in the High Court, travelling abroad to, or dealing with tax collectors.

There are special prefixes suitable for praising, for example se-, which indicates the habitual doing of something and is common in praises to suggest the hero's habit or character, and ma-, which appears in names with the idea of doing something extensively or repeatedly. Parallelism and repetition are marked features in praise poetry. Sometimes the repetition is not exact but the repeated phrase has something added to it, leading to progress in the action as in the Zulu 'He has taken out Ntsane of Basieeng He has taken out Ntsane from the cleft in the rock.' Or a thought may be repeated in following lines even when the wording is different:

Watchman of derelict homes,
Caretaker of people's ruins,
Guardian of his mother's deserted house.

Though animal metaphors are the most common, heroes are also compared to natural phenomena like lightning, wind or

storm, or to other objects like a shield, a rock, flames of fire:

> The whirlwind [the hero] causes people to stumble
> The people were swept by the downpour of spears
> The heavy rain of summer, a storm,
> The hailstorm with very hard drops.

Sometimes there is a whole series of metaphors by which the hero is compared, or compares himself, to various different objects:

> The rumbling which is like the roll of thunder,
> Ox belonging to the younger brother of the chief . . .
> I am the wind that raises the yellow dust,
> I am the rhinoceros from the Badimo cattle-post,
> Son of Mma-Maleka and nephew of Lesele.

Similarly in the Transvaal Ndebele lines:

> The hail that came down in the middle of winter,
> And came down at emaKhophana.
> The elephant that took fire in a potsherd,
> And went and set the kraals of men alight,
> And burned down those of all the tribe.

Special grammatical forms are also used to introduce a metaphorical impression. In Southern Sotho, for instance, there is sometimes a change within the poem from class 1 concords (the personal class) to others, a device that both conveys a metaphor and leads to variety. 'Wrong' concords in Zulu similarly suggest a metaphorical idea.

Hyperbole appears in emotional descriptions, adding vividness. The confusion and fierceness of the battle is indicated by 'A cow

should run carrying her calf, A man should run carrying his child' and 'The small herbs were frost-bitten in the middle of summer... The trees lost their leaves, The sparrows, the birds that lay eggs in the trees, forsook their nests', while a man's feelings are conveyed by 'He left grieved in his heart, He left with the heart fighting with the lungs, Heaven quarrelling with the earth.'

It is largely in this figurative and allusive mode that people are depicted in the praise poems. There is little stress on personal emotions, lyrical descriptions of nature, or straightforward narration. Rather a series of pictures is conveyed to the listeners through a number of laconic and often rather staccato sentences, a grouping of ideas which may on different occasions come in a different order. In this way impressions are communicated with economy and vividness. Consider the emotional shorthand in the Zulu poem:

> The thunder that bursts on the open
> Where mimosa trees are none.
> The giant camouflaged with leaves
> In the track of Nxaba's cattle.
> He refuses tasks imposed by other people.

The figurative language conveys the action. First the hero's temper is described as like a sudden thunderstorm, then his force is indicated by comparing it to a giant elephant hidden by the leaves of the trees. His strength is brought out further by the way he is able to win back the cattle taken away by one of the headmen (Nxaba) who fled north in Shaka's reign; finally that not even Shaka can impose his commands on him proves his hardihood and strength of mind.

This loose ordering of stanzas is typical: through a series of flashes a man's qualities and deeds are conveyed to the listener. Nevertheless there are also vivid descriptions of the action itself

in a way that fits the partly narrative aspect of praise poetry. Thus there are many examples of battle scenes in Southern Sotho praise poems. Here the *sounds* of the words, as well as the meaning, heighten the effect:

> Cannons came roaring, the veld resounding
> Sword came tinkling from all sides
> (*Kanono tsa tla li kutuma thota e luma.*
> *Lisabole tsa tla li kelema kahohle*).

The hero's attack and the fate of his victims are favourite topics:

> Maame, the whirlwind of Senate,
> Snatched a man off his horse.
> The European's horse took fright at the corpse;
> It took fright at the corpse without a soul.

> The lion roared when it saw them near.
> It jumped suddenly, wanting to devour them.
> They ran in all directions, the people of Masopha,
> They ran in all directions and filled the village,
> They scattered like finches.

The victim falls dead, and lies motionless:

> He lay down, the grass became taller than him
> While it was finally dead quiet on the ground ...
> A foul smell came from the ridge,
> They no longer drink water the people of Rampai,
> They are drinking clods of human blood.

The stress is generally on action and on the building up of a series of pictures about the deeds and qualities of the hero, rather

than on lyric descriptions of nature. A few passages can be singled out however, as Dhlomo and Vilakazi have done, to represent a more lyrical approach to the beauty of nature. In a Zulu praise poem we have

The greenness which kisses that of a gall bladder!
Butterfly of Phunga, tinted with circling spots,
As if made by the twilight from the shadow of mountains,
In the dusk of the evening, when the wizards are abroad.

But in general the stress is on the hero and his character, so that what pictures are given of the scene and surroundings are subordinate to the insight they give into the hero's activity. The weather, for example, may be described not for its own sake but as a kind of formalized indication that some important event is about to be depicted or to show the determination and perseverance of the hero whatever the conditions:

When he is going to act the mist thickens;
The mist was covering the snow-clad mountains,
Mountains from which the wind blows.
There was a wind, there was snow,
There was a wind, there was snow on the mountains,
 Some were attracted by pillows and remained.

Here, as in all these praise poems, the interest is the laudatory description of the hero rather than descriptions of natural phenomena or the straightforward narration of events. It is to this panegyricizing end that both the general form and the detailed style of these poems all tend.

The power of a praise poem depends partly on the delivery and the personality of the reciter, partly on its reception. It is said, for instance, that when the great general Ndlela kaSompisi recited,

the whole audience became awestruck. Indeed a man whilst praising or being praised was thought able to walk over thorns, without his feet being pierced.

> The reciter pours forth the praises with few pauses for breath and at the top of his voice. Often there is growing excitement and dramatic gestures are made as the poem proceeds. Grant describes a well-known Zulu praiser whom he heard in the 1920s. As the poet recited, he worked himself up to a high pitch of fervour, his face was uplifted, and his voice became loud and strong. The shield and stick that he carried were, from time to time, suddenly raised and shaken, and his gestures became more frequent and dramatic, so that he would suddenly leap in the air or crouch with glaring eyes while praises poured from his lips—until at last he stopped exhausted. (Mofokeng 1927: 202)

Amidst the excitement the bards must still obey the stylistic conventions of the genre. The penultimate syllable of certain words and the word just preceding a line- or stanza-end must be emphasised. Praise poems are generally delivered much faster, and in a higher tone, than ordinary prose utterances. In many places they are shouted or semi-chanted rather than sung, and a special intonation is expected. In Zulu the tonal and melodic movement is not a separate musical creation, but arises directly out of the words of a given line; and at the ends of lines and stanzas there are certain formalized cadences and glides, used as concluding formulae. With this complex and sophisticated form of poetry, unlike the simpler prose tales to be described later, the effect is not primarily dependent on the skill of the reciter (though that had its place), more on the art of the poet as composer—in his use of the traditional forms described above, such as figurative expression, allusion, and the various stylistic devices which, quite apart from his delivery, served to heighten the effectiveness and

power of the verse.

As in all oral art, the audience too take part and shout out encouragingly to support what the praiser is saying or cheer him on, adding to the emotional, even ecstatic mood that is induced by the delivery of these poems.

The *composition* of praise poetry was traditionally both a specialist and a universal activity. In many places all men were expected to have a certain skill. Commoners composed their own praises or those of their families and their cattle, while those of high birth or outstanding prowess had their praises composed by others, the chiefs by specialist bards. The poems about earlier chiefs were handed down and probably known by the chief's followers as well as by the specialist reciters; but it was the particular responsibility of the official bards to recite them on appropriate occasions.

Though the older poems were preserved in this way, this is not to say that each recitation of a single poem was verbally identical. Indeed several versions of the 'same' poem have sometimes been recorded, differing in, for instance, the order of the stanzas, their length, or the detailed wording or order of lines. The form of praise poetry makes it easy for poems to become telescoped without radically altering the sense; this is what seems to have happened with many of the earliest poems which tend to be considerably shorter than those about more recent chiefs.

The recitation itself could give the opportunity for additions by the performer, in the sense that a stanza or line may be introduced in that particular performance from his knowledge of the stock language and imagery. In these ways each separate performance of the traditional poem may involve a certain amount of 'composition' in the sense of introducing variant forms into a poem which has a clear outline but is not fixed into an exact verbal identity. Composition also of course takes place in the more familiar way with original creation by a single poet, notably by the

professional bards of the chief. Using the conventional forms the poet produces a new poem, perhaps designed to commemorate a particular occasion like the coming of distinguished visitors, perhaps in general praise of the chief's deeds and character. The poem may then become famous and be added to the repertoire of praise poems of that particular chief, to be handed down to the court poets even after the chief's death.

These original praise poems were—and are—often the property of the composer in the sense that until his death no one may recite them in public, and the names of the original poets may be remembered for some time. During the nineteenth and earlier part of the twentieth centuries, one of the main occasions for the composition of praise poems, among the Sotho-speaking peoples at least, was at the initiation ceremonies of boys. During their period of seclusion at the age of fifteen or sixteen the boys were required to compose and recite poems in praise of themselves, of their chief and of their parents, and they had to recite these praises publicly on their emergence from seclusion. In this way the art of composition was insisted on as a necessary accomplishment for every man, involving some acquaintance at least with the various stylized forms of expression and historical allusions mentioned earlier.

Praises come on many kinds of *occasions*. Most spectacular and public are when rulers are praised. Sometimes this takes a very simple form, as on the bush paths in northern Liberia or Sierra Leone when a petty chief, carried in his hammock, is accompanied by praises as he enters villages and the local dwellers are thus instructed or reminded of his chiefly dignity. Or it may be a huge public occasion as in the Muslim chiefdoms in Nigeria—Hausa, Nupe, Yoruba—when at the 'Sallah' rituals (the Muslim festivals of Id-el-Fitr and Id-el-Kabir) the subordinate officials attend the king on horseback, accompanied by their praise-singers. Their allegiance is shown by a cavalry charge with

drawn swords outside the palace; the official praise-singers take part in the gallop, piping and drumming the king's praises on horseback

Praise names are used when formal address is required. Among the Southern Bantu the praise name of an individual's clan was used on formal occasions, while among the Yoruba praise names, sung or drummed, are widely heard on festive occasions: drummers go about the streets formally addressing the passers-by and receiving a small reward in return. Among many West African peoples drummers at a king's gate play not only the king's praise names, but announce and honour important guests by drumming or piping their names as they enter the palace. A man's status is recognized and reaffirmed by the use of these formalized praise names, particularly when, as in the announcement of visitors, this is in public performance. There are also many informal occasions, praises used much in the same way as speeches or commentaries in other contexts. Thus among the Kele of the Congo, wrestling matches are often accompanied by talking-drum praises, saluting the contestants as they enter the ring ('the hero, full of pride') with drummed comment and encouragement from the drums as the match continues, and at the end praise for the victor.

On festive occasions—the Yoruba are one example—singers and drummers welcome those who attend with songs or chants of praise, usually led by a soloist who improvises to suit the individual, accompanied by a chorus. They can be used for profit by freelancers to stir people to genuine excitement: gifts are showered on the poets from enthusiasm as well as fear.

Praise poetry is essential in rites of passage: praises mark the new status or commemorate the old, as at weddings or for funeral dirges (themselves often eulogies). Again, self-praises by boys at initiation, as among the Sotho or the Galla, are an important aspect of their claim to adulthood, which is heard and accepted

by their audience. Among many peoples, weddings are also an obligatory occasion for praises of bride and groom either by friends and relations or by professional bards. Accession to office is another common context for praise poetry, usually in public and in the presence of those who take this opportunity to express their loyalty. The Hima of Ankole recited praises when a man was given a chieftainship by the king or (in self-praise) when he dedicated himself to the king's service in battle. Even when a new status is not being formally marked, praise poetry is often relevant in the analogous situation of publicizing an individual's recent achievements, particularly those in battle or the hunt.

Indeed any public event (the arrival of important visitors to the ruler, the installation ceremonies of a chief, a victory in battle) may be marked by praises by official bards or other experts; the ruler's position is commented on and recognized by the stress laid both on the dignity of the office and, more explicitly, on the achievements of its present incumbent. Periodic praises are often obligatory. Among some of the Yoruba the praises of the king, with the complete list of his predecessors and their praises, must be recited once a year in public. In many Muslim kingdoms the ruler is celebrated weekly by teams of praisers (reciters, drummers, pipers) who stand outside the palace to eulogize his office, family, ancestry and power.

The manifold social significance of praise poetry is clear. It can validate status by the content of the praise, by the number and quality of the performers, and by the public nature of the recitation. This validation is often acknowledged by gifts. Praise poetry stresses accepted values: the Hausa praise their rulers in terms of descent and birth, the Zulu emphasize military exploits, and the Nupe voice their admiration for modern achievement in their praises of the ruler's new car.

Praises can also be a medium of public opinion, for up to a point praisers can withhold praise or include implicit or explicit

derogatory allusions as a kind of negative sanction on the ruler's acts. Further social functions are publicizing new status or achievements in a non-literate culture, flattering those in power or drawing attention to one's own achievements, preserving accepted versions of history (particularly the exploits of earlier rulers), serving as an encouragement to emulation or achievement, and, not least, providing an economically profitable activity for those engaged in it. But it was, and is, appreciated for its intellectual and aesthetic interest too, also recited purely for enjoyment, in the evening recitations of the Hima, or in the salons of important Hausa prostitutes, where there was nightly praise-singing and witty conversation.

Self-praising also takes place at other times too. The most famous situation is after a battle when a warrior composes his own praises to celebrate his exploits or, if he is outstanding in bravery or birth, may have them composed for him by others. In this way every soldier had his own praises (in addition, that is, to the praise names possessed in virtue of his membership of a particular clan) which he either recited himself or, among the Zulu at least, had shouted out to him by his companions while he danced or prepared for war. War was the main occasion for such praises, but many other events may inspire them—exploits in hunting particularly, and the experience of going to work in European areas, which was a new type of adventure to be celebrated among the Tswana.

Whatever the initial occasions and subjects of their composition, the situations when recitations are made are basically the same—some public gathering, whether a festival, a wedding, a beer drink, or the performance of some public work. The chanting of praise poetry takes its place among the singing of other songs, and it is frequent for someone to walk about reciting praises of himself or his leader, while those present become silent and attentive. Among the Sotho peoples, divining is also accompanied by

praises of both the divining bones and the various 'falls' which the diviner follows in his pronouncements. Weddings too are a stock situation in which praises are not only possible but required, the bride or bridegroom and their ancestry lauded with praises .

The poems also acted as an inducement to action and ambition. A young man's promise and his future heroic deeds are foretold in his praises (including his own) and a new chief roused to activity by the exploits expected of him as by the knowledge that the praise poets could blame as well as praise. In youth a man was reminded in praises of the measure of his promise; in maturity his praises presented an inspired record of his deeds and ambitions; in old age he could contemplate the praises of his achievements and adventures; while after death the poems would remain as an ornament to his life, an inspiration and glory to his friends and followers to keep his name alive as one of the ancestors: 'People will die and their praises remain.'

As well praise poetry is a vehicle for the recording of history as viewed by the poets. There is little straightforward cataloguing of genealogies; knowledge of these is assumed or merely alluded to—the listeners will pick it up. It is the great deeds and characters of earlier heroes which are commemorated rather than their mere names or ancestry, and national glories are thus recounted and re-lived.

The social functions of praise poetry are clearly important and continue to be so. It would be wrong however to overemphasize these the expense of its literary and artistic significance. The genre can at times come out as bombast and pompous repetition, but also gives rise to poems of great imagination and power.

Praise poetry continues in the present. Although the aristocratic and military basis of society has gone and the content of these poems has been transformed by new interests and preoccupations, the form and tone of praise poetry remain. In some areas praise poetry may no longer be so popular as in earlier

years, but for many it is a constant inspiration:

> Young Zulu men from country areas who take up manual work in towns nowadays have the habit of interspersing long strings of their own self-praises between the verses of their guitar songs, despite the firm tradition that no Zulu should ever praise himself. (Guitars are a sine qua non and are played while walking in the street). Self-praises here serve to re-assure and raise morale in an unfamiliar environment. They seem to be found particularly useful as a stimulant praising when proceeding on a courting expedition, besides being used to impress the ladies, on arrival local newspapers still abound with written praise poems both as an everyday offering and on special occasions like the installation of a new paramount chief or the arrival of some famous visitor. (D. Rycroft)

In northern Sierra Leone and other parts of West Africa expert Mandingo singers, usually with drummers or xylophonists, wander through the streets or attend festivals on their own initiative. They pick on some outstanding or reputedly wealthy individual for their praises; and even those who refer to them contemptuously as 'beggars' are in practice glad to 'reward' them (buy them off) with gifts and thanks, and thus hope to send them on their way content, avoiding the possibility of public shaming for lack of generosity.

Some of the subjects treated in these modern praise poems are analogous to the traditional ones—new types of adventures, distinguished visitors, wedding feasts, self-praises in modern terms—and such topics can be treated with the same kind of solemnity and imagery as the traditional ones. Other new poems praise animals (race-horses, for instance) or objects:

> My frail little bicycle,
> The one with the scar, my sister Seabelo,

Horse of the Europeans, feet of tyre,
Iron horse, swayer from side to side.

Praise for a train includes the traditional motifs of metaphorical comparison to an animal, parallelism, allusion and adulatory address:

Beast coming from Pompi, from Moretele,
It comes with a spider's web and with gnats,
It having been sent along by the point of a needle and by gnats.
Swartmuis, beast coming from Kgopi-Kgobola-diatla [bumping]
Out of the big hole [the tunnel] of the mother of the gigantic woman
. . .
Team of red and white pipits [the coaches], it gathered the track unto itself,
Itself being spotlessly clean.
Tshutshu [sound of engine] of the dry plains
Rhinoceros (*tshukudu*) of the highlands
Beast coming from the South, it comes along steaming,
It comes from Pompi and from Kgobola-diatla.

The same style is also evident in modern written forms. Here is another praise poem about a train, this time written by a Sotho:

I am the black centipede, the rusher with a black nose,
Drinker of water even in the fountains of the witches,
And who do you say will bewitch me?
I triumphed over the one who eats a person [the sun] and over the pitch black darkness
When the carnivorous animals drink blood day and night.
I am the centipede, the mighty roarer that roars within.

The praise style can thus be the basis for written poetry too, and

such well-known writers as Nyembezi, Mangoaela, Vilakazi and Dhlomo have studied and admired traditional praises, finding in them inspiration for their own writing.

Amidst new interests and the inevitable changes of outlook consequent on the passing in many places of the old aristocratic order, praise poetry still performs its old functions of recording outstanding events, expressing praise, and recalling the history of the people. This striking literary form still flourishes and the ancient praises still bring inspiration to modern artists both within and beyond Africa.

5

THE SPEAKING OF DRUMS

A remarkable phenomenon in parts of Africa is communication, both everyday and poetic, transmitted through drums and, up to point, through other musical instruments. That this is *a form of language and literature* rather than music is clear when the principles of drum language are understood. Although its significance is often overlooked, expression through drums forms a not inconsiderable branch of the literature and communication resources in a number of African societies.

Expression in drum language, once thought so mysterious by visitors who failed to grasp its principles, turns out to be based directly on actual words and their tones. In a sense drum language fulfills some of the functions of writing, in a form, furthermore, better suited to tonal languages than representation on a one-mode written page. Its usefulness too is undeniable in regions of dense forest where the only possible way of communicating, apart from actually sending messengers, was by sound: it is not surprising that it is especially prevalent in the forested regions of Congo, Cameroon, and West Africa where the *sounds* can carry over many miles.

Communication through drums comes in two forms. The first is through a conventional code where pre-arranged signals represent a given message; here there is no directly linguistic basis for the communication. In the second type, the one used for African drum literature and the form to be considered here, the instruments communicate through direct representation of the spoken language itself, simulating the tone and rhythm of actual speech. The instruments themselves are regarded as

speaking and their messages consist of words.

Such communication then, unlike that through conventional signals, is a *linguistic* one; it can only be fully appreciated by translating it into *words*, and any musical effects are purely incidental. This expression of words through instruments rests on the fact that the African languages involved are highly tonal; that is, that, as we saw earlier, the meanings of words are distinguished not only by phonetic elements but also by their tones, in some cases by tone alone.

It is these *tone patterns* of words that are directly transmitted, and the drums and other instruments involved are constructed so as to provide at least two tones for use in this way. The intelligibility of the message to the hearer is also sometimes increased by the rhythmic pattern, again directly representing that of the spoken utterance.

It might seem at first sight as if tonal patterns, even when supplemented by rhythm, might provide but a slight clue to the actual words of the message. After all, many words in a given language possess the same combination of tones. However, there are various devices in 'drum language' to overcome this. There is, of course, the obvious point that there are conventional occasions and types of communication for transmission on the drum, so that the listener already has some idea of the range of meanings that are likely at any given time. More significant are the stereotyped phrases used in drum communications. These are often longer than the straight-forward prose of everyday utterance, but the very extra length of the drum stereotypes or holophrases leads to greater identifiability in rhythmic and tonal patterning.

The principle can be illustrated from the (unusually well-studied) Kele people of the Stanleyville area of the Congo, where the words meaning, for example, 'manioc', 'plantain', 'above', and 'forest' have identical tonal and rhythmic patterns.

By the addition of other words, however, a stereotyped drum phrase is made up through which complete tonal and rhythmic differentiation is achieved and the meaning transmitted without ambiguity. Thus 'manioc' is always represented on the drums with the tonal pattern of 'the manioc which remains in the fallow ground', 'plantain' with 'plantain to be propped up', and so on.

There are a large number of these 'proverb-like phrases' to refer to nouns. 'Money', for instance, is conventionally drummed as 'the pieces of metal which arrange palavers', 'rain' as 'the bad spirit son of spitting cobra, and sunshine', 'moon' or 'month' as 'the moon looks down at the earth', 'a white man' as 'red as copper, spirit from the forest' or 'he enslaves the people, he enslaves the people who remain in the land', while 'war' always appears as 'war watches for opportunities.' Verbs are similarly represented in long stereotyped phrases.

Among the Kele these drum phrases have their own characteristic forms, marked by such attributes as the use of duplication and repetition, derogatory and diminutive terms, specific tonal contrasts, and typical structure; and it is evident that they not only make for clear differentiation of intended meanings but are also often poetical in nature, part of the local oral culture.

Here is the Kele drum representation of a simple message, much longer both because of the repetition necessary to make the meaning clear and the use of the lengthy stereotyped phrases. The message to be conveyed is: 'The missionary is coming up river to our village tomorrow. Bring water and firewood to his house.' The drum version runs:

> White man spirit from the forest of the leaf used for roofs comes up-river, comes up-river when to-morrow has risen on high in the sky to the town and the village of us come, come, come, come bring water of *lokoila* vine bring sticks of firewood to the house with

shingles high up above, of the white man spirit from the forest.

The large leaves (used as roof tiles) suggest the pages of the Bible, hence writing. 'Spirit of the forest' is the (poetic) drum name for a European.

Drum communication is often used for formalized announcements, highly effective as they can be heard for three to seven miles. There are drum messages about, for instance, births, marriages, deaths, and forthcoming hunts or wrestling matches. A death is publicized on the drum by a special alert signal and the words, beaten out in drum

> You will cry, you will cry, you will cry
> Tears in the eyes
> Wailing in the mouth.

followed by the name and village of the dead man. An enemy's approach is transmitted by a special alert and the drummed tones of the words

> War which watches for opportunities
> has come to the town belonging to us today
> as it has dawned
> come, come, come, come.

Another stock announcement of a dance, again with the drum speaking in standardized and repetitive phrases:

> All of you, all of you
> come, come, come, come,
> let us dance in the evening
> when the sky has gone down river
> down to the ground.

A final Kele message warns that rain is imminent and advises hearers to take shelter:

Look out, look out, look out,
> Rain, bad spirit, son of the spitting snake
> do not come down, do not come down, do not come down
to the clods, to the earth
for we men of the village will enter the house
> do not come down, do not come down,
do not come down.

Not all the peoples choose the same topics for these standardized drum announcements. Among the Akan, for instance, births, ordinary deaths, and marriages are not normally publicized on drums. However, the use of drums to announce some emergency or a call to arms is very common indeed.

There are sometimes additional complications, arising from the conventions of the particular language. In the Congo it is the essential word tones that are transmitted and not the modifications of these as they would actually be pronounced in a spoken sentence. But the basic principle is always that of representing the tones of actual speech through stereotyped phrases.

Among some peoples such as the Ashanti or the Yoruba, drum language and literature are highly developed indeed. Here drumming is a specialized and often hereditary activity, and expert drummers with a mastery of the accepted vocabulary of drum language and literature were often attached to a king's court. This type of expression is a highly skilled and artistic one and adds to the verbal—and literary—resources of the language. It is not confined to utilitarian messages with a marginally literary flavour. This type of medium can also be used for specifically

literary forms, for proverbs, panegyrics, historical poems, dirges, and in some cultures practically any kind of poetry.

Unlike the relatively simple messages of the Congo area, West African drum forms are often imbued with strong literary and emotional overtones. Take the specialized military drumming of the Akan of Ghana:

> Bodyguard as strong as iron,
> Fire that devours the nations,
> Curved stick of iron,
> We have leapt across the sea,
> How much more the lagoon?
> If any river is big, is it bigger than the sea?

> Come Bodyguard, come Bodyguard,
> Come in thick numbers,
> Locusts in myriads,
> When we climb a rock it gives way under our feet.
> Locusts in myriads,
> When we climb a rock it breaks into two.
> Come Bodyguard, come Bodyguard,
> In thick numbers.

Drum language is also used for names, one of the commonest forms of drum expression even among people without other more complicated drum poetry. Among the Hausa, for instance, praise names and titles of rulers are poured forth on drums or horns on certain public occasions, and the Lyele proverb names (*surnoms-devises*) are commonly performed in the analogous whistle language; in both cases this gives special praise and flattery of the individuals named. Personal drum names are usually long and elaborate. Among the Congolese Tumba all important men in the village (and sometimes others as well) have drum names

of a motto emphasizing some individual characteristic, then the ordinary spoken name; thus a Belgian government official was referred to on the drums as 'A stinging caterpillar is not good disturbed'. A Kele drum name, given him by the father, had the individual's own name, a portion of his father's name and finally the name of his mother's village, such as 'The spitting cobra whose virulence never abates, son of the bad spirit with the spear, Yangonde'. Other drum names (i.e. the individual's portion) ran 'The proud man will never listen to advice', 'Owner of the town with the sheathed knife', 'The moon looks down at the earth, son of the younger member of the family', and 'You remain in the village, you are ignorant of affairs.'

Proverbs, to start there, are commonly transmitted on drums, sometimes as an accompaniment to dancing. In the Niger–Cross River area of Nigeria the drums review the philosophy and history of the group at a big dance and the dancers express with their bodies what is being conveyed—a skill they must learn to enter the men's societies. Among the Akan almost every proverb can be reproduced on drums, and in drum poetry generally always includes proverbs to provide encouragement. There are also longer proverbs specifically intended for drummed performances. Thus the common Akan proverb 'If a river is big, does it surpass the sea?' can be played just as it is, or be translated into the drum form:

> The path has crossed the river,
> The river has crossed the path,
> Which is the elder?
> We made the path and found the river.
> The river is from long ago,
> From the Ancient Creator of the Universe.

The Akan have a special cycle of proverbs associated with the

akantam dance and especially constructed for performance on drums. These have a regular metrical form and are marked by repetition of words, phrases, and sentences that create metrical and musical effects. Each piece contains at least two proverbs, beaten out in unison by the heavy drums while the small drums provide the musical 'ground'. The proverbs make a refrain, and the piece is concluded with special rhythms which merge into the introduction of the next piece in the cycle. For example (a short extract of only the twenty stanzas, interspersed with refrains):

The great Toucan I have, bestirred myself,
Let little ones lie low.
But Duiker Adawurampon Kwamena,
Who told the Duiker to get hold of his sword?
The tail of the Duiker is short,
Bur he is able to brush himself with it.

Kurotwamansa, the Leopard, lies in the thicket.
The thicket shakes and trembles in the dark forest.
Duiker Adawurampon Kwamena,
Who told the Duiker to get hold of his sword?
The tail of the Duiker is short,
But he is able to brush himself with it.

The antelope lies in its thicket-lair,
The hunter lures him with his call.
The hunter deserves to die.
For he will not answer him.
Duiker Adawurampon Kwamena,
Who told the Duiker to get hold of his sword?
The tail of the Duiker is short,
But he is able to brush himself with it . . .

The Chief, a full-bodied leopard in the hole!
The horses, here they are!
When the Chief did this, did that, they said it is not fitting.
The Chieftaincy is not a plaything!

When the girls have no husbands, they say they belong to the Chief!
The girl from the corner with shame in her head,
Let her take shame from her head,
Dancing is no plaything!

The leopard and the Chief have claws, have claws; the leopard and the Chief are coming today!
When the good thing is coming into public, what will the singer do today?
He who sits on the (royal) stool,
Lion of lions,
Chief, it is of him that I worry; the leopard and the Chief are no plaything!
He who is fitted for the kingship, let him be king!
It is God who makes the King!

Again, there are the elaborate Yoruba drum praises. The rulers of the old kingdom of Ede, for example, are still praised on the talking drum every month and in the course of all important festivals. These eulogies are built up on a series of praise verses. Thus in the drum praise of Adetoyese Laoye, the eleventh ruler, we have the building up of praises (mingled, as so often, with admonition), with the whole poem bound together by both the subject (the king) and the recurrent image of the tree. The context was a chieftaincy dispute when all the contestants were confused by the sudden appearance of Adetoyese Laoye.

Adetoyese Akanji, mighty elephant.
One can worship you, as one worships his head.
Son of Moware.

You enter the town like a whirlwind.
You, son of Odefunke.
Egungun blesses quickly when you worship him.

Bless, and bless me continuously;
Do not leave me unblessed.
Do not attempt to shake a tree trunk.
One who shakes a tree trunk, shakes himself.
One who tries to undo you, you who are as short as death,
He will only undo himself ...

You Adetoyese Akanji, bend one foot to greet them,
You leave the other unbent!
You, a notorious confuser!
You confused everybody by your appearance!
Akanji you confused all those
Who tie cloth round their waists, without carrying a child
 I beg you in the name of God the great king, confuse me not!
Do not allow me to starve.
The leaves on a tree, do not allow the tree to feel the scorching sun.

You are a lucky person to wear the crown
A person who is on the throne
When the town prospers,
 Is a lucky person to wear the crown.

—and all of this just on drums.

In a rather different style are the many Ghanaian drum panegyrics for rulers both of the past and of the present. The

following is an extract from one of these drummed poems:

> Korobea Yirefi Anwoma Sante Kotoko,
> When we are about to mention your name,
> We give you a gun and a sword.
> You are the valiant man that fights with gun and sword.
> If you were to decide, you would decide for war.
> You hail from Kotoko, you are truly Kotoko.

> Osee Asibe, you are a man,
> You are a brave man,
> You have always been a man of valour,
> The watery shrub that thrives on stony ground,
> You are the large odadee tree,
> The tree with buttress that stands at Donkoronkwanta,
> A man feared by men.

In another Akan example the chief is saluted and ushered to his seat by the drummer's praise, while all remain standing until he is seated:

> Chief, you are about to sit down,
> Sit down, great one.
> Sit down, gracious one.
> Chief, you have plenty of seating space.
> Like the great branch, you have spread all over this place.

> Let us crouch before him with swords of state.
> Ruler, the mention of whose name causes great stir,
> Chief, you are like the moon about to emerge.
> Noble ruler to whom we are indebted,
> You are like the moon:
> Your appearance disperses famine.

Among the Akan and the Yoruba, drum poetry also appears in invocations to spirits of various kinds. Longer Akan poems sometimes open with stanzas calling on the spirits associated with the drum itself—the wood and its various components—or invoke certain deities or ancient and famous drummers. Important rituals are also commonly opened or accompanied by the suitable drum poems. 'The Awakening' is performed before dawn on the day of the festival:

The Heavens are wide, exceedingly wide.
The Earth is wide, very very wide.
We have lifted it and taken it away.
We have lifted it and brought it back
From time immemorial.

The God of old bids us all
Abide by his injunctions.
Then shall we get whatever we want,
Be it white or red.
 It is God, the Creator, the Gracious one.
'Good morning to you, God, Good morning'
I am learning, let me succeed.

A final example from the Akan area will illustrate how drums can speak of the history of a community, from the drum history of the Mampon division, part of a festival performance. It had a deeply sacred significance for the names of dead kings are not to be spoken lightly, and with the recounting of such a history brings sadness to listeners. In all there were twenty-nine stanzas interspersed by a repeated chorus. It opens by invoking the spirits associated with the drum—all again totally conveyed, and without ambiguity, on drums.

Spirit of Earth, sorrow is yours, Spirit of Earth, woe is yours, Earth with its dust, Spirit of the Sky, Who stretches to Kwawu, Earth, if I am about to die, It is upon you that I depend. Earth, while I am yet alive, It is upon you that I put my trust. Earth who received my body, The divine drummer announces that, Had he gone elsewhere (in sleep), He has made himself to arise.

As the fowl crowed in the early dawn, As the fowl uprose and crowed, Very early, very early, very early. We are addressing you, And you will understand. We are addressing you, And you will understand...

Spirit of the fire, Ampasakyi, Where art thou? The divine drummer announces that, Had he gone elsewhere (in sleep), He has made himself to arise, He has made himself to arise;

As the fowl crowed in the early dawn, As the fowl uprose, and crowed, Very early, very early, very early. We are addressing you, And you will understand; We are addressing you, And you will understand.

Oh Pegs, (made from) the stump of the Ofema tree, Whose title is Gyaanadu Asare, Where is it that you are? The divine drummer announces that He has gone elsewhere He has made himself to arise, He has made himself to arise.

As the fowl crowed in the early dawn, As the fowl uprose, and crowed, Very early, very early, very early. We are addressing you, And you will understand; We are addressing you, And you will understand
...

Drum language, then, can be put to a wide range of uses: for messages, names, poetry, proverbs. It can also be used to comment on or add to some current activity. The chief drummer at a dance in the Benue–Cross River area, for example, kept up a running commentary on the dance on his drum, controlled the line dancers with great precision, called named individuals to dance solo, told them what dance to do, corrected them as they did it, and sent them back into line with comment on the

performance. He was able to make his drum 'talk',even above the sound of four or five other drums in the orchestra. The 'speaking' of the drum was a linguistic complement the musical and balletic aspects of the artistic event as a whole.

Elsewhere the talking drum—a *linguistic* medium remember— accompanied wrestling matches, saluting contestants as they enter the ring, uttering comment and encouragement throughout the fight, and ending up with praise for the victor, Similar drum comments were common among the Ghanaian Akan even to the outwardly mundane duty of carrying the chief, raised to a state ceremonial by the drum poetry that accompanied and commented on it: the drums were saying 'I carry father: I carry father, he is too heavy for me', to which the bass drum replied, 'Can't cut bits off him to make him lighter?' In funerals, too, drums played their part, echoing the themes of dirges and heralding the occasion with messages of condolence and farewell.

Many different things, then, can be conveyed through drum language—messages, public announcements, comment and poetry—and the same sorts of functions can be fulfilled as by the corresponding speech forms, with the additional attributes of the greater publicity and impressiveness of the drum performance. Indeed this kind of 'spoken' communication across distance also occurs in other parts of the world through instruments such as horns, flutes or gongs as well as bells, yodelling of various types, sticks, a blacksmith's hammer and anvil, stringed instruments and whistling—great across the valleys of Switzerland and other mountain regions.

Expression by drums or other instruments can also be an alternative medium to the human voice through which ordinary poetry can be represented. Among the Yoruba their many types of poetry can all be recited on the drum as well as spoken, and the famous *oriki* (praise) poems are as frequently drummed as sung

In spite of its wide range of uses, however, drum communication remains in certain respects a somewhat limited medium. There are limitations, that is, on the types of communications that can be transmitted; the stereotyped phrases for use in drum languages do not cover every sphere of life, but only the content conventionally expected to be communicated through drums. In certain societies at least (for example, the Yoruba and the Akan), drumming is also a highly specialized activity, with a period of apprenticeship and exclusive membership, so that to a greater extent than in most forms of spoken art, drum literature is a relatively esoteric and specialized form of expression, understood by many (at least in its simpler forms) but probably only fully mastered and appreciated by the few.

Among some peoples, then, the response has been the creation of a highly elaborate and conventional mode of artistic expression—with the apparent corollary that in this very specialized and difficult medium the scope for individual variation and improvisation is correspondingly limited, and yet within these limitations richly developed in a way that to most of us is an unfamilia--and marvellous–way.

6

THE DANCE OF MUSIC

More seems to be known and, by now, accepted about Africa's contribution to *music* than the other aspects considered here. So this chapter can be quite short. We know already of negro spirituals, pentecostal hymns, jazz, rock, and any popular music of the mid-twentieth and twenty-first centuries with a beat— ultimately from Africa. And not just in Europe and the 'west' but here and now, worldwide.

There are a few points however which it is worth examining more directly.

First, *rhythm*, the famous "beat" originating, it seems, in Africa. The subtleties of polyrhythms, tonal intersections and visual display go deep and are something that, in general, were, when first encountered, new to European culture. Though the details differ throughout Africa, the general syndrome of dense structure, repetition, melody-generated rhythm, polyphony and subtle intersections of many musical elements has now had a pervasive influence and is indeed totally amazing.

We usually associate this first and foremost with drumming. Yes, drumming is indeed of immense importance. But for the creation of musical beat drumming is, surprisingly, not the most common device at all. For that we have to look to *clapping*— the rhythmic and musical bringing together of the hands. This involves no special skill, no carrying of instruments, no training or class-, age- or gender-differentiation; and everyone has hands. Clapping is everywhere, accompanying just about every kind of music and not just in Africa. But it was not until that was drawn to our attention by one who had made a close study of African

music (John Blacking on Venda music) that we really noticed it.

There is also "foot work"—not exactly stamping in the sense of a deliberate contribution to the music, but the dancing foot, transferring the rhythm from and to the body, that in Africa, in contrast to the western-dance aspiration to float up *from* the earth, grounds the dancer-to-music and chorus down *into* the earth. The beat of the guitar, nowadays a truly African instrument, is heard everywhere, both on its own and with the voice as well as the vast array of different kinds of drums and gongs, supplemented too in places by the beat of xylophones, bells, sticks, gourd rattles, *mbiri/sanza* (hand-held "bush pianos") and other percussion instruments.

The special *tonal properties and intervals* of jazz and other recent popular music is, like it or not (I do!), by now familiar to just about everyone. Not all however may be aware that when these 'blue' micro notes were first encountered, then, finally, noticed by European visitors, they were regarded as evidence that these crude would be-musicians were "tone deaf", "out of tune", unable to recognize the normal intervals of the "proper" (no doubt God-given) musical diatonic scale. Nor were the sounds such that they could be transcribed or fitted into the conventions of the western notation system or the given time- or key-signatures of the accepted patterns for scoring music. So it must be that it was not really "music" at all, more just "noise". Little did these strangers realise that it was *they* that were deficient, unable to recognize the micro intervals of the sophisticated musics of the continent. Without the influence of these notes, of these different scales and their systems, how much poorer would the musics of the contemporary world prove to be!

To move on, there is also that miraculous musical instrument, *the singing voice*. Open to all, without training or added artefacts, it is heard in every country. In halls or churches, open air or smoky drinking houses; by soloists, small groups, choirs young

and old, male and female; microphoned, recorded, live, or in the memory of the remembering echoing ear, it is capable of infinite modulations of timbre, dynamic, volume, speed, tone, agitation, change, emotion, and so much else. It is small surprise to hear it everywhere in Africa, with or without instrumentation. We know it well already, no need to go to Africa. Still its characteristics there are worth noting.

Africa (and perhaps worldwide), the voice is most clearly heard in the musical "call and response" system: antiphonal interchange between soloist and chorus, often in the form of a verse, changing with each stanza, which is taken up in similar or different words but much the same music, repeated after each stanza by a chorus. The chorus singers often, though not always, circle in dance round the lead singer, or nowadays, as is also common, are a religious congregation, scattered "audience" members, a line standing, often dancing, behind the leader, or a backing group.

And this indeed may be the origin, the very heart of lyric. "Lyric": words *sung*, set to music, is found throughout the world (think of classical Greek or Latin, poetry, Shakespeare, Blake—did *he* not, and rightly, call his poetry "songs"?). And what a form it is, the expression of an individual's inmost thought and emotion, complement to the different genres, also great in Africa, of praise song. It is one of the prominent forms of Africa, one to which we owe so much insight and delight. For contrary to what was supposed about the "crude", "non-personal, "non-introspective" nature of African ways, their lyric poetry—words transmitted, musically, through the human voice—is among the beauties of human culture.

Lyric poetry is in fact is one of the most important literary forms of Africa. It was some time before I recognized that songs are indeed the texts of poems. Poems, musical poems, is indeed what they are. Whereas some other songs of Africa arise in specialist or even esoteric settings, these—and this is important

and with many consequences—above all others invoke audience participation. The verbal content is often quite short and intense (though the actual performance may be lengthy), and unlike praise poetry nay be ephemeral. There is usually plenty of improvisation. Unlike most western European folk-songs, it is not a matter of individual singer and (relatively) passive non-performing audience, but instead one that is interacting, and essentially so, with a chorus.

They are performed on both formal and, especially, informal occasions, in fact in an almost unlimited number of contexts. In words that might be applied more widely than to the Igbo singled out here, we hear of the wealth of culture and fine feelings which find expression in our music and poetry. "We sing when we fight, we sing when we work, we sing when we love, we sing when we hate, we sing when a child is born, we sing when death takes a toll."

Rites of passage are common occasions for singing: birth, with initiation and puberty, betrothal, marriage, acquiring a new title or status, and funeral and memorial celebrations. Songs can be part of either solemn or, more often, light-hearted festivities or social gatherings with singing for its own sake. Songs are sung to welcome someone home, to say farewell, to mourn a death, to start off a lesson. In the mid-twentieth century the Somali urban youth put on constant parties for performing the new *balwo* songs, the rage of the time: it is not only in Europe that fashion guides behaviour. People performed the lyrics they knew already or tried out new ones, the performances interrupted for tea and conversation. Sung music is, if anything, increasing, for example in the ever-popular "drinking songs" or the street musicians singing everywhere to their guitars. Nowadays the radio too, and in some places film, create many opportunities for the singing of lyrics.

All over the continent it is common for some stories to be

interrupted from time to time by a song, usually led by the story-teller, the audience acting as the chorus. Short verses in terms of basic content were the rule here, sometimes with many nonsense syllables to fill in the rhythm and tune, but made long in performance because of repetition over and over again between leader and chorus. One Limba story, "The clever cat", had a repeated verse of this kind. A cat craftily proposes to initiate the young rat maidens into the *bondo* (secret women's society). Like all young girls they are eager to enter— while the cat's aim is to get a chance to eat them! Like any *bondo* senior woman she lines them all up and leads the singing which the young rats take up in the way young initiates do in real life:

> When we go,
> Let no one look behind oh!
> When the cat is free,
> *fo feng*
> *fo feng.*

> *Chorus*

> When we go,
> Let no one look behind oh!
> When the cat is free,
> *fo feng*

The listeners were the chorus—call and response again—and the rhythmic and melodic song was repeated, perhaps eight or ten times, first by the cat (the narrator), then by the rat initiates (the audience), who had quickly picked up the new tune. But behind the singing what the cat is doing is quietly picking off the 'initiates', the rats of the tale, one by one. At last only one is left, still singing the song. Just in time, she looks round. She throws

herself out of the way and escapes. Wholesale laughter!

Without the music it would have been no fun for anyone! Simple as the words were in themselves, the audience all joined in enthusiastically. They would have gone on singing indefinitely, it seemed, if the narrator had not broken into their response to finish the tale,

The same song is sometimes repeated at different points in the story as a kind of signature tune with slight variations on the words to fit the development of the plot. The structure of the story is thus marked by the recurrence of the song in each new episode. Another Limba example can make this plain: The plot is the intentionally fantastic and humorous one of the hero Sara and his endeavours to kill and eat a guinea-fowl he had caught without sharing it with his friends. But the bird is a magic one and the more Sara tries to eat it, going through (we hear them all) the usual preparations and cooking procedures, the more it sings back at him. At last he *does* eat it. But even in his stomach the bird sings back at him in the same song, demanding, the next stage, to be excreted. In his final effort to satisfy that hilarious demand Sara falls dead. Each of the parallel stages has the same song, just with varied words to suit the event, the last phrase and response being repeated by narrator then over and over and over by the chorus. For the audience the interest was less in the words—though they were thought ludicrously funny—more in in the rhythm and melody and the way they could throw themselves, with full bodily involvement, into the singing.

And yes, bodily—which brings us to dance. A given song type is sometimes inextricably tied up with a particular dance. Indeed most of these songs are danced to and with: in Africa, perhaps above all, dance and music are mostly inseparable (hence the title of this chapter). Mostly this just happens as the natural concomitant of enacting rhythmic melodic words, but sometimes

there is an explicit connection between the two. The Swahili for instance had a special *gungu* song for the 'pounding figure' of the dance:

> Give me a chair that I may sit down and hold (the guitar),
> Let me sing a serenade for my Palm-daughter,
> Let me sing for my wife,
> She who takes away my grief and sorrow.

Music, as many of us learnt for the first time from Africa—and yet it is so obvious once we see it—is a matter for the whole body (whether or not overtly 'dancing'), not just for the voice or the hands.

There were also more formal occasions, for example the rites of passage, where music, sometimes instrumental only, was for initiations, memorial ceremonies or installations. They came too in greetings like the praise songs for a returning victorious football team or Olympics contender—or even someone just returning home after a long absence. .

To return to that other important point, *the participation of audiences.* The high-art models, still influencing many western perceptions of what is going on, focus attention on the musical work itself, the composed piece, to be received by silent and passive listeners, as something created and transmitted by others, they themselves having no contribution to make. Ethnomusicologists have taken a more open-minded and comparative approach. But even among them the interest has traditionally been more on musical structures composition, performers and instruments than on audience behaviour. Recent studies of modern popular music (Africa-influenced again) do take some account of audiences and bring many new insights, but have still rather tended to focus on the lead performers and, when audiences and listeners are mentioned, to explain away their experiences by references to

concepts such as 'illusion', 'consumption', 'commodification' and so forth. Daniel Cavicchi sums up the situation well in his *Tramps Like Us*:

> There are plenty of books about musical performers in the bookshops but not about music listeners. One can always find a biography of Beethoven but rarely an engaging account of what it was like to attend the performance of one of his symphonies. One can always find all sorts of analyses of the Beatles' lives and recordings but very little about all the people who used the music to get through the day, week after week, year after year.

Thus traditional musicological, like literary, approaches take little account of the audience/reader contribution to the experience. The authoritative *New Grove Dictionary of Music and Musicians* in a quite recent edition (2001) has no index entry under "audience", "listener", or "experience", and the short article on "reception" focuses more on reception into the prized "canon" than the experiences, interpretations or participation of audiences and listeners. And yet—can music really be said to exist without someone to listen to it? Do we again need to learn something from African practices and return to the valuing of performance described in a previous chapter of this volume?

The jazz musician (jazz of course) John Coltrane commented perceptively that 'the audience, in listening, is in an act of participation ... And when you know that somebody is maybe moved the same way you are, it's just like having another member of the group." The atmosphere, the "vibes", depend on audience as well as performer. As the ethnomusicologist John Blacking often pointed out, audiences too are musicians and have had to learn the skills necessary to take part.

Listeners to recorded music too participate creatively, through the personal ways in which they interpret their own experiences

and actively formulate what they hear. This is worth some emphasis, for live performances commonly take the centre, as if listening to audio-recordings is somehow merely secondary or deplorable (and I admit that I too took relatively little notice of this aspect in my own study of urban music). But in practice listening to recorded musical sound is an intrinsic part of most people"s lives today, and all over the world too. At one stage ethnomusicologists in their focus, understandably, on "authentic" music regarded recorded music as intrusive, even "artificial", while cultural analysts often explained them away. Hopefully we now see a greater appreciation of such listening as part of the whole mix of musical participation, especially now that open-minded studies of music in "everyday life" are receiving some attention. Taking these seriously and appreciating them in the light of African musical performance can bring us closer to the realities of musical experience.

To divert for a moment: in the high-art western model that influences us all, especially within formal educational settings, music has been envisaged as somehow belonging to the cognitive side of life; insofar as emotion is seen as entering in, it should somehow be guided by the intellect, with mental rather than bodily involvement being taken as the (classical) norm. "Other" musics like jazz, rock or African drumming were thus too easily be dismissed as non-intellectual and lower: "physical", the "mindless" outflow of uncontrolled emotion, not really "music" at all. The African-influenced rock music was just "noise". So while audiences for artfully constructed classical music were pictured as interacting with the music through their minds not their bodies, popular music listeners were supposedly mindlessly manipulated by the market or swayed by bodily rather than thinking concerns—and yet one only has to read a collection of African lyrics to see that they too provide wide scope for individual thought and artistry.

There is now some questioning of these ethnocentric models of "rationality", together with a greater valuing of embodied performance and emotive (not just intellectual) experience. This opens a wider vision of the ways people participate in music, with the multisensory body alongside the "mind". Simon Frith rightly argues that "all music-making is about the mind-in-the-body", with bodily movement in turn shading into dance. For all musical participation, it is worth asking about the purposive corporeal actions that so often form one dimension of the whole experiential process. They range from the studied still body during classical concerts to the dance movements of other musical genres or the bodily reverberations of hearing music recordings. All this can widen our understanding, giving us a richer and more realistic appreciation of the many ways that people participate in the wonderful human activity of music.

A final point, and a most important one for us all. Throughout Africa, though some individuals are indeed recognised as experts, *everyone* is recognised as having not only the capacity but the duty to sing, drum, and dance. Indeed one of the dreadful things about English education, it seems to me, is the way some (*not* all) "music teachers" exclude individual children and tell them they are "tone deaf" or "not musical", barring them from musical activity in a way that— wicked!—is only too likely to affect them all their lives. How much wiser, and how much for us to learn from Africa not just about musicological theory (much there indeed) but also about the practicalities of education and living is the awareness of the universal art of music-making in all its forms.

7

THE MAGIC OF NAMES

In all cultures and historical periods names and naming have deep significance for the named, the namer(s) and the society generally, something equally true of both western cultures and Africa—where however the process is more explicit and remarkable. Some account of the astonishing sophistication of names and naming in Africa should help us grasp more fully the deep import of names in human lives, including our own.

"Blessed is the one who comes in the name [the *name*] of the Lord" (Mark 11:9):"in thy name we ask it" names;—they go so deep in our lives, and our identities. And in our minds and existence.

And, it seems, in God's and the conscious universe's too. Until they were named the creatures of creation scarcely existed. In naming lay the beginning not just of the earth but of science and its taxonomies, the route to draw us within the spiritual, the universal, to discover ourselves to ourselves. As we have so often read:

In the beginning when God created the heavens and the earth the earth was a formless void and darkness covered the face of the deep while a wind from God swept over the face of the waters. Then God said 'Let there be light'; and there was light. And God saw that the light was good; and God separated the light form the darkness. God called the light 'Day' and the darkness he called 'Night'. And there was evening and there was morning the first day. And God said 'Let

there be a dome in the midst of the waters, and let it separate the waters from the waters.' So God made the dome and separated the waters that were under the dome from the waters that were above the dome. And it was so. God called the dome 'Sky'. And there was evening and there was morning, the second day ... (Genesis 1:1–8)

It is easy in our comfortable western existence not to have noticed all this. But it is very much to the fore in Africa, a pattern which can, possibly more than from anywhere else, alert us to ourselves, to our own experience.

Let me plunge straight in, then, with some examples from there, returning later to areas nearer home. Names are a subject of greater literary and cultural interest than might at first appear. In fact it would be true to say that in Africa they often play an indispensable part both in oral literature and in establishing personal identity and lifelong experience. Names like "One who causes joy all round", "Its hide is like the dust" (after his favourite ox whose hide had marks like writing), "He who is Full of Fury", "Devouring Beast", "God is not jealous" or "It is children who give fame to a man" add a depth even to ordinary talk or a richly figurative intensity to poetry that can be achieved in no more economical a way.

There have been many interpretations of such names, from psychological functions like providing assurance or "working out" tensions or (further treated below) expressing their bearer's self-image of their owner or providing indirect comment when a direct one is not feasible. As usual, there is some truth in most of these approaches, for ourselves as for Africa. Nicknames—names given by others—can be a succinct and oblique way of commenting on their bearers. Consider the nickname "Pineapple". How flattering! Look further: to the custom of planting pineapples over a grave: the administrator with that name, they were hinting, was burying matters brought to him (no doubt he had no inkling

what it meant!). Or there was the woman missionary called Hlan-ganyeti, "The one who gathers dry wood for the fire". Well, it is good to have firewood to hand—but not gathering wood for others, bringing information to her husband to kindle the fire, never showing anger herself but stirring up others. Not so good!

Similar clever nicknames were often given to Europeans, an effective and quiet comment on their characters: "The fury of the bull"; "Kindness in the eyes (only)"; "The little bitter lemon"; "The one who walks alone". Names are similarly used for oblique comment. Thus the Karanga subtly give names to their dogs as an elliptical way of chiding another. A dog called "The carrier of slanders" points to a particular woman, "A waste of cattle" reproves a bad wife, while "Others" and "A wife after the crops are reaped" are a wife's complaint, that unlike her co-wives, she is only fed in time of plenty. A parent may choose a child's name that carries an oblique open comment on the other parent's behaviour: "They like firewood", from the proverb "They like firewood but despise its gatherer", a name given by a neglected mother.

Names can also express ideas, aspirations, sorrows, or philosophical comments. Grief and an awareness of the ills of life are frequent themes. "Bitterness", "They hate me", "Daughter born in Death" express suspicion, sorrow or fear. Among the Ovimbundu a mother laments a dead child in the abridged proverb "They borrow a basket and a sieve; a face you do not borrow": she may have other children out, never one with that same face. Names are good for joyful sentiments too, mini-proverbs ("Joy enters the house", "The God of iron sent you to console me", "I have someone to pet"), or aspiration for oneself or others. The Bini "The palm-tree does not shed its leaves" claims its holder, like an old palm-tree, will stand against all opposition.

They can also play a directly literary role for a series of different forms (day names, by-names, praise names, and dirge names) together enhance the intensity and high-sounding tone of the

poems, and particularly in historical accounts bring a sense of allusiveness and sonority not easily expressed in other forms. This is strikingly so in panegyric poetry, a genre which is in Africa so often based on an elaboration of praise names like "He-who-fails-not-to-overthrow-the-foe", "Transformer-of-peoples", or "Sun-is-shining". Names also play a significant part in drum literature. In such a passage as "The Ruler of Skyere has bestirred himself. The Great Toucan, has bestirred himself…He has bestirred himself, The Gracious One. He has bestirred himself, The Mighty One". Meaningful names describe and bring honour to the addressee.

Names come everywhere in ceremonies—in funerals, marriage, baptism, christenings, rituals of being accepted into adulthood. In Limba ceremonies in West Africa it is the ancestors' names that are intoned: powerful and potentially dangerous, in a way ever-present, buried closely in the very compounds of the huts of the now-living—but to bring them close, and placate them their names must be called, intoned to four and five generations back in ceremonious listing "You X; You Y …"

Many African names are of course straightforward, with little hidden meaning. Most however are richly allusive. Because they often restate or abridge proverbs, they share some of their stylistic characteristics and associations. Sometimes the proverb is just hinted at, perhaps just by one word, but the name—and hence the person—carries all the proverb's overtones of meaning and allusion. In Uganda the Nyoro proverb name *Bitamazire*, 'The sandals which were made of banana fibre were no good' reminds listeners of the proverb that small children cannot be expected to survive long, or *Ruboija* ("It pecks as a fowl does") that just as one does not know which grain will be picked up next by a fowl, only that some grain will be attacked, so one cannot tell who will be struck next by death. The *Ganda* have thousands of proverbial names like *Nyonyin-tono* ("A small bird, to appear big, must clothe itself in many feathers"), and the female *Ganya*

from the saying "When a wife begins to disrespect her husband it shows that she has found another place where she intends to go and live." In West Africa, Bini proverbs about wealth appear, abbreviated, as names at the same time as recalling the proverb's full impact, as in the injunction to go prudently about gathering property ("It is with gentleness one pulls in the rope of wealth", i.e. lest it break), or the satiric comment on the lengths to which men go for money ("If one is seeking wealth, one"s head will go even through a drain pipe").

Strings of proverb names come in self-praises. Among the Nigerian Igbo when a man takes a special title he sings a list of the names he wishes to be addressed by, usually a series of proverbs metaphorically recounting his riches. exploits and wealth: "I am: The Camel that brings wealth, The Land that breeds the *ngwu* tree, The Performer in the period of youth, The Back that carries its brother, The Tiger that drives away the elephants, The Height that is fruitful, Brotherhood that is mystic, Cutlass that cuts thick bushes, The Hoe that is famous, The Feeder of the soil with yams, The Charm that crowns with glory The Forest that towers highest, The Flood that can't be impeded, The Sea that can't be drained."

The praise names touched on in an earlier chapter are impressively reminiscent of the famous Homeric epithets— honorific appellations and flattering epithets which are of notable literary and emotive value throughout the continent. Yoruba, Zulu and Hausa panegyric poetry is flooded with such names, in metaphorical and evocative forms as, for instance, "Fame-spread-abroad", "Thunder-on-earth", "Father-of-the-people", "Light of God upon earth", "Bull Elephant", "Weaver-of-a-wide-basket-he-can-weave-little-ones-and-they-fit-into-one-another", and (one of several praise names for Cecil Rhodes, the empire builder) "A powerful bull from overseas". Praise names are also applied to non-human, even non-animate objects like a chair or—once a wonder!— a train, a mountain, tobacco. The

Nigerian Hausa have elaborate praise terms for animals like the hyena: "O Hyena, O Strong Hyena, O Great Dancer"; the eagle"s reputed wisdom is alluded to in "O Eagle, you do not settle on the ground without a reason" (i.e. without seeing something to eat there), while the name used between wife and husband can be "O Woman whose deception keeps one upon tenterhooks (thorns), your mouth though small can still destroy dignity. If there were none of you there could be no household, if there are too many of you the household is ruined". Names conferred on non-human creatures reflect back, as it were, on human beings, often (with dogs' names) with an insulting intention or, for cattle names, in a laudatory and honorific sense, as, for example, the "ox-names" transferred to human beings in East Africa.

Also very striking are the praise names of Bantu languages, again picking out some striking quality of an object, used in their fullest form as names for people. We meet compound names that could be translated as, for instance, "Forest-treader", "Little animal of the veld", "Crumple-up-a-person-with-a-hardwood-stick", "Father of the people". Other examples are the Ankole "He Who Is Not Startled", "I Who Do Not Tremble", "He Who Is Of Iron", "He Who Compels The Foe To Surrender", "He Who Is Not Delirious In The Fingers" (grasps his weapons firmly), and the Zulu "He who hunted the forests until they murmured", "With his shields on his knees" (always ready for a fight), or "Even on branches he can hold tight" (able to master any situation). Sometimes the reference is to more recent conditions and formulations, as in Kamba praise names for girls in popular songs: *Mbitili* (from English "battery"—car-batteries provide heat just as the girl's attractiveness heats up her admirers); *Singano* (needle), praising the sharpness of the girl's breasts; and *Mbyuki* (from "Buick", famous for their high-gloss black finish like the beauty of the girl's dark skin).

Praise names are expected on ceremonial occasions of note.

They are used, called or drummed, in formal address to superiors, welcome, ritual announcements of the arrival of some leading personage (I have myself heard my honorific name drummed for myself and other participants at academic conferences in Ghana and South Africa, and very moving it is too), at funeral rituals, or uttered as a part of personal aspiration or encouragement to another to live up to the ideals in the name. Some names are just short phrases but others are like a poem.

They are widely used whenever polite exchange is expected. They are shouted out during the ritualized combats that in some places are staged during mortuary ceremonies when a dead man is addressed by his full title and conjured to leave his people in peace. Praise names are also much used at a time of physical exertion when a group of young men join together to work, as custom demands, in their father-in-law's fields, they cry out each other's praise name to incite greater efforts, calling on their *amour propre* and invoking the names of ancestors from whom the names are severally inherited and of whom each individual must show himself worthy.

Praise names are usually given by fathers or grandfathers, a link and earnest of the individual's relation to earlier generations, thus evoking more than just the individual. Expressed through a conventionally recognized artistic form, often marked by elliptical or metaphorical language, they bring a range of associations to all involved, and set both the bearers and the utterers of the name in a wider perspective, another world. They regularly invoke some proverb of cosmic application with some quality that the bearer is believed, or hoped, or flatteringly imagined to possess.

African names are indeed especially striking—flamboyant and explicitly full of meaning and imagery. But what lies behind all this, we now see—once such examples incite us to stop to look—is common enough throughout the world. It has long been a feature of Judaic, Egyptian and Mesopotamian thought to see names as

essentially the same as the person named.

The power of names is everywhere. In fairy tale and myths, you have to know someone's name before you can act. In Babylonian myth, changing his name saved someone from what would otherwise have been his just deserts, and in Catholic ritual the exorcist cannot drive out a demon until he gets power over it by learning its name. There is the Welsh warrior who cannot be killed in battle until his opponents learn his name, or the power of witches only once the victim's name is known. Some names are too powerful—too dangerous—to utter. Such was the Hebrew name of God: sacred beyond all other names. In Babylonian thought a name and its bearer were identical: to speak the one was to control, most likely, to kill the other. Small wonder some names are avoided.

By the same token to invoke the name is to invoke—even gain a claim over--the person. "At the name of Jesus, every knee shall bow"; "How sweet the name of Jesus sounds ..."; "Sing out, my soul, the greatness of his Name [note the capital N] ... His holy Name—the Lord, the Mighty One"; "All hail the power of Jesus" name": Christendom"s "national anthem". "For all the saints who from the labours rest, Who thee by faith have of their sins confessed, Thy Name, O Jesus be for ever bless'd, Alleluia, alleluia." It is not the presence or even the thought of Jesus being invoked here but his name. The "Holy Name" has become an extended part of Christian theology, something powerful in itself, with its own holy day and mode of celebration. Not "May God bless you" but "In the Name of the Father the Son and the Holy Ghost". And so on—check it yourself—throughout all hymn books and the sacred texts.

Your first name is your permanent and for the most part ineradicable identifier, Unlike other names, it seldom if ever changes from toddler days to school to job to old age. It is the token that singles you out from others at school, work, marriage,

death, your bureaucratic existence in space and time. Birthdays with the recipient's name prominently on the cards and, in some countries, the name saint's day (more celebrated than the day of birth), add further fuel. So too does the repetition in the Christian tradition of the participants' first name(s) during the key event of marriage vows, as do first names in funerals, exorcisms, email messages, and introductions on radio and television. Hence the force of changing your name or having it changed by order or suggestion.

And what when people undergo a transformation of their life and identity? They change their names. So it is with a nun being given a new name—a new persona—on joining a convent; so too with a man initiated into a secret society, a prisoner stripped of his usual name—his very selfhood—when entering prison. Remember Abram and Sarai becoming "Abraham and Sarah" as they took on new roles, Saul no longer his previous self but Paul, the new personage, leader and inspirer of the church. Simon became Simon Peter, a new role, acquired titles give new dignity and tasks, changing the person and the life. And did not the recently created Pope give a sign to all the world by taking the name and persona of Francis, symbolising to all by his very name his humility and love for all God's creatures.

To bring it right close to home and the personal, during my longitudinal study of names in the context of family history I was startled by the number of repetitions, as in Africa, drawing me into, and back to, earlier generations: grandparents recalled in grandchildren's names and in "why they had been given that name. Here are the symbolic stories of the family, earlier-dead forebears brought back, in a sense, from the cosmic eternal, through their names of their great-grandchildren and more. There is a sense in which, akin to reincarnation, theses namesakes are nearly the same person, even in some cultures even the same soul.

And in Islamic tradition too. Muslims, most notably among the

immigrants to western countries, are called by carefully chosen names such as "Beloved of God", "Wisdom", "Honoured", "God's servant" and so forth throughout the world, through centuries of heaven and earth and recycling generations of men.

At a deep level too the name must be appropriate. I have heard that if a baby does not thrive it is because it has been given the wrong name, and for it to grow it (still "it" perhaps, not yet properly named or, therefore, existent) must be either called by a nickname, a (better) second name or, in some cases, a different name altogether; then all will be well.

There are groups, the Kabalarians among others, who prosper through finding—or supposedly finding—a more "balanced" name for the clients of whom there is no shortage. As they claim, with (judging by the many responses) some truth, when you choose a new balanced name, the effects are immediate and dramatic. "Your name creates your mind." So how you see yourself, how others perceive and treat you, your energy, creativity and self-esteem—all, they claim, all can improve significantly, for you are now drawing from your inner source, your assigned birth path. Your old name was your limitation; your new name is your freedom (see www. kabalarian.com).

Some names have special psychic associations and power, most obviously names of religious leaders ("Call my name and you will …") but, surprisingly, it is also so of some more earthly names. In myself (which may be personal rather than generic) far and away the most powerful are the many forms of Catherine, Kathryn, Cathie, Kirsten and their multiple derivatives. Above them all is "Kate". This is a name, I know not why, that seems *everywhere* one to conjure with (there have also been many in the history of my family, including my granddaughter, great-grandmother and the little Catherine, my mother's sister, who died in childhood and whose dreams I believe I now have). Kate too—myself—is the heroine of my dreamed novel *Black Inked Pearl,* as in its many

prequels. The hero's name may vary—though it is always some derivative of Chris, Christ, Christopher—but the girl is always, from dreamed impulsion rather than conscious choice, never varying; she is the (family name) 'Kate".

So, as in

All creatures of our God and king,
Lift up your voice and with us sing,
Alleluia! Alleluia!
Thou burning sun with golden beam,
Thou silver moon with softer gleam!

Refrain
O praise Him! O praise Him!
Alleluia! Alleluia!
Alleluia!

Thou rushing wind that art so strong,
Ye clouds that sail in Heaven along,
 O praise Him! Alleluia!

Thou rising moon, in praise rejoice,
Ye lights of evening, find a voice.
O praise Him! Alleluia! …

Let all things their creator bless,
And worship Him in humbleness,
O praise Him! Alleluia!
Praise, praise the Father, praise the Son,
And praise the Spirit, Three in One!
O praise Him! Alleluia! (hymn attributed to St Francis of Assissi)

we have to know their names to be able to recognize, hold them to sing these praises, *the names*, the magic power of *names*. Just as God named the creatures of his creation, so scientists develop nomenclature to realise and control the created world, musicians name their notes to take possession of them, astronomers from the distant past have made our skies graspable by assigning beautiful names to stars and constellations, themselves often with significant meanings or mythic associations; a group of musicians seem unable to exist, still less to perform in public, without forging a name for themselves; whether serious, mystic, humorous or self-mocking: the name ratifies their joint being and, by extension, their music. Writers and artists set their names on book title pages or published images to demonstrate and assert their ownership. Can we really hold an idea clearly in our minds without "giving it a name"? In this sense, it can be said, names have created the world.

Names matter. And yet western philosophy has mostly been—at any rate has *seemed* to be—to ignore them and bypass their significance. It sometimes seems that only things that happen far away or long ago are worth noting. So it takes an effort, as here, for us to bring our insights from abroad back to ourselves, to something nearer home.

8

THE WISDOM OF PROVERBS

In Africa proverbs are no marginal childish activity, but widely used to settle dispute in unofficial settings, in law cases, to advise obliquely and without offence, and to pass on and consolidate the wisdom of the ancients. In many cases they are also the beautiful, sonic and rhythmic basis for elaborate literary forms. There is much to learn.

In apparent contrast with other areas of the world such as aboriginal America and Polynesia. proverbs are found just about everywhere in Africa. Easy to record, they have been exceedingly popular with collectors. Particularly well represented are proverbs from the Bantu area (especially the Southern Bantu); the Congo and West Africa. It is notable, however, that there are apparently few or no proverbs among the Bushmen of southern Africa and the Nilotic peoples, and few seem to have been recorded in Nilo-Hamitic languages. In other areas proverbs are universal and in some African languages occur in rich profusion. 4,000 have been published in Rundi, for instance, about 3,000 in Nkundo, and 2,000 in Luba and Hausa.

The literary relevance of these short sayings is clear. Proverbs are a rich source of imagery and succinct expression on which more elaborate forms can draw. As Nketia puts it in his comment on Ghanaian proverbs:

> The value of the proverb to us in modern Ghana does not lie only in what it reveals of the thoughts of the past. For the poet today or indeed for the speaker who is some sort of an artist in the use of words, the proverb is a model of compressed or forceful language.

In addition to drawing on it for its words of wisdom, therefore, he takes interest in its verbal techniques—its selection of words, its use of comparison as a method of statement, and so on. Familiarity with its techniques enables him to create, as it were, his own proverbs. This enables him to avoid hackneyed expressions and give a certain amount of freshness to his speech. This…approach to proverbs which is evident in the speech of people who are regarded as accomplished speakers or poets of a sort makes the proverbs not only a body of short statements built up over the years and which reflect the thought and insight of Ghanaians into problems of life, but also a technique of verbal expression, which is greatly appreciated by the Ghanaian. It is no wonder therefore that the use of proverbs has continued to be a living tradition in Ghana.

In many African cultures a feeling for language, for imagery, and for the expression of abstract ideas through compressed and allusive phraseology comes out particularly clearly in proverbs. The figurative quality of proverbs is especially striking; one of their most noticeable characteristics being their allusive and metaphorical wording. This also emerges in many of the words we translate as "proverb" and in the stress often laid on the significance of speaking in symbolic terms. Indeed, this type of figurative expression is sometimes taken so far as to be almost a whole mode of speech in its own right. The Fulani term *mallol* for instance, means not only a proverb but also allusion in general, and is especially used when there is some deep hidden meaning in a proverb different from the obvious one; so too with the Kamba *ndimo* which, though it does not exactly correspond to our term "proverb" is its nearest equivalent, and really means a "dark saying" or "metaphorical wording", a sort of secret and allusive language.

The literary feel of proverbs in Africa is also brought out by their close connection with other forms of oral literature. This

is sometimes apparent in the local terminology, for proverbs are not always distinguished by a special term from other categories of verbal art. The Nyanja *mwambi,* for instance, refers to story, riddle or proverb. The Ganda *olugero* means, among other things, a saying, a story, a proverb, and a parable. The Mongo term *bokolo* is used of all poetic expression including fable, proverb, poetry and allegory, and the Limba *mboro* refers to story, riddle and parable as well as to sayings which we might term proverbs, while the Fulani *tindol* means not only a popular moral story but also a proverb or maxim. In some languages (Yoruba, Zulu) a distinction does exist in terms for proverbs and for other forms of literary expression. But even then there is often a practical connection between them. Mbundu proverbs are closely related to anecdotes, so much so that anecdotes are sometimes just illustrations of a proverb, while a proverb is frequently a tale in a nutshell. Again, the Nyanja proverb "Pity killed the francolin" is a direct allusion to the story in which the francolin came to the help of a python and was in return eaten by it, and a moralizing story may end with, or imply, a proverb to drive home its point.

As well, proverbs frequently come in songs and poems, as well as in the drum proverbs of Ghana and Dahomey. The Nguni saying "The earth does not get fat" (i.e. however many dead it receives the earth is never satiated) also appears as the central theme and chorus in a long Ngoni lament and the Swahili poem about silence based on "Much silence has a mighty noise" (Still waters run deep) is elaborated in the verses arising from it. Written forms too make use of traditional proverbs, as in Muyaka's Swahili poems, and these in turn give further currency to new or old proverbs

Proverbs are sometimes connected with riddles. A fine South African proverb, also asked as a riddle, was only too appropriate in apartheid days but applies well now too—aptly repeated during the early days of Trump's America when he, as President, seemed

to be supporting the effectiveness of torture:

> How do you catch an elephant?
> Find a mouse and beat it until it admits it is an elephant.

As well as these obvious and common ways in which proverbs overlap with other kinds of verbal art, they also appear in certain specialized forms. Their use in the form of "proverb names" is one. The Mbundu woman's name Simbovala is a shortened form of the proverb "While you mark out a field, Death marks you out in life"—in life you are in the midst of death. Proverbs also frequently come in conversation and in oratory to embellish, conceal or hint. Another connection is with bird—Camalier — lore, a form particularly popular among the Southern Bantu. The cries attributed to certain birds can be expressed as proverbs .The hammerkop appears as a symbol of vanity both in a brief proverb and a full song where he engagingly praises himself as the song's hero.

Proverbs are also sometimes connected with other artistic media: they can be drummed (a characteristic form in some West African societies), sung, as with Lega judicial proverbs, or can appear on the flags of military companies, as among the Fante. Most striking of all is the Ashanti association of specific proverbs with one or other of their many "gold-weights"—small brass figures and images originally used to weigh gold dust and worked with great skill and humour. Thus a snake catching a bird represents the proverb "The snake lies upon the ground, but God has given him the hornbill" (that flies in the sky). Another depicts two crocodiles with a single stomach between them: "Bellies mixed up, crocodiles mixed up, we have between us only one belly, but if we get anything to eat it passes down our respective gullets"—a famous saying cited when one individual in a family instad of sharing tries to seize everything for himself.

Certain of the direct links between proverbs and other artistic forms such as metalwork or drumming are peculiar to specific societies, but the general association between proverbs and other forms of literature is not after all very surprising. These close connections are perhaps particularly characteristic of an oral literature without a clear-cut distinction between written and unwritten forms, but the sort of way in which proverbial expression and other types of literary art (including the art of conversation) mutually enrich and act upon each other is something that is presumably a quality of most cultures. In this sense, then, proverbs in Africa are not so very different from those in any literate culture, in both of which their main impact seems, in fact, to be through an oral rather than a written medium. In neither case should they be regarded as isolated sayings to be collected in hundreds or thousands on their own, but rather as one aspect of artistic expression realised in their social and literary setting.

The exact definition of "proverb" has never been easy. There is, however, some general agreement as to what constitutes a proverb. It is a saying in more or less fixed form marked by "shortness, sense and salt", and distinguished by a popular acceptance of the truth tersely expressed in it. Even so general a picture as this contains some useful pointers for the analysis of African proverbs.

First, then, their form. They are picked out first and most obviously as being short; and secondly by the fact that even where the wording itself is not absolutely fixed, at least the main structural pattern is accepted in the society concerned as an appropriate one for this purpose. Most sayings classed as proverbs are also marked by some kind of poetic quality in style or sense, and are in this way set apart in form from more straightforward maxims. The question of "popular acceptance" is a more difficult one. If one of the signs of a true proverb is its general acceptance as the popular expression of some truth, we seldom have the data

to decide how far this is indeed a characteristic of the sayings included in collections of "proverbs". We usually, even in our own cultures, have no sure way of telling whether some of the "proverbs" included are not just the sententious utterances of a single individual on a single occasion, which happened to appeal to a collector.

However one of the first things we notice in collections of African proverbs is their poetic form. This, allied to their figurative mode of expression, serves to some degree to set them apart from everyday speech. The general truth being touched maybe conveyed more or less literally, through a simile, or (most commonly) through a metaphor. Even the more literal forms often contain allusive or a picturesque speech, and among certain peoples at least are marked by some other poetic quality –rhythm for instance. "The dying of the heart is a thing unshared", "If the chief speaks, the people make silent their ears", and the humorous description of a drunkard, "He devoured the Kaffir-beer and it devoured him!" are instances from South Africa Comments on what is considered to be the real nature of people or things often occur in proverb, as in the Thonga "The White man has no kin. His kin is money", the Xhosa description of Europeans as "The people who rescue and kill" (they protect with one hand, destroy with the other), the witty Akan "An ancient name cannot be cooked and eaten; after all, money is the thing" or the humorous Ila injunction to hospitality, "The rump of a visitor is made to sit upon." Proverbs present a thought in a short and straightforward way, sometimes set apart from ordinary speech by being, for example, abbreviated, used as a name, expressed in some other medium than speech, especially on drums, or overtly applied, as with stories, to animals or birds while really, as everyone knows, commenting on human behaviour,

Wealth and its shortcomings are stock themes. The Swahili say, "Wits– wealth", the Thonga "To bear children is wealth, to dress

oneself is (nothing but) colours" or "To marry is to put a snake in one"s handbag"; Ashanti proverbs succinctly advise listeners that "A wife is like a blanket; when you cover yourself with it, it irritates you, and yet if you cast it aside you feel cold."

A feeling of allusion and metaphor is evident in almost all proverbial expression. Nowhere is this more clear than among the Congolese Azande. The term we translate as proverb, *sanza*, also refers to ambiguous or hidden language in a wider sense. Usually this form of speech is used in a malicious way, often with the intention of speaking *at* someone while seemingly making an innocent remark. It is particularly common between man and wife and between courtiers in jealous competition with each other at a prince's court, but it enters into all Zande social activities. By using this form of speech, as with the narrower class of proverbs, a man can get at another while at the same time keeping himself under cover; the sufferer will not be able to make trouble, and the insult, being hidden, can be withdrawn without loss of dignity. This oblique and veiled form of speech nicely fits the suspicious and competitive outlook of the Azande, and can be connected with the authoritarian nature of their relationships and their dominant fear of witchcraft.

This hidden and oblique dimension, with its overtones of playing safe and avoiding direct commitment, is developed to a high degree among the Azande. However it seems to be an element in all use of proverbs, coming out particularly in situations of conflict or uneasy social relationships and where depths of hidden meaning are sensed or implied, an aspect which may well, when we stop to think about it, apply equally to our own more familiar proverbs.

The veiled allusiveness is sometimes in fact achieved by devices other than direct imagery. here, again a comment is being made about human life and action through reference to non-human activity. Egotism, for instance, is satirized in the Sotho "I and

my rhinoceros" said the tick bird' or the Ndau "The worm in the cattle kraal says 'I am an ox', while for Ila squanderers "The prodigal cow threw away her own tail." Similarly the Thonga "The strength of the crocodile is in the water" neatly reminds listeners that a man is strong because his kinsmen help him and that a man should stick to his own place and not interfere with others. The importance of self-help is stressed in "No fly catches for another", while the Zulu generalization "No polecat ever smelt its own stink" alludes picturesquely to people's blindness and self-satisfaction.

Proverbs about animals are particularly common. But other everyday things come in too. The Zulu observe that people can and should manage their own affairs by "There is no grinding stone that got the better of the miller", and the Ndebele remind one that "The maker of a song does not spoil it", warning that it is not right to interfere with someone who understands his own business. The Lamba "Metal that is already welded together, how can one unweld it?" is like our "Don't cry over spilt milk."

Even more common is when an abstract idea is conveyed not through any direct generalization at all but through a single concrete situation that is only one example of the general point. Thus "The man with deepest eyes can"t see the moon till it is fifteen days old"—don't be so narrowly focused that the obvious escapes you. Overconfidence and officious advice are satirized in "Mr. Had-it-been-I let someone else"s baboons escape", while, on fools, "Mr. Didn"t-know took shelter from the rain in the pond" and "The boy says he wants to tie water with a string.'

Hyperbole and exaggeration come in too as in the Zulu description of an unblushing and flagrant liar, "He milks also the cows heavy with calf" (says the impossible, that he can milk cows even before they calve), a paradox, as is the neat "He has the kindness of a witch." I like the Nyana "Little by little the tortoise arrived at the Indian Ocean", or the pointed Yoruba equivalent of

our idea that one reaps as one sows—"One who excretes on the road, will find flies when he returns." Contrast is used effectively in many proverbs, as in the Lamba "The body went, the heart did not go" or by cross parallelism (*chiasmus*), as in "One morsel of food does not break a company, what breaks a company is the mouth", or repeated words or syllables "Hurry, hurry, has no blessing" (*haraka, haraka, haina bar oka*) or "Splutter, splutter isn't fire" (*bugu-bugu simuliro*).

There is often a sense of detachment and generalization in proverbs—a kind of judging that makes them especially fitting in oratory, particularly in law cases or disputes. Among the Nigerian Ibibio, for instance, proverbs are skilfully introduced into speeches at the crucial moment and are influential in the actual decisions reached. In one law case, the plaintiff managed to stir up antagonism towards the accused (a chronic thief) by alluding to his past record and untrustworthy reputation. He did this through a proverb: "If a dog plucks palm fruits from a cluster, he does not fear a porcupine" (if a dog can deal with the sharp needles of the palm fruit, he can probably face even the porcupine's prickles; similarly a thief will not be afraid to steal again). The thief in his turn won his acquittal by citing another a proverb about how he alone had no sympathizers and supporters—"A single partridge flying through the bush leaves no path." Proverbs are in fact frequently used to smooth over a disagreement or bring a dispute to a close. According to the Yoruba proverb, "A counsellor who understands proverbs soon sets matters right" and a difficult law case is often ended by the public citation of an apt proverb In a less formal context, the Kikuyu bring an interminable and profitless discussion to an end by asking the question, agreed to be unanswerable, "When new clothes are sewn, where do the old ones go?"

Wit can be utilitarian too, and laughter, lightening the atmosphere, is seldom far away. Because of their susceptibility to

ridicule the Ila, like many others, can be laughed out of something more easily than deterred by argument or force. Thus Pharisees are mocked as those who "spurn the frog but drink the water" (they are the kind of people who object to finding a frog in their drinking water but are perfectly happy to drink once the frog has been removed). Another pressure is through irony, indeed any kind of satirical or penetrating comment on behaviour may be made in the form of a proverb and used to warn or advise or bring someone to his senses. He is reminded of the general implications of his action and the fact that the reminder is cast in apparently innocent terms means it is all the more effective.

There are usually no special people with the job of evolving proverbs. New ones nevertheless arise through individuals, following of course the known and recognised forms, and are then taken up by others. Many Zulu proverbs are said to have been first uttered by famous men or by bards or jesters before the king, or at a beer-drink. It is common, as for some of our own sayings, for certain proverbs to be attributed to well-known historical personages

Though proverbs occur in many different contexts, they are particularly important in situations where there is both conflict and, at the same time, some obligation that this conflict should not take on too open and personal a form. Such conflict can occur in many different ways—there may be competition for scarce resources, there may be a stress, as among the Zulu or Igbo, on the idea of personal achievement or, as among the Congolese Azande, on the importance of hierarchy, with the competitiveness for advancement and notice so closely connected with these; in all these situations there may also be an idea that the conflict involved should not be allowed to become extreme and explicit Indeed, proverbs may also be specially suitable even in everyday situations of advice or instruction where the hidden tensions that are sometimes inherent in such relationships are controlled

through the use of elliptical, proverbial speech.

The proverbs in many African cultures are also deliberately used to embellish their oratory, a much admired skill , of particular importance in a largely or partially non-literate context.. An accomplished orator must adorn his rhetoric with apt and appealing proverbs. Proverbs are also used to add colour to everyday conversation. This aspect seems to be very widespread indeed and in some cases at least to be an art cultivated to a very high degree. Thus among the Zulu, someone who did not know their proverbs would totally fail to grasp conversational allusion, while among Bambara proverbs are so honoured that use a proverb every two or three phrases in their conversation, The Akan allude to the subtlety in proverbs when they say, "When a fool is told a proverb, the meaning of it has to be explained to him", and as Nyembezi writes of the Zulu, in words also applicable to many other African cultures, proverbs are essential to life and language: "Without them, the language would be but a skeleton without flesh, a body without soul."

Proverbs, finally, are often said to represent a people's philosophy. In proverbs the full range of human experience can be commented on and analysed, generalizations and principles expressed in a graphic and concise form, and the wider implications of specific situations brought to mind.

9

THE INSIGHT OF STORY

Whether we realise it or not, western culture is shot through with the insights and experiences of African story—origin myths, intriguing tales of human ingenuity and suffering, antics of animals (who now fails to see the human faces behind these Greek-like animal masks?), side-splitting exploits of fantastic twins and triplets. Still a vibrant form today, not least in the masses of newly written novels, there is still much to learn from the narrative traditions of Africa: both from the wisdom—the plots, the characters—of the tales and epics and also, though existent, only too often overlooked in our own culture, the multisensory qualities and audience interaction of live performance.

The magic moment of performance is one indeed inescapable quality of story-telling. We will never come near the power of African stories if we forget their multisensory performance qualities, their participating audiences, the craft of their expert tellers in the settings of the moment: drama as much as narrative. This is the first feature to bear in mind.

But the narrative themes and motifs are of interest too. They are both embedded in particular situations and stretch our imaginations beyond the bounds of some given time or place. Let us plunge straight into another Limba story to introduce this chapter (which will turn out to be a light-hearted counterpoint between, on the one hand, some Limba (and other) stories in Africa and, on the other, a selection of the larger narratives that have been told about Africa).

So—"A story for you", as a Limba narrator might say:

A spider once lived on earth who was very full of fight.

He went to the elephant and said, 'I want to fight you.'

The elephant said 'Huh, you're not strong enough to take me on!'

But the spider got a rope and said, 'Hold onto this; when you feel it shaking and quivering, *yigbë yigbë* [an ideophone depicting the quiver of the rope], it's me; the fight's coming.' He went off.

He went on some way and met a hippopotamus.

'Hippopotamus, I want to fight you.'

The hippopotamus said, 'Huh! You're not strong enough to take me on!'

'Well, hold onto this rope.' The hippopotamus took it.

The spider went off saying 'When you feel it shake and quiver, *yigbë yigbë*, it's me, me'. (He'd said the same to the elephant you know.)

Well, when the spider had gone off, the elephant moved along not far away from the hippopotamus. When he felt *yigbe* on the rope, he said, 'Aha! look at that! I can feel the spider I'm fighting with.' The hippopotamus tugged too at the end where he was.

They spent all day, the whole of that day, struggling.

But the spider just went and lay down *këlëthë* ! [ideophone--lightly and easily].

They spent the whole long day like that.

Then the hippopotamus let go the rope: 'I'll go and see if it's really true that all that long time I was tugging away it was really the spider.'

Well, the elephant was coming along too. They met and asked each other: 'Where were you today?' and 'Where were *you* today?'

"The spider gave me a rope today, saying we would fight.'

The hippopotamus answered, 'That's right; it was me he gave the rope to; he said, "Let's fight."'

They stood there greeting each other and saying, 'The spider has

tricked us. Look, we were fighting each other not the spider. Brother, wherever we see the spider, let's kill him for that.'

The spider didn't want to be killed. That's why he ran away here into our houses.

This is a tale (translated into English of course) from 1961. It was told in the veranda of his hut by an old man named Bubu Dema in the hill-top village of Kakarima in the Sierra Leone northern uplands. It can serve as an initial focus for considering some of the frames and characters in Limba narrative before going on to a wider perspective.

First, the characters in African stories. Most familiar of all are the animals, particularly the wily hare, tortoise, spider, and their larger dupes. But there are also stories about people, ordinary and extraordinary. They are also occasionally woven round other personified objects like, say, the parts of the body, vegetables, minerals, the heavenly bodies, or abstractions like hunger, death or truth. These various characters do not usually appear in separate cycles, but interact among themselves: thus a story mainly about animals may introduce a human being or even God as one of the figures, or a human hero can succeed through his magical powers in speaking with and enrolling the help of various animals. The same plot may centre on different types of characters in different areas or on different occasions in the same society. In Lamba stories, to cite just one instance, the exploits of the little-hare and of a curious little human, Kantanga, are very much the same.

It is sometimes ambiguous whether the central figure is animal or human. The Kikuyu Wakahare, for instance, appears sometimes as a squirrel, sometimes as human; the Zande trickster is called "spider" but envisaged as a man, while the famous Zulu equivalent of Tom Thumb and Jack the Giant Killer rolled into one, *uHlakanyana*, is usually a tiny clever boy, but in other

contexts a weasel.

The characters of African stories vary in different places but there are some remarkable consonances. As with the Limba there is often a "trickster" figure, sometimes shy and wily (the antelope), sometimes bombastic like the spider. It may be—to mention only a few instances—a hare, a spider, a mouse, a tortoise or, in the American and Caribbean versions, Brer Rabbit, or the Spider, Anansi. The large animals tricked are most commonly an elephant and a hippopotamus, but sometimes a rhinoceros. Another common plot,known in fact widely throughout the world, describes the aggressor out-tricked: an animal tries to kill his rescuer but is outdone by a third character who persuades him to re-enter the trap to prove the truth of the story, and leaves him in it. Among other characters are: for the aggressor, a snake, leopard, or crocodile; for the intended victim, a child, baboon, gazelle, water antelope, rat, or white man; for the wily character who foils the aggressor, a jackal, hare, pygmy antelope, or spider.

Besides the leading animal figures, others who come in in secondary roles. Some of these stock characters are common to many areas of Africa: the lion, strong and powerful but not particularly bright; the elephant, heavy, ponderous, and rather slow; the hyena, *the* type of brute force and stupidity, constantly duped by the little quick animals; the leopard, untrustworthy and vicious, often tricked in spite of his cunning; the little antelope, harmless and often very bright; the larger deer, stupid and slow, and so on. Surprisingly, other animals, the zebra, buck or crocodile, seldom occur, or, if they do, tend to come in just as animals and not as the personified characters presented by those already mentioned. One rather different is the mantis in Bushman tales, their favourite hero. He shares some of the trickster characteristics (powerful and foolish, mischievous and kind), but his supernatural associations and the unusual type of action in these stories set him apart from other animal characters.

With few exceptions, these animals are portrayed as thinking and acting like human beings, in a human setting. This is sometimes brought out by the terminology, like the personal prefix neatly and economically used in Sotho to turn the ordinary form of, say, lion (*tau*) into a personal form (*motau*—Mr Lion) or the honorific class in Lamba which makes an ordinary animal term into a personal name—Mr Blue-Snake. In other cases no grammatical change is, or needs to be, made. The animals act like human characters, experiencing human emotions. And yet the fact that they are also animals is not lost sight of. This can be exploited either through grammatical forms, like the alternation in Zande stories between animal and personal pronouns, or through allusions to the animal's characteristic cry, appearance or behaviour to add to the tale's wit or incongruity. In a Limba tale, for instance, a spider is shown taking off his cap, gown, and trousers in a vain attempt to placate his magic pot; in the story he is unquestionably like a man, albeit an absurdly foolish man, with a house, wife, and human garb, but the fact that he is, nevertheless, a spider struggling with all these clothes adds just the touch in the telling which makes the whole story hilarious.

Many of these stories are light-hearted, even satirical, set in a wide range of adaptable and adapting situations. But there are also more serious themes. One common form is a story ending up with a kind of moral, sometimes in the form of a well-known proverb. The listeners are told that they can learn a lesson from the experiences of the animals in the tale—that, say, one should not be rude to one's mother-in-law, that men's words are more weighty than women's, that strangers should be treated well, that it is ill-advised to oppress the weak, or even that determination sometimes triumphs over virtue. In some places too, Christian morals are specifically introduced

In some narrations the moral element seems to form the core of the story, so that we could appropriately term it a parable

rather than just a tale. But in other cases, sometimes even those from the same area or teller, the moral seems no more than a kind of afterthought, appended to give the narration a neat ending. Another common framework is when an explanation is given for some behaviour in the present world, or a known characteristic of some animal or bird. For example, there are stones about how the ringdove came by its ring or got her name, how Squirrel robbed Coney of his tail, how Squirrel and Jackal became distinct, how Skunk came to be a helper of man, why Duiker has a fine coat and coloured tail, why Zebra has no horns, why there are cracks in Tortoise's shell—and so on.

Aetiological themes (explaining the original cause for something we know in today's world) are not confined to animal stories but come in all types of African tales. However, they are particularly popular—and fertile—when the lead protagonists are animals. Striking animal characteristics, well known to the listeners from their own observation, are wittily "explained" in the story. Not all these tales are equally humorous and light-hearted. A few explain more serious matters: the animals are depicted as interacting with humans or with God as well as with other animals; they explain, for instance, the origin of murder, of death or of chiefship. An explanatory ending, in fact, can apparently be tacked on to almost any plot as a pleasing and conventional conclusion fitting in with current literary conventions. Animal trickster stories, aetiological tales, or even "myths" are not mutually exclusive types but merely favourite themes which may or may not be combined in any one story.

An example of the non-essential nature of an aetiological conclusion can be seen from the rollicking Kikuyu tale about Wakahere (a popular squirrel-human story-figure; the explanation at the end seems very much an afterthought.

One day a Hyena went with Wakahare to collect honey in the forest,

where men used to hang their beehives from the trees. Wakahare climbed the tree, extracted big lumps of combs full of honey from a beehive, and when he was satiated, said to the Hyena: 'Open your mouth and I will drop some honey into it.'

The Hyena did so and swallowed the honey with great pleasure several times, until she was also satisfied.

Then Wakahare left the tree and returned to the ground. He asked the Hyena: 'How did you enjoy the honey?'

'Very, very much, what bliss, my dear friend.'

'But remember,' said Wakahare, 'this is a kind of sweetness that must not be evacuated from your body.'

'Yes, I think it must be so; but how can one prevent it from going out?'

'I'll tell you what to do. I will stitch your orifice together with your tail and you may be sure that no sweetness will come out.'

'Good, my friend, do it for me, please.'

Wakahare fetched a few sharp thorns and stitched the orifice with the tail of the Hyena and went off.

After some time the Hyena felt a terrible urge to evacuate. She looked around for help, but nobody was to be found. At last a Jackal happened to pass there. '"Oh, dear friend Jackal,' said the Hyena, 'come please, and help me.'

'What can I do for you, dear friend?'

'Please, release a little bit the stitches which are at the neck of my tail. I cannot bear it any longer.'

'Sorry, my friend, I am unable to do that. I know you have diarrhoea habitually, and don't want to be splashed with a discharge of that kind.' And so saying, he went on.

After some time a Serval arrived on his way to the forest. The Hyena beseeched him for help.

'Sorry, Mrs. Hyena, you are very prone to discharge violently,' said the Serval, 'I don't want to be buried under your excrements.'"

He too went his way without looking back.

Later on a Hare passed by. The Hyena asked again for help, but to no avail.

'I am very sorry,' the Hare said. 'Don't you see how clean I am? I am going to a feast. I don't want to soil my dress and get untidy for your dirty business.'

He too went his way leaving the Hyena groaning and tossing on the ground on account of the pain she was suffering.

At last, a Crow perched on a tree nearby. Looking down at the Hyena lying still on the grass, he thought she was dead, and began to foretaste a good meal: but as he was planning what to do next, the Hyena opened her eyes and seeing the Crow on the tree, said: 'Oh dear Crow, dear friend of mine, help! help! please.'

The Crow left the tree and approached the Hyena.

'What's the matter with you?' he asked.

'Oh please, release a bit the stitches in my tail. I am dying of the urge of my body and I cannot evacuate.'

'You say dying--dying?'

'Yes, help me, please.'

'But you see, I am only a bird with no paws. How can I help you with that business?'

'Oh dear try as much as you can and you will succeed.'

'I doubt very much, and besides that I am very hungry. I have no strength to do any work.'

'Oh nonsense! My belly is full of meat. You will eat today, tomorrow, and the day after tomorrow and be satiated.'

When he heard that, the Crow set himself to think and after a little while decided to see what he could do. With his strong bill he succeeded in extracting the first thorn, and truly, two small pieces of meat fell on the ground. The bird devoured them very greedily, and encouraged by the success, began to tackle the job seriously.

After a great effort he succeeded in extracting the second thorn, but alas! a burst of white excrement gushed forth with such vehemence, that the poor Crow was cast back ten feet and was buried head and all

under a heap of very unpleasant matter. The shock was so great, that he remained buried for two days, until a great shower of rain washed the ground, freeing the Crow of the burden. He remained a full day basking in the sun and regaining strength. He was so weak that he could not fly.

The Crow was washed by the heavy rain, but his neck remained white. That is the reason why crows today have a white collar in their plumage.

The Crow very much resented the alteration of his plumage and decided in his heart to take revenge.

One day he heard that the hyenas had arranged for a great dance in a thicket he knew very well. He cleaned himself with great care in the morning dew, put on a beautiful string made of scented roots and proceeded to the meeting place. On his arrival he was greeted by the hyenas and several of them asked him to give them some of those little pieces of meat he wore around his body. They took his ornamental beads to be meat.

He refused to give any of the beads away, but rising on his feet with an air of dignity, he said: 'My dear friends, forgive me this time, I cannot give away this kind of meat, which is specially reserved for our kinship, but I promise you a great quantity of good meat and fat if you follow me to the place I am going to show you.'

'Where is it?' they asked anxiously.

'You see, we birds fly in the air and our deposits of food are not on earth, but on high for safety's sake. Look up at the sky and see how many white heaps of fat we usually store there. That's where you will find meat and fat in great quantity.' The hyenas gazed up to the sky and asked: 'But how can we get there?'

'I will show you. You can reach there very easily. Now, let us make an appointment. The day after tomorrow we will meet here again. Tell your people, old and young, men and women to come here with baskets and bags; there will be meat and fat for all.'

On the day appointed the hyenas came in great numbers. I think

the whole population was there. The Crow arrived in due time. He started by congratulating the crowd on their punctuality, and with great poise said: 'My dear friends, listen now how we are going to perform the journey to the place of meat and plenty. You must grapple one another by the tail, so as to form a long chain. The first of the chain will hold fast to my tail.'

There was a general bustle among the hyenas, but after a few moments all were in order. At a given sign, the Crow began to fly, lifting the hyenas one by one till they looked like a long black chain waving in the air.

After some time he asked: 'Is there anybody still touching ground?'

The hyenas answered: 'No, we are all in the air.

He flew and flew up into the sky for a long time and asked again: 'What do you see on earth? Do you see the trees, the huts, the rivers?'

'We see nothing but darkness,' they answered.

He flew again for another while and then said to the hyenas nearby: 'Now, release for a while, that I may readjust my ornaments.'

'But dear friend, how can we do it? We will surely fall down and die.'

'I can't help it. If you don't release me, I will let go my tail, I am sure the feathers will grow again.'

'Oh dear friend, don't, please don't for your mother's sake, we would die, all of us.'

The Crow would not listen at all. He thought the time had come for his revenge. With a sharp jerk he turned to the right. The feathers of his tail tore out, and with them the long chain of hyenas. They fell heavily on the ground and died.

One of them escaped with a broken leg. She was pregnant and so saved the kinship from total destruction. That is why hyenas these days limp when they walk.

One of the obvious points in these stories is just the sheer entertainment afforded by the description of the amusing

antics of various animals, and they are often told to audiences of children. The fact that most of the animals portrayed are well known to the audience —their appearance, their behaviour, their calls, so often amusingly imitated by the narrator—adds definite wit and significance that is lost on readers unfamiliar with this background. The gentle, shy demeanour of the gazelle, the ponderous tread of an elephant, the chameleon's protuberant eyes, or the spider's long-legged steps are all effectively conveyed and provide a vivid and often humorous picture for those present. It is true that the imagery associated with the animal figures in tales hardly matches that implied in other contexts (praise songs for instance). But on a straightforward and humorous level the animals in stories are appreciated and enjoyed simply for the vivid portrayal of their amusing antics.

But there is more to be said than this. On another level, what is often involved is a comment, a satire, on human behaviour. When the narrators speak of the actions and characters of animals they are also representing human faults and virtues, somewhat removed and detached from reality through being presented in the guise of animals, but nevertheless with a well-understood relevance for observed human action. As Smith writes of the Ila, in words that can be applied far more widely: "In sketching these animals, not Sulwe and Fulwe [Hare and Tortoise] only, but all the animals in these tales, the Ba-ila are sketching themselves."

So there is no need to try to explain these animal stories by outdated theories about, say, "totemism" or the ridiculous notion that "primitive man" could somehow not clearly distinguish between himself and animals. Nor need we refer to literalistic interpretations of the stories, and assume that they are there simply to give moral messages. Rather these animal are a medium through which, as in much of our fiction, the experience of narrators and listeners can be represented and in a way judged.. The foibles and weaknesses, virtues and strengths, ridiculous

and appealing qualities known to all those present are touched on, indirectly, in the telling of stories and are what make them meaningful and effective in the actual narration. In contexts in which literary expression is neither veiled by being expressed through the written word nor (usually) voiced by narrators removed from the close-knit listening group, comment on human and social affairs is expressed less rawly, less directly, by being enmasked as animal characters.

Some plots and explanations in the tales may at first sight seem puerile and naïve—and so no doubt they are when stripped of the social understanding and dramatic narration that give them meaning. But the background to, say, some little story about a competition between two animals for chiefship, or a race between two birds to the colonial secretariat for the prize of local government office, renders it meaningful to an audience fully aware of the lengths to which political rivalry and ambition can lead people. And if we cannot say that such events are represented directly in the stories, we can at least see how the tales strike a responsive chord in their audience. In a way common to many forms of literature, but doubly removed from reality in being set among animals, the animal tales reflect, mould, and interpret the social and literary experience of which they form part.

There is a further point about some of the animal stories. This is the effective use of the trickster image (usually but not invariably an animal) that can be adapted to express the idea of opposition to the normal world or of the distortion of accepted human and social values. This applies particularly when the trickster figure is made not only wily but also in some way inordinate and outrageous—gluttonous, uninhibited, stupid, unscrupulous, constantly overreaching himself. Here, the trickster is being presented as a kind of mirror-image of respectable human society and behaviour. Or he can be used to fictionally represent traits or personalities which people both recognize and fear. Take

Ikaki, the tortoise trickster figure among the Kalahari, in both masquerade and story the amoral, psychopathic confidence trickster the type who accepts society only in order to prey upon it, the intelligent plausible psychopath, that universal threat to the fabric of the community.

More than this. Not only does the trickster figure stand for what is feared, his representation in literature also helps to deal with these fears. In the first place, he is represented in animal guise which allows narrator and listener to stand back, as it were, and contemplate the type in tranquillity. By capturing him in story, people can show the trickster clearly closely related either to animals or to the djinns and genies familiar from Islamic tradition, as himself outwitted and overreached, often enough by his own wife. By exaggerating and caricaturing him to the point of absurdity, they in a sense "tame" him. And so the disturbing real-life experience of plausible psychopaths is controlled, confined, and cut down to size. People laugh from out of their depths at the ravening forest beast, because for once they have got him behind bars.

These animal tales have been the most popular and well-known type of African narrative among many European collectors and readers. The stories are often amusing in themselves, they fitted preconceptions about the supposed "childlike mentality" of Africans, and they provided pleasing parallels to the Uncle Remus stories of America which they had ultimately fathered. Many more animal stories have therefore been published than those about other characters, and the impression given that animal tales are the main type of prose narrative in Africa or even of oral literature altogether. This in fact is far from the case. In some areas at least stories about people or supernatural beings are preferred and tend to be more elaborate, lengthy, or serious.

Many of these stories are about everyday events and characters. They treat problems like the relations of two co-wives and how

these affect their children or their husband; wooing a wife; jealousy between two equals or between chief and subject; the extremes of friendship and affection shown by two companions; or a series of clever tricks by some outrageous but in essence recognizably human character. Often a story is set back a little further from reality by the introduction of some marvellous element in setting, event or character. The man who goes to woo a woman, for instance, may have to undergo a series of far-fetched or magical tests before he can win her—sowing and harvesting some crop in a single day, or guessing his beloved's closely guarded and amazing secret, or avoiding death only through the magical help of animals or spirits. The cunning of the central character may rest on enchanted powers and lead the listener into some far-away and fantastic world. The imagination of both teller and audience can thus rove freely and the exploits of the hero become the more romantic and exciting for being enacted against this imaginary background.

Other stories are thrillers or horror tales. The hero struggles against ogres and monsters about to devour him. These fearsome beings are stock characters in many stories in Bantu Africa. There are the one-legged, two-mouthed cannibalistic ogres of East African tales, for instance, the Di-kishi cannibal of Angolan stories (sometimes appearing as a named "hero", Dikithi with his one eye and a single leg made of beeswax), or the half-man, half-animal monsters of some tales in Malawi or the Congo. We meet powerful monsters, giants and spirits in West African stories, many of them man-eating but apparently less often physically deformed; a number of turces. The basically non-human and asocial character of these figures comes through clearly either by reason of their deformities or through their association with non-human creatures.

Even without exotic characters and settings, an element of fantasy is often apparent. In one Sierra Leonean story, to give

just one instance, a pregnant woman's belly grew "as big as Sierra Leone and Great Britain put together' , while all over the continent kings possess fabulous wealth and power, heroes are revived from death, girls are wooed by hundreds and thousands of suitors, young men win kingdoms for themselves by force of arms or politic love, hunters kill and capture amazing beasts who bring them all their desires. In the areas strongly influenced by Islam, particularly on the East Coast, we hear tell of sultans with wealthy and glittering entourages and of the miraculous assistance given to a hero by genies.

The detailed way story-tellers' imagination combines fantastic elements with their knowledge of the real naturally varies not only from society to society but also from narrator to narrator. Each has his own contribution to make of wit, satire, elegance, or moralizing. It is too simple to pick on just one element, like "realism and lack of sentimentality" or "placid serenity", and extrapolate this to African narratives in general. Some are realistic; some not—unless by "realism" one merely means that a narrator builds on his own experience to add point and vividness, in which case assertions about "realism" become meaningless.

Similarly some stories do give an impression of serenity; others most definitely do not. It is better to say that the opportunities for various kinds of literary effect are exploited differently in different contexts, and that even when plots are much the same, the tone and impact of the story itself may vary in different areas and different narrations. Two stories can illustrate this. In both there is both fantasy and human action—but the stories are very different in tone.

The first ("One Cannot Help an Unlucky Man"—a proverb) is by a Hausa teller.

There was a certain Man, a Pauper, he had nothing but husks for

himself and his Wife to eat. There was another Man who had many Wives and Slaves and Children, and the two Men had farms close together.

One day a Very-Rich-Man who was richer than either came, and was going to pass by on the road. He had put on a ragged coat and torn trousers, and a holey cap, and the People did not know that he was rich, they thought that he was a Beggar.

Now when he had come up close, he said to the Rich-Man 'Hail to you in your work, but when he had said "Hail", the Rich-Man said "What do you mean by speaking to me, you may be a Leper for all we know!"'

So he went on, and came to the Poor-Man's farm, and said 'Hail to you in your work.' And the Poor-Man replied 'Um hum', and said to his Wife 'Quick, mix some husks and water, and give him to drink.' So she took it to him, and knelt, and said 'See, here is some of that which we have to drink.' So he said 'Good, thanks be to God, and he put out his lips as if he were going to drink, but he did not really do so, he gave it back to her, and said 'I thank you.'

So he went home and said 'Now, that Man who was kind to me I must reward.' So he had a calabash washed well with white earth, and filled up to the top with dollars, and a new mat was brought to close it.

Then the Very-Rich-Man sent his Daughter, who carried the calabash, in front, and when they had arrived at the edge of the bush he said 'Do you see that crowd of People over there working?' And she replied 'Yes, I see them.' He said 'Good, now do you see one Man over there working with his Wife?' And she replied 'Yes'' 'Good', he said, 'to him must you take this calabash.' Then she said 'Very well'.

She passed on, and came to where the Poor-Man was, and said 'Hail', and continued 'I have been sent to you, see this calabash, I was told to bring it to you.' Now the Poor-Man did not open it to see what was inside, his poverty prevented him, and he said 'Take it to Malam Abba, and tell him to take as much flour as he wants from it, and to

THE INSIGHT OF STORY

give us the rest.'

But when it had been taken to Malam Abba, he saw the dollars inside, and he put them into his pockets, and brought guinea-corn flour and pressed it down in the calabash, and 'Carry it to him, I have taken some.' And the Poor-Man [when he saw that there was some flour left] said 'Good, thanks be to God, pour it into our calabash, and depart, I thank you.'

Now the Very-Rich-Man had been watching from a distance, and [when he saw what had happened] he was overcome with rage, and said 'Truly if you put an unlucky Man into a jar of oil he would emerge quite dry. I wanted him to have some luck, but God has made him thus.'

Then there is the Kikuyu tale of Wacici and her friends:

Wacici was a very beautiful girl, admired by many people for her elegance and charm. Her girl friends were very jealous of her and always ill-treated her. One day her friends were going to visit a mwehani [an expert in beautifying teeth] to have their teeth filed, spaced, and beautified as girls used to do. Wacici joined them. He was a man of great fame who was highly reputed for his skill.

They all had their teeth well done and the girls looked very attractive and charming, but no one looked as pretty as Wacici. The expert praised Wacici's teeth and beauty and added that she had natural beauty and charm in everything. This annoyed her girl friends very much.

On their way home they stopped and talked to young men from time to time. They laughed as they spoke to the boys, 'Aha-aaa! Uuuuuu! Eia!' (this is the most romantic laughter which was artificially employed by Gikuyu girls specially when speaking to boys). 'Aha-aaa! Uuuuuu! Eia!' They continued to laugh repeatedly as they spoke to young men and the boys would admire their teeth and their charm and sense of humour. 'You have been to the tooth

expert, have you not?' the boys inquired.'"Aha-aaa! Uuuuuu! Eia!' The girls continued to laugh. 'Wacici is looking most attractive' one boy remarked kindly, 'she is really gorgeous and wonderful.' And all the boys agreed and repeated this remark to Wacici. This infuriated the girls, who were very jealous of Wacici's beauty and many of them wanted her out of their company.

The girls continued their journey towards their homes and on the way they all conspired to bury Wacici alive in a porcupine hole which was somewhere in the forest near the road. It was suggested that they should all enter the forest and gather some firewood to take back home as it was the custom that girls should return to their homes with some firewood after a day's outing. They all agreed to do this and Wacici particularly was very eager to take home some firewood. She was not only a beauty but also a very good girl who upheld the respect expected of Gikuyu girls, and her mother loved her dearly.

When the girls reached the porcupine hole in the forest, they grabbed Wacici and pushed her down the hole and quickly buried her alive. She was taken by surprise and she did not have a chance to scream as she thought that they were playing with her. They did not beat her or do anything harmful to her body. They sealed the hole very carefully on top, quickly left the forest and returned to their homes; they did not speak to anybody about Wacici.

That evening Wacici did not return home. Her parents waited and waited. When she did not come they went about asking Wacici's friends if they had been with her that day or whether they had seen her anywhere. They all denied having been with her or seeing her anywhere that day.

All this time Wacici was crying in the bottom of the porcupine hole in the forest while her parents were wandering all over the villages looking for her.

'Where has she gone to?' her mother asked. 'Could a young man have eloped with her?' Her disappearance caused so much concern that her father had to go to consult witch-doctors and seers and ask

what had become of his daughter.

Next morning Wacici's father met somebody who had seen his daughter in company of the other village girls going to the tooth expert. He reported this to his wife and without wasting any time he went to see the dentist in order to verify this information. The dentist confirmed that Wacici and her friends had been to see him and that he had done their teeth on the day she was reported missing. Also on his way home Wacici's father met some young men who had seen and spoken to his daughter with the other village girls.

He returned home and reported to his wife and the family all the information he had gathered. Wacici's brother, who knew most of the girls who were said to have been seen with his sister, had known for some time that most of the girls had been jealous, and hated Wacici. He suspected foul play. He left home quickly and tracked the route through which the girls had returned from the expert. He knew that if they gathered some firewood, they must have entered the forest on the way. He went into the forest to check if his sister had been killed there.

When he came near the porcupine hole he noticed that it was freshly covered and that there were many footmarks which suggested that many people had been there. He examined them very carefully. He also saw a bundle of firewood which had been abandoned.

This time Wacici could hear some noise and footsteps above her. She was crying and singing and calling her brother's name. 'Cinji! Cinji! Nondakwirire-i! Cinji, Nothiganagwo-i! Cinji; Cinji! Cinji! Cinji! Cinji! I already told you, Cinji, I have been hated and spied on, Cinji; Cinji! Cinji!'

When he listened carefully he heard the voice of Wacici clearly and he had no doubt that she had been buried there by her girl friends who were jealous of her beauty. He called out, 'Wacici-i! Wacici!'

Wacici heard him and she felt so happy that he had come to liberate her. She answered quickly, 'Yuu-uuu!'

At once her brother started digging and removing the soil. He

dug and dug until he came to where she was sitting and crying. He carried her to the surface and examined her: she was in good shape except that she had weakened because of hunger and fear. He took her home and her parents were so happy to see her again. She was given a good bath and a lamb was slaughtered to offer thanksgiving to Mwene-Nyaga who had preserved her life.

Wacici reported what her friends had done to her. The following morning the evil girls were arrested and sent to a trial before the elders in a tribunal court and their fathers were heavily fined. They had to pay many heads of cattle and many rams and bulls were slaughtered and a lot of beer had to be brewed for the judges and the elders to eat and drink.

The bad girls were exposed and they were all shunned in society and were unable to get husbands for a long time. Wacici was widely respected and she got married and became a mother of many children and lived happily ever after.

Some societies have their own favourite named heroes--the Lamba Kantanga (a little mischievous fellow), the Zanda Ture or Tule (an amusing rogue), the Zulu Uhlakanyana as a human (a deceitful and cunning little dwarf), the Fon Yo (a glutton with supernatural powers), and so on. As with animal tales it would be misleading to assume that all these stories about named characters fall into clear-cut cycles in an attempt to give an overall and in principle unitary history of the hero. In some cases at least though the listeners may well mentally connect the story with other tales about that hero and be already acquanted with his character, there seems to be no attempt at consistency or chronology, the stories are told as short independent narrations on different occasions, and their inclusion into one united narrative may represent the outlook of the Western systematizing scholar rather than the intentions of the narrators.

Other characters in African stories are named but independent,

coming only in isolated stories. The names are merely taken from everyday ones and given to a character for ease of reference. Or, alternatively, the name itself has meaning without necessarily carrying on into other similar stories, like the Zande "Man-killer" and "One-leg", or the Limba brothers "Daring" and "Fearful". In very many cases, however, the characters are not given names. They appear just as "a certain woman", "a chief, "a small boy", "a hunter", "two twins", and so on. Each literary culture has its own stock figures whose characteristics are immediately brought into listeners' minds by their mere mention. The Ila are particularly fond of stories about fools, the Kamba tales about those from the extreme bracket of society like the one-eyed, sickly, orphan, or a poor and despised widow; and the Hausa, among others, make great play with unfaithful wives. Some stock characters appear and reappear in settings: a jealous husband, a boaster, a skilful hunter, an absurdly stupid person, a despised youngster making good, a wise old woman, an oppressive ruler, twins, good and bad daughters, and young lovers. The basic human dilemmas have clearly brought inspiration to hundreds of story-tellers practising their otherwise diverse skills throughout the continent.

The language of the stories shows little of the allusive and obscure quality of some African literature; rather apart from the songs, they are in straightforward conversation-like language. Opening and closing formulas are very common, espcially appropriate in setting the story apart from other talk in oral contexts. Kamba tellers end their stories with a wish for narrator and audience: "May you become rich in vermin in your provision-shed, but I in cows in my cattle-kraal"; "May your cattle eat earth and mud, but mine the good grass"; the teller is to be better off than his listeners so the audience had better learn to tell stories. Other closing formulas include the Nigerian Bura "Do not take my life, take the life of a crocodile" (notorious for its long life), the Swahili "If this is good, its goodness belongs to us all, and

if it is bad, its badness belongs to that one alone who made this story" and the Akan "This my story, which I have related, if it be sweet, (or) if it be not sweet, take some elsewhere, and let some come back to me". In such closing formulas the narrator hands over, as it were, to the audience, as well as making it clear that his story is concluded.

Conversely the opening formulas rouse the interest of the audience and set the mood. Among the Fjort of West Equatorial Africa the narrator opens with "Let us tell another story; let us be off!" to which the audience replies "Pull away!", and the narrator is off. Among the West African Ewe, where a narrator is often accompanied by a drum, a few beats are played to call attention and then the narrator announces his subject: "My story is of so-and-so"; the audience replies "We hear" or "We take it up" and the recital begins. Among the Hausa it is "A story, a story. Let it go, let it come." or "See her (the spider), see her there". There is also the rightly famous Akan "We do not really mean, we do not really mean [that what we are going to say is true]"

There are also other less obvious phrases. These are, so to speak, the internal formulas by which the story is begun and ended. Thus all Limba stories tend to open (after the introductory formulas) with a phrase setting them firmly in the fairly remote past (rather like our "Once upon a time")—"A woman once came out (on the earth)", "A spider once got up and . . .", "A chief once married a wife . . ., and so on. A Kamba tale often begins with the more dramatic "How did it happen . . ." , a Mbundu one with "I often tell of . . .".

The stock endings, in both phraseology and situation, are also interesting. There is the common Hausa conclusion: "they remained"; the Limba return home, marriage, or formal reporting to some authority of the adventures undergone by the hero; or the frequent conclusion in Ila fool stories about how the events have now become a byword: "And to this day it is put on record. When

a person looks for a thing he has got, they say: 'You are like yon man who looked for the axe that was on his shoulder.' "

On a slightly higher level, in studies of stories the literary conventions peculiar to a culture about the treatment of certain motifs and situations. Thus one of the stock climaxes in Kamba tales is for a monster, about to die, to tell his conqueror to cut off his finger; when this is done, all the people and the cattle devoured in the course of the story come to life again. In Zulu stories a standard way of killing an enemy is to give him a bag of snakes and scorpions to open, while the *deus ex machina* in Luba stories is usually a little dirty old woman who appears at the critical moment. Similarly we can find many other cases of stereotyped and yet, through that very fact, markedly allusive and meaningful treatments of particular episodes. There is the pregnant but outwardly simple Limba comment in a story "he sharpened his sword", which at once hints at drama and danger to come; or the economical indication of the horror, finality, and shock of finding a dead body lying on the floor by a brief reference to the flies buzzing round the corpse. Both these motifs occur in several narrations; yet their full impact would not emerge were they not known to be common and yet allusive literary stereotypes.

Even more important than the points mentioned so far is their dramatic realisation. To ignore this aspect is to miss one of their most significant features. The vividness, subtlety, and drama with which stories are delivered have often been noted in general terms by those who know a lot about the literature they present (as distinct from collectors who merely reproduce texts written for them by employees). Here is one good description, however:

> We have to reconcile ourselves to the fact that for us, at least, it is impossible to do justice to these tales, and we doubt if the most skilful hand could reproduce in a translation the quaintness, the liveliness, and humour of the original . . .

They gradually lose flavour as they pass from the African's telling, first into writing and then into a foreign idiom. It would need a combination of phonograph and kinematograph to reproduce a tale as it is told. One listens to a clever story-teller, as was our old friend Mungalo, from whom we derived many of these tales.

Speak of eloquence! Here was no lip mumbling, but every muscle of face and body spoke, a swift gesture often supplying the place of a whole sentence. He would have made a fortune as a raconteur upon the English stage. The animals spoke each in its own tone: the deep rumbling voice of Momba, the ground hornbill, for example, contrasting vividly with the piping accents of Sulwe, the hare. It was all good to listen to—impossible to put on paper.

Ask him now to repeat the story slowly so that you may write it. You will, with patience, get the gist of it, but the unnaturalness of the circumstance disconcerts him, your repeated request for the repetition of a phrase, the absence of the encouragement of his friends, and, above all, the hampering slowness of your pen, all combine to kill the spirit of story-telling. Hence we have to be content with far less than the tales as they are told. And the tales need effort of imagination to place readers in the stead of the original listeners.

Similarly of Lamba narrators:

To reproduce such stories with any measure of success, a gramophone record together with a cinematograph picture would be necessary. The story suffers from being put into cold print...

In my own study of Limba stories, the single characteristic that I found both most striking and most incommunicable in writing was just this—the way narrators added subtlety and drama, pathos or humour, characterization or detached comment by *how* they spoke as much as by the words themselves. The narrator takes on the personalities of the various characters, acting

out their dialogue, their facial expressions, their gestures and reactions vividly portraying his characters' acts and feelings of his characters in dramatic dialogue or through facial expressions and gestures.

Speeches by animal characters are often sung, sometimes in falsetto, and always with a nasal twang, sometimes too with some attempt to imitate, for example, the cries of birds. The Bushmen have a specialized form of speech conventionally attributed to certain animals (and the moon) in stories; the Blue Crane, for instance, adds *tt* to the first syllable of almost every word and the tortoise's lisping makes him change all the clicks and other initial consonants into labials.

The delivery and treatment of the words themselves is also relevant. Even when he does not choose to elaborate any extremes of dramatization, the narrator can and does create vivid effects by variations and exaggerations of speed, volume and tone. He can use abrupt breaks, pregnant pauses, parentheses, rhetorical questions as he watches the audience's reactions and exploits his freedom to choose his words as well as his mode of delivery. Onomatopoeia adds elegance and vividness. A style plentifully embroidered with ideophones is one of the striking characteristics of an effective story-teller. We can actually *hear* the Limba boy leaping into a lake (*tirin!*), the Akan spider hitting the ceiling (*kado!*), the tortoise swimming (*seki seki seki*). The action is dramatized by a skilful teller.

The participation of the audience is, as we know, essential. They are expected—obliged—to make verbal contributions of spontaneous exclamations, questions, echoing of the speaker's words, emotional reaction to the development of yet another parallel and repetitious episode. They are the chorus of the songs introduced into some narrations, and without which the stories would be only a bare verbal scaffolding. Indeed sometimes the songs seem to be the main point, the story merely an extemporized

and unimportant link between them.

The songs fulfil various functions in the narrative. They often mark the structure of the story in a clear and attractive way. Thus, if the hero is presented as going through a series of tests or adventures, the parallel presentation of episode after episode is often cut into by the singing of a song by narrator and audience. Further, the occurrence of songs adds a musical aspect—an extra dimension of both enjoyment and skill. In some areas (particularly parts of West and West Equatorial Africa) this musical element is further enhanced by drum or instrumental accompaniment or prelude to the narration.

Songs also provide a formalized means for the audience to participate by singing loudly in the choruses, clapping or, sometimes, dancing. The common pattern is for the words of the song, whether familiar or new, to be introduced by the narrator, who then acts as leader and soloist while the audience provide the chorus.

Composition as well as performance is involved. Narrators introduce their favourite tricks of verbal style and presentation, variations on the basic theme different from those of their fellows, even from their own on a different occasion. In addition to this, there is the individual treatment of the various incidents, characters, and motifs; these do not emerge when only one version of the story appears in published form. Finally, there are the occasions when we can rightly speak of a 'new' story being created. Episodes, motifs, conventional characters, stylistic devices which are already part of the conventional literary background on which the individual artist can draw are bound together and presented in an original and individual way. This real originality, as it appears to the foreigner, is really only a difference in degree, for there is seldom any concept of a 'correct' version; most stories arise from the combination and recombination of motifs and episodes with which the individual is free to build. Stories are

thus capable of infinite expansion, variation, and embroidery by narrators, sewn together in one individual's imagination..

Two versions of the 'same' plot may be quoted to illustrate this: similar in subject matter, very different in tone and character. They both explain why birds of prey swoop down and carry off chickens from the mother hen—in return for a debt the hen owes from the old days. The versions are chosen for their relative brevity; many longer stories have been recorded from each society.

First, a version from the Kikuyu of East Africa, recorded by the early twentieth-century missionary, Father Cagnolo, who had spent many years in the area.

Long ago the hen and the vulture used to live on excellent terms, helping each other at any time they needed a hand to procure their domestic necessities.

One day the hen thought of borrowing a razor from the vulture, to shave the little ones. The shaving was already much overdue, but it couldn't be helped, because she had no razor, and was depending on the kindness of her neighbours. So the hen went to see the vulture and said: 'Dear vulture, I should like to borrow your razor; mine was lost months ago. My little ones are looking very ugly, and also very untidy, with their long unkempt hair overgrown.'

The vulture listened to the hen with great concern and, after a short silence, said: 'Dear hen, I cannot refuse you this favour. Tomorrow perhaps I might need your help as well, and we must help each other. However, you must remember one thing. You know what that razor means to me. I have no other income except the rent of that razor; that is to say, that razor is my field, whence I get my daily food. I do not intend to ask you any fee as I do with others; but please be careful to return it to me, as soon as you have finished your shaving.' 'Thank you, brother vulture, I quite understand what you say, and I am very grateful to you. I'll bring it back very soon.'

The hen was very glad of the favour, and as soon as she arrived

home, made arrangements to be shaved by another woman. The following morning she also shaved her two little ones, so that the whole family was now shining like the moon. The work over, instead of immediately returning the razor to the owner, she put it in a leather purse, which was hanging in a corner of the hut.

The days passed, and passed away like the water under the bridge, but the hen never thought again of returning the razor to the vulture. She forgot it completely. The vulture grew impatient, and deeply resented in his heart the unkindness, nay, the ingratitude of the hen. Pressed by necessity, he decided to go personally to the hen and demand his razor.

'Oh dear vulture,' said the hen with confusion and great regret, 'forgive me; I am so sorry for this my negligence. I really intended to return your razor very soon, but I put it in my leather bag, and forgot it completely. Let me go and take it; you will have it in half a minute.' 'Yes, I know you are a forgetful creature; but look at the damage you have caused me. You have deprived me of my sustenance for many days. Mind you, if you have lost it, you will pay for it and very dearly,' said the vulture.

The hen rushed into the hut to fetch the razor. She plunged her hand into the leather bag, but alas! it was empty; there was no razor in it. She was very shocked at the unpleasant discovery. She started searching on the floor to see if by chance it had dropped from the bag, but there was no finding it. She looked under the children's bed, near the fire stones, in the store; but there was no sign of it. Tired and defeated, she came out and, imploring, said: 'O dear friend and master, I can't find it. Have mercy on me! I will search better; I am ready to demolish my hut altogether, and search diligently until I find it and return it to you.' 'I told you to be very careful, and I repeat it again: I want my razor back! But mind, I want the very one I gave you, and no substitute.'

The poor hen spent all the day searching and searching, but nothing came to light. She demolished her hut, and started searching

in the roof-grass, among the rubble of the walls, between the poles, in the ashes, and even in the rubbish pit; but nothing was found.

The following day the vulture came to see the results of the searching. He found the hen still scratching the ground among a heap of dry grass and ox dung; but no razor was yet discovered. 'I am very sorry, dear hen,' said the vulture, 'but now I cannot wait any longer without compensation for my razor. For today you must give me a chicken. To-morrow I will return and see what has happened in the meantime.' So the vulture flew away with a chicken gripped within his talons under its breast.

The following day he returned to the hen. She was still scratching the ground; but she could not see any razor. Another chicken went with the vulture. And the same happened in the following days until today.

That why the hen is always scratching the ground, and the vulture swooping on chickens even in our days. The hen is still searching for the razor, and the vulture compensating himself for its loss.

The second story, a Limba one, is one I recorded in 1961, given here in a rather literal translation.

The finch, a small bird, once borrowed money from the eagle's grandfather. He borrowed that money. Now the eagle—(he died) leaving his children alone. But he left a message with them: 'Your grandfather had money borrowed from him by the father of the finch.' Since he (i.e. his family) had lent the money, the (young) eagle spent a long time looking for the finch. He looked and looked; but he could not find him

One day he went and sat down where they pound the rice. He was sitting there. When he saw the hen standing there, eating the rice, he asked her: 'Oh, hen.' 'Yes?' 'What are you doing here?' 'I am getting my food.' 'Do you know whereabouts the finch is? He's the one I'm looking for. He made use of my father's property. I want him

to return it…Do you think I will be able to find the finch?' 'Yes, you can find him.' 'Well, how can I find him?' 'When people get up to go and pound the rice, if you go there and you hide you will find the finch there.'

The eagle got there. He went and hid. The finch alighted and began to pick at the ground, searching for his food. The eagle swooped down. 'Ah! you! What a long time I have spent looking for you. Now here you are today. Today you will have to give me back the property your family took.' 'What?' asked the finch. 'Eagle?' 'Yes?' 'Who told you where I was?' 'The hen.' 'It was the hen that told you?' 'Yes.' 'Oh! dear!' said the finch. 'We're both in trouble then. I—ha! I have been looking for the hen here but could not find her. And all the time you have been looking for me and could not find me! Since the hen was the reason you found me, that's why I am going to give her to you now.'

The eagle did not believe the finch. 'Haven't you seen my house then?' He still didn't believe. 'Eagle' said the finch. 'Yes?' 'Come on.' They went. They went and stood near the wall where the finch lived. 'Here is where you can tell that my grandfathers owned the hen as a slave. As for the hen-family—just look here at where my children sleep. You can't find any leaves there, can you, only feathers.' When they got there the eagle went and looked. He saw the hen's feathers. He turned them over—and over—and over. He could only see feathers. 'Yes, finch. You spoke the truth. Well then let there be no quarrel between us two.' 'I will give you the hen-family, my slaves.'

That's why hens are carried off by eagles. That is the story. It is finished.

Among the many topics and characters treated in Limba tales, the spider was a hugely popular figure (like other translators and transcribers I had to decide whether or not the Limba wosi should be tanslated into English as "Spider", "a spider", "the spider", "Mr Spider", "Bra spider" or more: taking account of the language and

style of the stories and local discussions I chose "a/the spider" but neither this nor, I conjecture, alternative choices necessarily capture the notable and effective ambiguities of the original). As soon as a story-teller uttered the word wosi the audience would start to smile, ready for hilarity and startlement, rolling with laughter as they listened. Like other trickster-type characters he was not just crafty but also only too liable to overreach himself. Sometimes he was the weak outwitting the strong (with a hint of untamed irresponsibility), more often arrogant and a-social, his over-the-top self-aggrandisement leading to some wonderfully ludicrous downfall.

These spider stories were in one way specific to the Limba tellers of their time and place, both in their subtle performances and audience co-creation and through the overtones of their events and settings. But the Limba spider partakes too in the kinds of antics and associations of the trickster personae that are found so widely throughout the world. He is not far from many of the Afro-American and Caribbean "Anansi" (Spider) stories too, tales that have by now engendered a large literature on the mingling themes of the irresponsible loutish a-social trickster (the "badman" who goes beyond the accepted norms), and the justified rebel, the weak against the strong, breaking the unjustifiably imposed rules of dominant society and chiming in with the West Indian motif not of the "bad" but of the moral "ba-ad" man with something admirable as well as arrogant about him.

Limba tellers and listeners knew the stories were not just about one clever-silly animal—the spider who was at the same time Spider with his named wife Kayi—but also in a way about human life. These may be tales of animals but they are not "just" animal tales. As, again, with the masks of classical Greek tragedy, the enduring human issues—even the normally unsayable and ungraspable—can be projected in the guise of animals.

Not all of the Limba stories I heard involved rollicking humour

or trickster disasters. There were sad tales too, like the tragic one about why humans die (one version is translated a little later) and the stories, sometimes serious but often light-hearted or deliberately fantastic, in which God features as one character or about how chiefship or rice-farming first began.

Other tales were overtly about people and their adventures, sometimes just "a man", "a girl", "a child", sometimes stock names like Sira or Sara, sometimes, as in *The Story of Deremu*, with named hero or villain. They revolved round themes of love, of marriage, friendship, competition, chiefship; of the deeds of orphans, of twins, of monsters, of far-fetched and ridiculous fools; or of the dire results of slander or disobedience. As with the animal tales (with which indeed they overlapped), they were shot through with fantasy but also with realism.

The scene was often that of village life or of travel between settlements (a familiar experience), but even where the settings were designedly far-fetched and imaginary the characters carried on—the performers showed them carrying on—in ways that were familiar and credible. They might be depicted in exaggerated larger-than-life ways but they resonated with the known dilemmas of people's lives and relationships—of marriage, power, love, jealousy. At the same time a kind of enchantment ran through the performed tellings too, moving the narrative into a realm beyond the here and now.

And then there were the many popular tales that culminated in an explicit dilemma: sometimes just a haphazardly tacked-on conclusion to end up a performance neatly, sometimes a setting for soul- searching about some (perhaps insoluble) moral and intellectual quandary. Some are little more than exaggerated frolics, like the mini-tale of three men smoking a pipe. One supplied the pipe, a second the tobacco, the third the match, so when a beautiful girl came out of the ashes who should get her?—an occasion for laughter.

Here is a more extended tale. It has an engaging plot in its own right but ends with a real question revolving round the familiar Limba theme of the contending children of co-wives. A young man is saved from a series of dangers, even from death, by the love of four women: which child should succeed him?

A chief married a wife. He loved that wife but they had no child. He called a moriman. 'Moriman! I love my wife, but we have no child. I want you to help me, so we can have a child.' The moriman said. 'Well, all right.' He went into his room and stayed there for long time, about a month. Then he came out and said, 'You and your wife will get a child. But that child must be seen by no one, except for you and your wife and the person who cooks for him—just those three people.'

The wife became pregnant, and gave birth. The child was brought into a house, up above, in an attic. There he remained for many years, he grew up there. For many years he was there. He learned to walk on his own. There he was in the house, high up. He became a young man, he grew up tall. He stood up above there on the house, looking at the people below. Over a long long time he looked at the people below.

One day a girl came out in the village. She stood there. The boy came out above. He stood looking. They let their eyes meet, she and the boy. They saw each other. The boy had been told that no other person should see him. But it came that they saw each other—he and the girl. The girl said, 'I must go and see for myself where that boy lives.' She went and searched for a ladder, she tied it together—a long one. She went and leant it against the house.

The evening came. The girl went there and climbed up. She went in and found the boy there. The boy said, 'E! What have you come here for?' 'I love you. Ever since I saw you yesterday, my heart has not stood still. That's why I've come, I love you.' The boy said, 'But no one else should see me.' They lay down.

As the sun was about to rise, the boy died. The girl—she didn't run away when the boy died. In the morning the woman who cooked for him brought water for the boy to wash. She found the girl sitting there. The child, the boy—he was dead! She went and called the chief and his mother. 'Come here! come here! I've seen something amazing. The boy has died. But I found a woman there, sitting there.'

The chief went with the mother. He went and saw the dead boy, and the girl sitting there. He said, 'E! Have you killed the boy, our son ?' 'Yes. It was love that caused it.'

Well then—they called the moriman. 'Ha! that child that you struggled for us to get—he's died.' The moriman said, 'Well then, get me men to go and cut wood and bring it to the village.' The men went to cut the wood and brought it to the village. They put it down. The moriman said, 'Have you a can of kerosene?' 'Yes.' 'Well then, fetch it.' It was fetched. He put the kerosene all over the wood. He struck a light and put it to the wood. The fire caught.

'Aha. Chief, do you love your son?' 'Yes.' 'Well then, go into the fire.' The chief went up, but the fire was hot. [The narrator vividly mimed the searing heat of the fire driving the parents back, much against their will]. He drew back. He went forward again. 'Ah ah, the fire is hot indeed.' He went and sat down. He wept. 'Ah! Chief', said the moriman, 'You do not love your son.' He called the mother. 'Do you love your son? 'Yes.' 'Well, go into the fire, so that you can be burnt with your son.' His mother went up too –it was hot. She drew back. She came near again. The fire was hot indeed. She said, 'All right. I will not be burnt too. I will leave it as it is.' 'Well, all right.'

Then the girl was called, the one who had come and found the boy and caused him to die. 'Girl, do you love the man?' 'Yes.' 'Well then, go into the fire, so you can both be burnt.' The girl leaped into the fire. They were both burnt, the two of them.

The fire died down. The moriman took the ashes. He wen to his room and stayed there for one month. He made a woman and a man, complete. He brought them out as human people. He said, 'Aha,

THE INSIGHT OF STORY 159

chief. I've completed the task you called me for. Here is the man, and the woman.' The chief said, 'Thank you, thank you, thank you.' He paid the moriman and the moriman went off.

The boy came out with his wife. He said, 'Father, I cannot live here. I will go up country, far away.' 'All right, my son, all right. Go, with your wife.'

They went off travelling. They spent the day travelling—the whole day. But hunger seized the man. He became weak all over, unable to travel.

Now there was a woman there who'd ordered out men to clear a swamp garden for her. The men went to clear the swamp. The girl had cooked rice with meat for them—a lot of it—and put the food on her head. Now she was taking it to her workers.

She met the man, the two of them, him and his wife. 'E! that's a fine man, isn't he! I'll follow him in marriage.' The first girl said, 'No! No! No! I won't allow it.' 'E! If you agree to me following him in marriage, I'll take this cooked rice and give it to him, and he can eat it—the rice for my workers. I'll not give it to them.' The other girl said, 'All right.' She gave him the rice. They sat down and ate. 'All right. Let's go.'

They set out. They went on and met a woman at a riverside, a mother of a young child, washing. She said, 'E! that's a fine man! I'll follow him in marriage.' The second girl said, 'I'll not allow it. No! No! No! I took my rice, the rice for my workers, I gave it to the man, he ate the rice, my workers were left just like that, I didn't give them their rice. Now you come and say just like that that you love the man. I won't allow it.' The other girl said, 'If you'll let me follow him, and let him marry me –you see this water here, this big river? There are many crocodiles here. No one can cross it without throwing someone into the water for the crocodiles to eat. Right then. If you want to cross over quickly in the boat so the crocodiles won't catch you, I'll take my child and throw him to the crocodiles. So—lets' cross.' The other said, 'All right. Throw your child in.' The mother took her child and threw him into the water. They got into the boat quickly, and

crossed quickly. The crocodiles didn't catch them.

They set off again. Now, in the village they were going to the chief was by now old. But no stranger was allowed to go in unless he could show where the chief's afterbirth was buried. When they reached the village, the chief's daughter, his first-born, said, 'E! ha! I love the man who's come to our village. I'll go there and marry him.' Then the other one said, 'No! No! I won't agree. I took my own child, I threw him to the crocodiles in the river, we got into the boat, we found a chance to cross over. Now we've reached here, this village here, you come and say you're coming to our husband and marrying him. I won't allow it.'

The chief's daughter said, 'Oh? If you let me come in marriage to your husband, I'll show you the secret of the village. So then your husband won't be killed. Whenever a stranger comes to this village he has to show where the chief's afterbirth is buried. Well, if you allow me to come to your husband in marriage, I will show him the place tomorrow.' 'All right.' 'Tomorrow when he gets up in the morning and stands on the veranda, and stands and looks, I will be sweeping the compound. And where I beat out the broom—that is the place. I'll do that as many as six times, let him look there.'

Well then, he was tested by the old people of the village. 'Stranger! Well now, a stranger cannot come into the village here unless he can show where the chief's afterbirth is buried. If you don't know the place, we will kill you.' The man said, 'Oh, well, all right. Everything there is, is as God wills.' He went and showed the place: 'Is it not here ?' 'It is here.'

The old chief of the village died. After he'd died the stranger who had shown where his afterbirth was was made the next chief. He lived for a long time in that chiefship, and had children by all of his wives. He lived many years. Then that chief came to die. His wives were left with the children, those the chief had fathered.

Then the wives got up. The one who had gone into the fire with the man said, 'My child owns the ßinheritance.' Then the next one said, 'It is not your child who owns the inheritance; my child owns it. I took

the rice I'd cooked for the workers I'd summoned and gave it to the man, for he was unable to walk for the hunger that oppressed him. My rice saved him. I abandoned my workers.' Another said, 'No. That's not so. My own child—I took him and threw him to the crocodiles in the big river. We found a chance to cross in the boat. If I'd not done that, we would never have crossed the river. The crocodiles would have eaten you.' Then said another, 'E! What about me? I came and showed my father's afterbirth, so the stranger wouldn't be killed. He saw where the afterbirth was buried. My father died. Now, you come and say it is your child who owns the inheritance . No, it is my child who owns the inheritance.'

Well, of all these women, those four wives, whose child owns the inheritance?

The listeners debated it light-heartedly but without making much of an issue of it—maybe the first: without her he wouldn't have survived at all to marry the others, would he (well that's what I thought anyway)? But the story would have been enjoyable whether or not the narrator had chosen to sign off with an enjoyable intellectual teaser. The deeper import lay less in the verbally posed dilemma than in the story's oblique delineation of the unavoidable tensions of daily life: the position of wives, of women and of children; the forces of individual choices and of love; the contrary pulls of contending obligations and relationships.

Such themes are not of course confined to Limba story-tellers, nor to the particular era in which I heard them told. Comparable stories among the neighbouring Kuranko speakers have been described as 'allegories', a term that perhaps suggests something more systematic and explicit than would be the case for Limba (and perhaps other) tales. But there is indeed a sense in which narratives can be deployed to "dramatise uncertainty ... [and] reflect on customs and values which are ordinarily not brought

into discussion".

It is not so much the specific plots or characters as the social and personal issues formulated through the power of narrative to shape or challenge perceptions and organize experience through the frame of temporally unfolding fiction. Throughout Africa, and beyond, there are tales of life, death and struggle, of the birth and heroic careers of miraculous children, of relations between men and women, competition, travel, trickery, failures, successes. Such narratives, written or oral, are not confined to fictional tales with inward-looking local import but also include accounts which directly or riddlingly tell of relations and attitudes between larger powers as when the Nigerian Igbo stories pit their accounts and values against the hegemonic claims of the kingdom of Benin, and narrative after narrative lace their tellings with themes of domination, power, powerlessness, gender, identity, government or resistance. So too with the life stories of migrant workers and others in which they organize their experiences and make them real while in the prolific popular novels people not only steep themselves in vicarious experience but also engage in the meaningful enshaping of their own and others' relationships and of their interpretation of the world.

Read within their narrative frame the Limba and comparable local tales might seem best approached as part of a shared African culture, handed down through the ages, dating back, maybe, to 'the start of time' A Limba story about the origin of death gives an apt example. This tells how God wanted people to live for ever but his plan was foiled.

> The toad—ah, the toad did not love us. God was squeezing out leaves for a herbal potion. He squeezed out the potion. He wanted people not to see death.
>
> He said, 'But who will carry the potion to the Limba?' The snake said, 'I will carry it.' But the toad said, 'No. I will carry it to them.

We're near each other.'

But he—ah!—he did not love us. He wanted to kill us all.

'Here is the potion,' he was told. He put the bowl on his head to carry it, he set out. As soon as he jumped, töliñ! [sound and movement of the jump], the potion fell off, bukute! [the potion spilling]. He spilt it.

Ah! It had been laid down that whoever carried that potion must not spill it. The toad did not let the snake who loved us bring it to us. The one who hated us, it was he brought it. He went and upset it.

So, if you now see us dying, it is because of the toad. The white people and we the Limba—we would not have died but for the toad. And now, this is how it is between us and the toad: where we build houses, that's where he loves to be. And that's why we drive him out. But the snake, who loved us in the beginning, is always pursuing the toad—and the toad runs to us for refuge. Well, the one who loved us then, well, when we meet him now, we kill him. We do not kill the toad.

Well, God looks at us for that. Since you said you wanted to hear about it, that is how we are with the toad.

That is it. It is finished.

This could indeed be interpreted as springing from a shared African inheritance, for stories on these lines occur widely in Africa. The details vary; in another Sierra Leone tale God's chosen messenger was a dog and it was a snake who stole the skin meant to save mankind from death But the basic plot is apparently widespread. But overall here, it would seem,we have a perfect example of age-old tradition, of authentic African experience. So too with the manifold animal trickster stories, not just in Africa itself but strongly surviving through the African diaspora. Such instances seem to exhibit the enduring heart of Africa. But in other ways the narrative of unchanging homogeneous Africa is less than illuminating.

But it was not the only version I heard. The one above was by a young man-boy, Sangbang Yeleme, who had himself experienced his share of tragedy. He had hoped to travel and perhaps go to school but the spirits of the dead had clearly not willed it, for crippling stomach pains from which he still suffered had prevented him. Even more crippling, he had been unable to enter the initiation rituals with his peers and was left in the between-state of no longer young boy but not-yet-man. Sangbang told the tale with quiet sadness, evoking the uncontrollable paradoxes and unpredictabilities of life, where the tragedy lay not so much in the bringing of death as in the reversal by which we care for the toad, the one who hated us, and kill the snake who would have helped us. In his telling it was a profoundly tragicale.

In the two other tellings God again intended to stop humans dying, the toad rushed in to replace the messenger and spilt it. But instead of Sangbang's moving and painful drama, a more travelled and light-hearted teller produced a rollicking characterization of the amusing antics of animals (that is, of people) that had listeners rocking with laughter. A third, the imaginative narrator and smith Karanke Dema, gave a long-drawn out and ironic account of the different twists in the tale, lengthening it to a fuller conclusion around the emotive Limba theme of the dire results of disobedience. To look only to some arguably "old" features of the plot in such tellings is to miss an essential dimension of their performed and understood meanings.

These Limba stories back from the 1960s shatter the assumption that without writing, urban development or cash economy there can be no true creativity or change. Limba tales, even those recycling well-known plots, were no passive handing down of "age-old" traditions. As in any cultural tradition (not excluding, of course, the traditions of western literature and historiography), the repertoire of familiar plots, characters, motifs, metaphors, narrative twists and much more were manipulated and stretched

by their individual narrators into personally created and often very different works of art. A talented story-teller like Karanke Dema could indeed speak of himself as learning his stories from earlier tellers and from "the dead"--but also as "thinking about his story beforehand, adding in a little and enlarging it from his own heart".

Even a generation ago Limba story-telling was far from focused just on what the "changeless Africa" proponents would regard as "traditional" plots and themes. One tale depicted the chief's spoilt daughter refusing to be married without six diamond combs and the hilarious way the chief had to keep going back to the once-poor man who had found diamonds inside a fish; he ended up giving him money, cheques, banks, a house, a car, even a new name, 'you will be called "Millionaire", the money in your hands will never come to and end and everyone who wants anything will have to go and borrow from you'—evocative indeed for an audience well acquainted with the diamond smuggling industry on the Sierra Leonean–Liberian borders. Or we hear a humorous account of how lorries were invented. God handed out gifts to the different animals, with a wheel for the dog and wisdom for the white man (you can see on his bald head where God poured the wisdom-water in). The animals went to bathe—"their smells were a bit strong where they'd all been rubbing up against each other'—and left their gifts on the riverbank. But what the white man then did was to make off with the wheel. He swam and swam and swam with it across the sea till he got to England and finally worked out what to use it for—a lorry. So now whenever a lorry comes humming along the dog jumps at it to get his wheel back—"but oh! the power the Europeans had been given! all that happens is that the dog is killed."

Narrtive subject matter was—and is—by no means fixed. Not only are there multiple references to obviously recent material introductions—like guns, money, books, lorries, horse-racing,

new buildings but -- whole plot of a story can centre round an episode like an imaginary race for an official position (Limba), a man going off to get work in Johannesburg and leaving his wife to get into trouble at home (Thonga), or a young hero winning the football pools (Nigeria). The occupations and preoccupations of both present and past, the background of local and changing literary conventions, and the current interests of both teller and listeners—all these make up the material on which the gifted narrators can and do draw and subject to the originality of their own inspiration.

It is the same, as we know, in highly literate contexts there too. Familiar plots are sometimes revered as something "old", sometimes (think of Shakespeare plays) reshaped into new forms with topical references. But this is far from saying that they somehow "belong" to the old days or are insulated from the present. And contrary to the suggestion that oral forms must somehow be part of the past and on the way out in the modern world, in practice they abound in today's towns and villages, among young people as well as old, and in contexts which it would be hard indeed to regard as anything but contemporary.

In Africa as elsewhere we find the mingling of oral with other media of expression in so many situations of today, in plays, songs, sermons, life stories ... Spoken and sung genres flourish on radio, television, film and video, on the streets, in the bars, in the homes. Writing, voice, electronic and broadcast media intersect in a host of contexts, vigorous diverse modes of doing things with words that the simplifying stories about Africa would have us neglect. The stories of Africa speak through the silence that post-colonialists theorists would have us suppose imposed on Africa—the actions and human subtleties formulated in the Limba or Kuranko or Igbo tales, the heroic narratives of West African griots, the storied images of Xhosa narrators, Somali and Hausa novels, Onitsha market literature, local newspaper stories,

the dramatic productions of Yoruba touring companies, even the self-narratives of famine survivors in the Sudan. Boys caught up in the horrific civil wars of Sierra Leone told their own stories (some depicted in a later chapter) and even under the brutal hand of South African apartheid Basotho migrants recomposed and performed their personal and collective narratives because the unauthored life is scarcely worth living.

Written versions —and there are still any many being written and read around the old themes—may seem more permanent and globally transportable perhaps—but are they? Oral narratives have ways of travel too. And they too treat of the great as well as the small human issues of life, of change, continuity, assertion of self-interest, dilemmas, agency, drawing them within the frame of narrative. All these stories in fact—including those I regard as misleadin—are examples of the human inclination to do things with storying words in ways that both affect and are shaped by experience. Not just among a few Limba narrators in the 1960s or just in the academic groves of contemporary Britain or America but throughout Africa and throughout the globe people participate in that great human resource of narrative, using stories to create and organize and manipulate their worlds—engaging that human propensity for deploying narrative words and in doing so to encapsulate and control and comment on the world they inhabit. People emplot their actions and their understandings of the world through the narratives they recount and listen to; "a life as led is inseparable from a life that is told, not "how it was " but how it is interpreted and reinterpreted, told and retold."

Plays, novels, self-narratives, stories of empire, tales of tricking and tricked spiders—all can be used to chart and mould the puzzling, cruel, humorous or precious actualities and dreams of life. In spoken no less than written discourse people deploy that rich resource for creating their lives and those of other—the sustained, organized and co-ordinated narrative sequences of

words. Whether inside or outside Africa we construct our own and others' identities and aspirations and meanings through stories. Words—the sustained and meaningful unfolding of narrative words—are not "mere" words but ways of doing and experiencing, of asserting and claiming reality.

10

THE STRENGTH OF WOMEN

M en's voices come through loud and clear in African songs and stories and histories. But women ... ? The conventional image is of oppression and subjugation, and it has often been assumed that this is reflected in African story and literature. But this is to neglect the moving, individually inspired, and creative women's arts of love poetry, young girls' reflective songs, protest poems, slyly rebellious work songs and the inspiring strength of women in situations like apartheid and slavery, bringing desperate suffering and oppression. This chapter, like many of the others, is illustrated by texts from first-hand primary research in the field.

It is "well-known' that in Africa women have both historically and in the present been oppressed, hidden, their voices silent. And it is true that they have suffered, and in many places (even, shockingly –a heritage from the past—in today's Europe) still suffer the silent horrors of clitoridectomy, the non-individuality of polygamy and in many cases non-presence in the written historical records and the official hierarchies. With a few exceptions, mainly in West Africa, men have held the political power and for centuries it has been their voices that have come through loud and clear in African songs and stories and histories.

This chapter draws examples from three centuries: back to the mid-nineteenth century in the voices of the external (mainly male) observers, and up to the present, with a speculative

glance at the time yet to come—the history of the future. In the often metaphorical and elusive language of story and song—a source too often neglected or too roughly and literally treated by historians—we can reach out more intimately than in most historical sources to truths otherwise hidden from us (is there a lesson here, perhaps, not just about women but for all historians?).

The accepted powerlessness picture came out strongly in many of the stories that I, a woman, recorded in Sierra Leone in Western Africa in the 1960s, just after the ending in theory, if not quite yet in practice, of colonial rule there. Only one of the scores of narrators was a woman (not for want of my trying). In the tales women are seen as devious, expensive, out for their own ends—a common preconception among men more generally.

Among the Limba people with whom I spent many months this dates back, they say, to the beginning of marriage. They explained it in one of their stories –in a way just a fairy-tale but with its own truth. Marriage began, I was told, because once upon a time a mythic old woman set up a market stall, as West African women do (and very powerful they are too). A beautiful young girl comes by and buys something for the then large sum of £4; soon afterwards a boy does the same. The old woman tells him:

> 'Follow this path. When you meet a girl standing there, when you meet her, as soon as you see her standing there with her breasts all firm, yakarakara—then don't hesitate! When you see her, as soon as you reach her, then wupu! fall on her!' The boy went and did so. Then the girl said, 'Hey! hey! See, I have bought good merchandise.' The man too said, 'Hey! hey! See, we bought good merchandise from the old woman.'
>
> But—the boy hadn't paid!
>
> The old woman said, 'Very well.' Because of that, that is why you must now work for your wife. We Limba were cursed by that old woman to whom Kanu [God] sold the merchandise. The man refused

to pay. Today if you want a wife, you have to give money. If you don't, you won't get one. That man used deceit on us. Now if you marry a wife, she just goes off! It was the curse the old woman laid on us. She took the blessing and gave it to the girl [...] The bridewealth he didn't pay the old woman, that is what we have to pay for a wife, right up to this day.

Told by a man, the story reflects understandable male resentment of marriage rules where unless he has wealthy parents he has to spend years earning money to pay for a wife, if he gets one at all. And after that she may not even be faithful or, even worse, obedient. Men know well that wives can speak for themselves and are only too ready to complain to their mothers and set off for home. Marriage, and wives, are a curse: expensive—and at the same time, unfortunately, valuable.

Or take the story-origin of chiefship, regularly a male prerogative among the Limba. It was told by Karanke Dema, a man, a smith. Gentle and kindly he yet enunciates a typical Limba picture of women: their devious, unfaithful and untrustworthy nature and the right of men to rule.

In his story, Kanu—God—comes to earth to institute chiefship, looking for a wise man to give it to. He disguises himself as a beggar covered with filthy sores and goes round the villages on earth. Nowhere is he given a welcome (a key Limba virtue, specially for a chief) but is instead driven off with sticks and curses. At last he comes to a hut where he is hospitably received, given warm water to wash, has a hen killed for him (to the disgust of the resident wife) and, best of all, kind words and dignity. He decides to bestow the chiefship on his (male) host and goes off to get the necessary insignia of office. But no! The man's wife Sirande (prototypical name for a woman in story) overhears and decides to twist the favour instead to—you have guessed it—her secret lover.

So when Kanu comes back with the chiefly chair, staff and gown, even a special scarf and ready-made dress for Sirande as the senior wife, he inevitably mistakes the (unnamed) lover for his kind host and gives him all the things of power.

"Typical!" is the reaction of the mixed-sex audience (a regular concomitant of any narration), just like a wife! Mission completed Kanu sets off back to heaven. On the way he meets Sara and recognises the very gourd in which Sara had served Kanu palm wine. Kanu realises, and rights, his mistake and gives Sara a whip to turn Sirande into a wandering cat: another sign of women's silence and, in male eyes, deserved subservience and due punishment? Yes indeed if we take such stories seriously— as we should. Not literally of course, that would be to be more credulous than either the tellers or the listeners, but certainly as carrying a resonant meaning, justifying current estimations.

But there is more than just these and similar stories. The continent is full of voices, women's as well as men's. They extend through the centuries, from the time of slavery to the new voices on the web, across the world and to new continents and new cultures, from India to Europe, the Caribbean too and the Americas. During my own fieldwork I talked a lot with women, all with their own stories. Among them was the sad, homeless, semi-mad woman who had been accused of being a witch and told me of having red pepper rubbed in her eyes; the old lady with no relations who explained how she fended for herself from her own small hut; the head of the women's secret society; the lovely and not so lovely young women, eyes roving towards men too poor to buy a wife; the initiate girls daubed with white chalk, ready for marriage to some elderly man of wealth; the children with beads around their as-yet slim hips and pitchers of heavy water on their heads, enthusiastically entering into their duties as women. They knew well—and accepted—that they would live as co-wives in a polygamous household; but knew too that that very

institution of polygamy was what would save them from the even heavier labour of a sole wife.

A male researcher—no fault to him—could not have got so close. Small wonder women's voices seldom come through in earlier reports. It does not necessarily mean they are 'oppressed'—just that their voices remained unrecorded. Many stories denigrated women, true. But women are admired too. I soon discovered in both my own fieldwork and from reading the research of others that women are not seldom the heroines too— the lovely girl who wins the man from his duties and saves him as well; the wily heroine who the story-teller clearly approves— avenges her murdered father by seducing and then craftily killing his slayer; the four girls who in turn save the hero and win him the chiefship, ending, as often, with a dilemma: which girl had sacrificed most, so whose child should succeed him as chief? The question led to long argument- no one believed that the relations between men and women, familiar as they were, were either simple or unambiguous.

Other heroines were tragic, characters portrayed with pity and understanding, above all in Karanke's story of the man Deremu whose mother was forced to give him over to a deadly spirit. It ends in disaster, for to save himself he poisons her, but then buries her with honour. The love between mother and son is for ever sacrosanct—here lay the tale's reflective tragedy: that a mother, the one who, who everyone knew, would always protect her son, would be the very one to betray him. Women also appear as vivid personalities in the novels, poems and plays of both traditional and modern Africa. Though this is not the same as a woman's direct voice, such forms, both positive and negative, indubitably help to shape women's views of themselves—men's too- and their confidence to articulate them. The number of love songs is surprising—at least to those brought up to the idea that personal love is bound to be lacking in African cultures. But as often as in

the familiar European literature women and girls are addressed as the precious objects of love. Take the Hausa poem from nineteenth-century northern Nigeria for instance to "Dakabo, a maiden":

Dakabo is tin! Dakabo is copper!
Dakabo is silver! Dakabo is gold!
 Where greatness is a fortune
 The thing desired is (obtained only) with time.
Thy things are my things,
My things are thy things, Thy mother is my mother,
My mother is thy mother,
Thy father is my father,
My father is thy father! Be patient,
O maid! Be patient, young maiden!

or again, the Ghanaian (Akan)

I sleep long and soundly;
Suddenly the door creaks.
I open my eyes confused,
And find my love standing by.

Somali love poetry is notable for its tenderness and appreciation of the beauty and, not seldom, the inaccessibility of women. The Somali *balwo* poems, a new genre that developed, particularly among the younger, urban, population in the mid-twentieth century, provide striking articulations of romantic and emotional love—and the women know it. These are "miniature" and intense love lyrics, often only two lines long and characterised by genuine and deeply felt emotion. They are typically addressed to a beloved woman, either near or far off, sometimes seen only once, whom the poet has little hope of ever seeing again:

Woman, lovely as lightning at dawn,
 Speak to me even once

or, a longer one,

I long for you, as one
Whose dhow in summer winds Is blown adrift and lost,
 Longs for land, and finds
Again the compass tells—
A grey and empty sea.

and

A camel burdened with curved hut-poles broke loose and ran
over me.
He set me alight like a blazing log-fire.
I saw you in a dream, adorned for a wedding-feast.
I cry out to you—have trust in me!

or, as if struggling, vainly, with the beautiful cruel forces of nature

O distant Lightning!
Have you deceived me?

The Tanzanian Nyamwezi sing:

My love is soft and tender,
My love Saada comforts me,
My love has a voice like a fine instrument of music.

The Kuanyama Ambo of South West Africa used antiphonal
love poems in courtship, with call and response between man and

girl. Usually some analogy is made between nature and human relationships. This comes too in the light-hearted love song by a young Soga in East Africa:

All things in nature love one another.
The lips love the teeth,
The beard loves the chin,
And all the little ants go 'brrr-r-r-r' together.

There are humorous and satiric songs too like the cheerful 'town dancing song' sung in mid-twentieth-century Zulu townships in South Africa where words are subordinate to melody

This is the girl that jilted me,
The wretch of a girl that jilted me.
At Durban, the dance leaders are afraid of us!
Zululand, my home, I love you. Goodbye,
Willie I like you too.

We find the same sense of fun in the plentiful 'drinking songs' which for all their lightness, can express the thought with economy and grace in true lyric form, as in the Zimbabwean Shona:

Keep it dark!
Don't tell your wife,
For your wife is a log
That is smouldering surely!
Keep it dark!

What of the women's views themselves, their own voices?

In my own field research in Sierra Leone, not unparalleled, especially in West Africa, it was women, not men, who were the

recognised expert in the highly revered specialist arts of song and dance, taking the lead role in the midst of the circling female chorus—the men were merely the exponents of the vastly less esteemed prose narratives. And if the Zulu and Xhosa praise poets were predominantly men, among the great Yoruba people they were women, handing down their expertise from mother to daughter, documented now in the perceptive work of Karen Barber—one would never have thought it from the writings of earlier (predominantly male) researchers. We hear women's voices directly in the poetry with which Africa, we now know, is so prolific. They sing reflectively for instance of their endless labour in the homestead or the fields:

> If there were a little shade in the sky
> If there were a little milk in the gourd
> If there were a little porridge in the calabash
> The ploughing would be more pleasant
> The ploughing in the mid-morning would be pleasant …

Or of the need for patience before difficult mothers-in-law, death of children, widowhood, a song taken up by the women's chorus:

> Patience, everything comes out of patience,
> Yes everything depends on patience.

Girls and women speak for themselves, deploring or commenting, for example on the nature and experience of marriage or its prospect: "*Chien que tu es! Tu fais: oua-oua!*". A Ugandan song of farewell by a young girl going off to be married in the mid-twentieth century is more reflective and personal:

Oh, I am gone,
Oh, I am gone,
Call my father that I may say farewell to him,
Oh, I am gone.

Father has already sold me,
Mother has received a high price for me,
Oh, I am gone.

Akan "maiden songs" are good examples of verse that is both
sung and composed by women, with women taking it in turns to
lead the verses. Here they sing ecstatically to honour a loved one:

He is coming, he is coming,
Treading along on camel blanket in triumph.
Yes, stranger, we are bestirring ourselves.
Agyei the warrior is drunk, T
he green mamba with fearful eyes.

Yes, Agyei the warrior,
He is treading along on camel blanket in triumph,
Make way for him.

In the women's voices marriage is, perceptively, viewed from
many angles, both blunt and subtle. Thus a Baganda song lightly
warns young suitors:

When he sees a pretty girl he falls for her,
 "I will go with you, let us go".
 Not knowing that he is going with a girl with a fiery temper!

Among the Congolese Bashi marital relationships were the
most common song subjects. One popular ditty gives a vivid

picture –historical source indeed as throughout the world, in their riddling and indirect way are many stories and songs– of a young girl rejecting her suitor (for good reason too!) and of the economic setting in which she did so:

"You want to marry me, but what can you give me?
A nice field?"
 "No, I have only a house".
 "What? You have nothing but a house? How would we live?
Go to Bukavu; there you can earn plenty of money.
You can buy food and other things".
"No, I won't go. I don't know the people there.
I have always lived here, and I know the people and want to stay here".
"You are a stupid man.
You want me to marry me but you have nothing.
 If you don't go to Bukavu and earn money to buy me things then --
I won't marry you".

Humour is after all one of the best ways out of oppression. A different point of view again is expressed in one of the many Chopi songs on this subject in southern Africa. The girl is pictured as sad and solitary without her husband, only too common a situation (but leaving her with much power too); like so many others he has gone off many hundreds of miles to work in the mines. She is still concerned about material possessions of course:

I am most distressed,
I am most distressed
My man has gone off to work,
And he does not give me clothes to wear,
 Not even black cloth.

The songs composed and sung by Luo girls in Kenya are among the most delicate. Filled with imagination and art they convey a vivid, first-hand, picture of a young girl's reflective and imagined internal world:

I am possessed,
A bird bursting on high with the ree lament
I am the untiring singer.
Dear bird, let's sing in rivalry
 Our *doreereeyo* ...;

It is my wayward self,
Singing in rivalry
The *doreereeyo*;

I am the untiring singer
That rocks far-off Mombasa
With the *doreereeyo*;

It is the voice crying the *doree*
That rocks far-off Nakuru;
I am the compelling Ondoro drum,
The bird bursting with the *doree*'s plaintive tones;
I am the untiring singer
Choking herself with the *doreereeyo*.

The song expresses the singer's longing, and the way she is possessed by the song. At other times we are given a picture of the willful and unpredictable side of her nature, disrupting ordinary rules of behaviour. A picture of girlhood is articulated in these songs—as with poetry anywhere it is scarcely an exact reflection of reality, but, conventional in this particular genre, pictures the singer living in a dreamland and expresses the idealised role

she longs to fill. For girls singing these songs enabled them to announce their presence and exhibit their own idiosyncrasies—a very personal mode of expression.

Zulu love poetry is frequently by women. A mid-twentieth-century girl's song that is both realistic and romantic:

Never shall I fall in love with a suckling.
Joy, joy, O mother, this one sleeps unrealising.
Never shall I fall in love with one who is no ladies' man.
Joy, joy,

O mother, this one sleeps unrealising.
I would like to fall in love with a dashing he-man.
Joy, joy, O mother, this one sleeps unrealising.
Would love him-who-appears-and-causes-heart-aches!
Joy, joy,

O mother, this one sleeps unrealising.
Yes, I would like a whirlwind of a man!
Joy, joy,
O mother, this one sleeps unrealising.

More disillusioned is another Zulu love song, this time by an older woman in Durban where amidst the constraints of apartheid she still successfully ran her own small group of singers. The song expresses her despair and the mundane yet heart-breaking aspects of parting, historic text revealing emotions for a fraught historical period that would otherwise be lost to us:

I thought you loved me,
Yet I am wasting my time on you.
I thought we would be parted only by death,
But to-day you have disappointed me.

You will never be anything.
You are a disgrace, worthless and unreliable.
Bring my things. I will put them in my pillow.
You take yours and put them under your armpit.
You deceived me.

Or, more succinctly—and realistically?—the Bamana

I love those people who love me,
I separate from those people who are not interested in me.

Ila and Tonga speakers in Central Africa recognize the *personal* ownership of songs, notably by women. A girl is expected to sing her own song on the day she dons adult dress. Their individual songs are composed and sung by women at beer-drinks or at work. Every woman must have her own solo repertoire while her friends and relatives interrupt with praise and small gifts.

Composition is a difficult process and each village has a few women who are specially skilled in the art. When someone wants to make an *impango* [personal song] she first thinks out the words—perhaps praise of herself, her lover or her husband—then calls in her women friends to help. Together they go to a well-known local composer. After hearing the woman's initial ideas, the expert then, usually over a period of several days, composes the complete tune for the whole song. She calls together a group of women to practise each evening after supper, and they continue until the new song is complete and they have all mastered it. The group can then disband and the woman who 'owns' the song sing on her own. She knows that if she forgets at any point she can ask one of the practice party to help out. She is now fully mistress of her *impango* and proud of her accomplishment. Whenever she is invited to a festival she keeps 'singing it in her heart' until it is time for her to stand up and perform it in public.

Women *organise* things and use song to do it. Read the striking twenty-first-century Sahel song for the Association of Women of the North, sign of women's gathered power and a notable force in the politics of today (and tomorrow too no doubt): what greater force throughout history than collective song?

> In the name of God, I will compose a song
> About the solidarity of women in the north.
> I invoke God's aid, may he increase my insight

and so with full detail of the many countries and regions taking part, of thanks and of the name of the composer. Or again

> I, the singer:
> Wrestle men,
> Wrestle people.
> When there will not be men in the arena
> It will be for the women.

There are many narrative accounts of women's experiences and travels. Some of the most poignant are of how they had to travel with their children, fleeing famine, across the desert; of long stays in refugee and marauded 'temporary' camps; of missionizing, loss or leadership; of settling in a strange land; of triumphs or of impossible suffering.

The stories come in written as much as in an oral voice for Africa is of course a place of writing too, and, contrary to the stereotypes, has been so for centuries. So it is often in the written word too that we hear the voices of women. They come in poems and reflections, in academic analyses, in drama, novels, histories, and the mass media: there is no end to them, nor will there be. We hear them in women's published memoirs too, both fictional and "true": look at Andreski's *Old Wives Tales: Life Stories of African*

Women or Aminata Forna's evocative *Dancing with the Devil*, or the works by novelists like Olive Schreiner—one does not have to be "black" to be African—or Buchi Emecheta in her so aptly named *Head above Water*,

Many come, the most moving context of all, in the historic tales of slavery. However produced at the time (this is sometimes controversial), they as surely as any autobiographical reminiscences represent the authentic voices of women. They present harrowing tales of suffering—but of strength and survival, even celebration, too. Who could forget Harriet Jacobs' *Incidents in the Life of a Slave Girl*. Born a slave into a southern plantation life she escapes and writes the events of her life:

> My grandmother had taken my old shoes, and replaced them with a new pair. I needed them; for several inches of snow had fallen, and it still continued to fall. When I walked through Mrs. Flint [her owner]'s room, their creaking grated harshly on her refined nerves. She called me to her, and asked what I had about me that made such a horrid noise. I told her it was my new shoes. 'Take them off', said she; 'and if you put them on again, I'll throw them into the fire'. I took them off, and my stockings also. She then sent me a long distance, on an errand. As I went through the snow, my bare feet tingled.

Some things seemed more shameful than death, not least to one who was after all still only a little girl:

> Everywhere the years bring to all enough of sin and sorrow; but in slavery the very dawn of life is darkened by these shadows. Even the little child, who is accustomed to wait on her mistress and her children, will learn, before she is twelve years old, why it is that her mistress hates such and such a one among the slaves. Perhaps the child's own mother is among those hated ones. She listens to violent

outbreaks of jealous passion, and cannot help understanding what is the cause. She will become prematurely knowing in evil things. [...] Soon she will learn to tremble when she hears her master's footfall. She will be compelled to realize that she is no longer a child. If God has bestowed beauty upon her, it will prove her greatest curse. That which commands admiration in the white woman only hastens the degradation of the female slave.

My master met me at every turn, reminding me that I belonged to him, and swearing by heaven and earth that he would compel me to submit to him. If I went out for a breath of fresh air, after a day of unwearied toil, his footsteps dogged me. If I knelt by my mother's grave, his dark shadow fell on me even there. The light heart which nature had given me became heavy with sad forebodings. The other slaves in my master's house noticed the change. Many of them pitied me; but none dared to ask the cause. They had no need to inquire. They knew too well the guilty practices under that roof; and they were aware that to speak of them was an offence that never went unpunished.

Dehumanising experiences indeed. But these women were not dehumanised. Perhaps indeed there is a detachment and a power, as many of us have learned in our own lives, in the very act of articulating what oppresses us, if only silently to ourselves. And even amidst the horrors of slavery there are indeed vivid flashes of women's resilience and of glory too:

My grandmother had, as much as possible, been a mother to her orphan grandchildren. By perseverance and unwearied industry, she was now mistress of a snug little home, surrounded with the necessaries of life. She would have been happy could her children have shared them with her. There remained but three children and two grandchildren, all slaves. Most earnestly did she strive to make us feel that it was the will of God: that He had seen fit to place us under

such circumstances; and though it seemed hard, we ought to pray to him. It was a beautiful faith, coming from a mother who could not call her children her own. But I, and Benjamin, her youngest boy, condemned it. We reasoned that it was much more the will of God that we should be situated as she was. We longed for a home like hers. There we always found sweet balsam for our troubles. She was so loving, so sympathizing! She always met us with a smile, and listened with patience to all our sorrows. She spoke so hopefully, that unconsciously the clouds gave place to sunshine. There was a grand big oven there, too, that baked bread and nice things for the town, and we knew there was always a choice bit in store for us contentment.

The same combination of weakness and strength comes in more recent times too (suffering is not just in long-past history). Women's spoken voices come through in the tales of displacement from the atrocities of Ruanda—so often hidden from us except in song—coming, thankfully but still in despair, to a refugee camp in South Africa. Hear the mother questioned by her seven-year-old daughter:

'Mummy but we are black! Mummy but we are black! Why must they don't like us?' I say, 'No, no, no, no, we are not from South Africa.' 'Mummy, fine you're not from South Africa. But me, I born here. I'm a South African. Mummy they won't hurt, hurt me. They won't even hit me'. I say, 'No, no, no, no because your parents are not coming from here, so they may hit you'. 'No mummy, no, no, no mummy, I will fight for you don't worry'. What do I say to her?

Women's voices are expressed with striking immediacy in testimonies to South Africa's Truth and Reconciliation Commission, an institution of present-day history, bringing people together after the shared affliction of apartheid. It gives those involved, the oppressors (themselves victims too) with the

oppressed, a place of peace to tell their stories in their own voice. Women even more than men were ashamed (once again, their voices more hidden) to speak of their torture or the sexual assaults that humiliated them and denied their identity as mothers, as wives, as human beings. One woman describes the brutality of police attempts to destroy them, the language as painful as physical attack:

> You are irresponsible, you are an unnatural woman, an unnatural mother. They say all sorts of things to you. [...] You are 30, you are single, therefore there is something wrong with you as a woman and that is why you get involved with politics. They were attacking your identity with their own particular conception of what a woman is.

We see lives crushed by the experience. And yet surviving. And yet able to speak.

It is not only in Africa that the famed 'power from below', the strength of the weak, can be so clearly seen or that, as we know from older people, the verbalisation of memories can unveil new and abiding reality. And inspire us. But it is in Africa that we do indeed see at close-up women who do draw their glory, as the medieval poet Rumi, still so close to us, had it, precisely from their *wounds*, from the suffering. It is there in the voices of those once seen as voiceless.

Thus it is that in Africa women's stories and histories can, if we learn from the strength of these African women and attend to their voices, gain at last the rightful place in the world for those of the apparently "powerless" whether in Africa or beyond. The voices that convey these experiences, singing or speaking, known or published or broadcast, famous or "ordinary", or, even more, hidden and in secret within their own souls—these shape our universe.

11

THE PLAY, PAIN AND MIRACLE
OF CHILDREN

Although less known than children's lore elsewhere, children's play in Africa has long been recorded and admired. Contrary to what is often believed, the outcomes of play in Africa are serious as well as playful, comprising the lore of adult-generated lullabies, songs for work, and the all too serious slogans and play of child soldiers in the horrific wars of today.

Let me start, as a typical anthropologist, with my own first-hand experience, expressed here, as throughout, in personal and, at times, conversational, style rather than explicitly theoretical terms, before going on to the documentary, comparative findings. When, in 1960, I embarked, as a budding anthropologist and literary analyst, on fieldwork among the Limba-speaking people then living in northern Sierra Leone and just emerging from the then British empire, I at first took little interest in children's lore, even though it was all around me.

After all I was unmarried, had as yet no children, and had not—consciously at any rate—come across the Opies' now-famous work on children's lore in Britain so had not thought that children's lore was of interest, far less worth serious study. In any case in terms of the functionalist anthropology in which I had been mainly trained in Oxford, children were marginal, irrelevant to the serious functions of society: government and order. Nor, needless to say, were they of any interest to the Colonial Office

189

which was financing my trip. However, my background in classical literature and, I might add, my Ulster upbringing, soon drew me to take an interest in local verbal art. For once, and unusually among the anthropological fieldworkers of the day, I had brought a portable tape-recorder with me, encouraging me to make use of it to justify the then huge expense (£60 if I remember rightly).

So I soon started noticing, and then recording, the local songs and stories, either as they happened or in specially arranged sessions in which the exponents were only too pleased to participate.

I listened without at first recording (music was rather beyond my recorder's resources), to lullabies, the first songs that—as in my own childhood listening to my mother's Donegal singing—a child would hear. That was of course alongside the work songs that, first in the womb, later on their mother's back, a young child would hear during the rhythmic strokes of the pounding of rice, introducing the growing person willy-nilly into the rhythmic and musical and literary riches of their cultural heritage. So let me start with lullabies, not on the face of it a part of children's lore—more something in the domain of adults—but yet influential throughout a child's life and, like nursery rhymes, by adults but surely a part of the lore we attribute to children..

Lullabies are a good example of how what might be expected to be a simple, "natural" and spontaneous expression of feeling in all societies—a mother singing to her child—is in fact governed by cultural convention and affected by the particular organization of the society. As I soon discovered, lullabies were not unique to the Limba but—unsurprising really—widespread in Africa, a vehicle shaping the child's growing sensibilities. They can express the uncertainties, sometimes woes, of a wife's and mother's lot. Take the following example, in which the Nyoro nursemaid comments on the mother's abdication of responsibility, and where the intended audience must be the child as much as the

remote mother:

> Ha! that mother, who takes her food alone.
> Ha! that mother, before she has eaten.
> Ha! that mother she says, 'Lull the children for me.'
> Ha! that mother when she has finished to eat.
> Ha! that mother she says, 'Give the child to me.'

Other African lullabies vary in their tone and purpose. Some are for rocking a child to sleep, brought out in the lulling rhythm and liquid vowel sounds of the original. Here, for instance, is the first verse of a long Swahili lullaby, the meaning conveyed by sound rather than sense:

> *Lululu, mwana (wa) lilanji,*
> *Luluhi, mwana (wa) kanda!*
> *Luluhi, mwana (wa) lilanji,*
> *Lululu, mwana (wa) kanda!*

The same soothing repetitive sounds come in one of the commonest Zulu lullabies:

> *Thula, thula, thula, mntanami,*
> *Ukhalelani na? Ushaywa uBani?*
> *Thula mntanami, umam'akekho*

> (Peace, peace, peace, my child,
> Why are you crying? Who annoys?
> Peace, child, mother is not home).

There are also rhymes or songs for grown-ups to recite to children—like European nursery rhymes, distinct from both lullabies and adult songs. The Zulu had many 'nursery songs"

in both rural and urban areas, among them one made up of an amusing combination of clicks to teach children the correct pronunciation: "*Qhuweqha weqhuweqha, Qhingqilithi qh!*" and so on. Sthere are many examples of such rhymes for children, like the one for finger play, a familiar activitiy :

> Le petit doigt a dit; oncle j'ai faim
>
> L'annulaire a dit: nous allons recevoir (à manger)
>
> Le majeur a dit: demandons
>
> L'index a dit: volons
>
> Le pouce a dit: je n'en suis pas (pour voler).
>
> Depuis ce temps, Ie pouce s'est ecarte des autres doigts.

Anther song tries to stop a small child crying by (how familiar!) tickling up his arm

Riddles—to move on--are in most places mainly the preserve of children. But just what exactly are "riddles'? In a general way they can be readily distinguished by their question-and-answer form, and by their brevity. The popular European or American picture of a riddle is of an explicit question to which a respondent must try to puzzle out the correct answer. In African riddles the "question" is often not an interrogative at all in form (though listeners recognise the challenge implied by the setting and in the questioner's mien and tone), it is a statement.[1] An answer is expected but very often the listeners are not directly asked to guess but merely faced with an allusive sentence referring analogously to something else which they must then try to identify. The point normally lies in some play of images--visual, acoustic, or situational--rather than, as in many English riddles, in puns or plays on words.

There are many such forms in Africa. Often the riddle is a short phrase about some well-known object in more or less veiled language. Examples of these are found all over the continent: the

Thonga "Little things that defeat us—Mosquitoes", Swahili "Water standing up—Sugar-cane", Fulani "Be born; come morning, give birth— Fresh milk" (milk is left overnight before making butter), Shona "The little wildcat in the long grass— Scissors", r the Lamba "The house in which one does not turn round—The grave". The Nyanja have a beautiful series in which not only the answer but the "question" consists of one word only— "Invisible—The wind", "Innumerable—Grass"; what is required is that the answerer should identify the object indicated in some allusive general statement.

Solving such simple-seeming riddles often needs a double process, for the analogy in the initial statement may not be immediately obvious. The solver must therefore first select the salient features of the object or situation mentioned and only then go on to identify a similar object. A good example is the Fulani "T threw a lance, it flew over seven rivers and went and speared the Chief of Masina"s bull", where the answer is "A vulture", the salient features being the fact that it goes far and lands on an animal, In the Karanga riddle "My father"s little hill which is easily destroyed" the solution is "Porridge" because of the way porridge is heaped up on the plate and soon eaten, or "A flame in the hill—A leopard", and the Zezuru "The little chap who plays the typewriter—The tongue". some generalization or some image is suggested and the answer involves pointing to the particular object implied. This is often just one word, and the analogy is one of meaning; the respondent must recognize the similarity of situation, character, or behaviour in the statement and its answer.

Sometimes the analogy involved is not of meaning but of rhythm, sound, or tone, often with a longer reply. In South Africa for example the "bird riddle" involves a competitive dialogue between two boys or young men in front of an audience. Each has to prove he "knows the birds" by making an assertion about one, then an analogy likening it to a type of person. Each in turn

tries to show that he "knows" more birds than his opponent. In this game freshness of idea, wit and humour count more than just the number of birds named. Thus a competitor with the following was declared the winner with a single attempt:

Challenger What bird do you know?
Proposer I know the white-necked raven
Challenger What about him?
Proposer That he is a missionary.
Challenger Why so?
Proposer Because he wears a white collar and a black cassock, and is always looking for dead bodies to bury.

Riddling occasions of this order are strikingly similar throughout Africa. They are often a prelude to the telling of stories, typically by children in the evening before the rather more serious narrations commence. Sometimes, as among the Fang, riddles are asked between stories, partly to allow the professional story-tellers some respite in their lengthy narrations The other very common occasion is a game of riddling, usually among children; this is conducted according to special rules and formulas and is often highly competitive. Again it takes place most typically in the evening. Competitive riddling has been extensively described for many of the Bantu-speaking peoples. In southern Africa it not infrequently takes the form of a contest between two teams. Among the Tlokwa, for instance, the children are divided into two groups as they sit round the fire in the winter when it is too cold to be outdoors, and the first group to start goes on asking until the other side can no longer answer. Or the competition is between individuals, not teams. Among the Kgatla, if two children are involved, one begins asking the other, and continues until the other is unable to answer; the second then says, "Let the buyers come" and questions in turn; when the other fails he says,

"Tell me yours", and there is an exchange of the riddles each had not known. It is much the same if several children are playing, with a division into sides which "buy" the unknown riddles from each other, the more skilful side taunting their

This fiction of having to "pay" in return for the unguessed answer comes in quite often. In Central Africa the pretended recompense is cattle—"We pay up oxen." "How many?" "Such-and-such a number", while in Kenya the one giving up has to name a town ("Give me a town"—"Go to Mombasa", etc. Similarly in West Equatorial Africa Mbete children have to "pay" a village.

Riddling is for entertainmetn, a distinctive and restricted activity. It is common in all parts of Africa for there to be a general rule—not always strictly observed, but a rule nevertheless—that riddle-telling should take place in the evening and not during the day; in East Central Africa there is sometimes the further limitation that you should not tell riddles during busy times in the farming year. Riddles are thus, unlike proverbs, regarded as a kind of marginal activity reserved for special times rather than a universal aspect of human activity and communication.

It is almost always children (plus of course researchers) who take an interest in the light-hearted asking of riddles. There are some exceptions to this: among the Yoruba, for example, both children and adults are said to enjoy riddles, although they are especially popular with young children while Kamba adults, even more than children, compete in riddling; two outstanding riddle experts are described as exchanging 'riddles and answers with a rapidity resembling two skilled fencers making thrusts and parries'. However, these situations are not common. More generally, riddles are associated with children's amusement in contrast to the more serious use of proverbs by their elders.

The explicit purpose of riddles, then, is almost invariably amusement, but as with almost any activity incidental functions too, riddles are sometimes claimed to play an educational role

by training children in quick thinking, in intellectual skill, and in classification, providing, through their sexual or comic bias, a release from tensions imposed by the moral and social code or leading to a fuller participation in social life. They are also sometimes used as an indirect means of saying something without the risk involved in stating it explicitly.. Like proverbs, they are a concise form of conventionally stereotyped expression.

Though in some ways only a minor form of art, suitable merely for children, riddles nevertheless have some relevance for the general literary background. This comes out partly through the connections of riddles with literary forms like proverbs, epigram, praise names, and rhetoric. More significantly, the imagery and poetic comment of even the simple riddles are clearly part of the literary culture. Insight into the nature of people's behaviour can be expressed in a poem or a story—or in a riddle. The Kgatla say, "Tell me: two civet cats which when they fight are not to be separated"—It is a married couple, while the Kamba show their insight in "Matters of importance—Children's secrets'. There is the Ila comment on humankind with "It is far—And it's a long way to God!", and the Bambara and Lamba express their view of man in 'What is the fastest thing of all?—Thought', and "The things that digs about in the deserted village—The heart" (which always turns to think of the past). That paradox too can be conveyed vividly in the brief words of a riddle can be illustrated from the Hausa—"A prince on an old mat—A kola nut"—where we are given a vivid picture of the way the beautiful pink or white kola nut, so valued a commodity, is exposed for sale in the market on a piece of old matting.

Most of all, riddles, however simple, involve a play of images, visual and sonic, through which insights and comment can be expressed. In this way, even this apparently minor form of art, with its own stylistic peculiarities in different cultures and owned especially by the children, has its part to play in the literary

richness of African societies.

Like children elsewhere, African children have the familiar range of games and verse for their own play, including nonsense songs, singing games, catch rhymes and similar creative forms, as well as riddles. But a note of caution before quoting instances of such children's lore. Obviously, what is to count as "children"s verse" in a given society depends on the local classification of "children", and one cannot necessarily assume that the "children's songs" of another society are directly comparable with those of one"s own. In English society, for example, the concept of "a child" is connected with the idea of a school population, a partly separate community of schoolchildren with their conventions and lore to an extent opposed to those of adults. But this close association of children and formal schooling does not hold true in all areas of Africa—even less so in the past—and one cannot necessarily assume the same clear-cut separation between the interests and orientations of children and those of adults. This is not to say that there are, and were, no ways of marking off the age-group of children from that of the adult world, merely that these do not necessarily parallel those of Western Europe.

For one thing it is common for a ceremonial initiation to mark a clear dividing line between childhood and maturity, often taking place at around the age of puberty, but in some societies (or with some individuals) this could be much earlier or much later. In some cases, initiation may be as young as seven or eight years old, and the special initiation songs which are so often a feature of this ceremony might seem to parallel songs sung by similar age-groups in other societies. In fact they can be quite different in intention: to be sung by the children qua initiates (i.e. officially no longer children) and often taught them by their elders. They cannot then be regarded as children's songs in the sense the term is often used. In some African societies, there is strong pressure from children, as they get older, to prove themselves ready to

enter the adult world. This means that, besides having their own verse and games, they are likely to try to show themselves masters of songs and other activities regarded as suitable for adults and, indeed, may be encouraged to do so. Among the Ila and Thonga of Zambia, for instance, ziyabilo songs in praise of cattle and other possessions are sung by grown-up men; but many of the adult songs were in fact composed by their singers when they were still young boys minding their fathers' cattle in the bush. The children model themselves and theirs verse on their fathers and other adult men rather than concentrating on a special type "appropriate to children".

Another way that children are often separated from other groups is in the kind of work they are expected to do, and there are sometimes special songs associated with these tasks. These include the light-hearted songs sung by the young Limba boys who spend long weeks in the rainy seasons in farm shelters scaring away the birds and animals from the ripening rice, or the children's song among the Dogon, sung to discourage birds from plundering the millet. The separation of children from adults is also encouraged by the fact that many live in large family groupings, with much time spent outside their homes in the open air rather than in small, enclosed family circles. Nowadays, there is the additional factor of the increasing number of schools.

Amidst all this there are plenty of sheer nonsense songs, tongue-twisting rhymes, and trick verses. Igbo girls in Nigeria sing the nonsense rhyme *Iyòo, ó / Abọ, kẹkwe,/ ihwu, Iruka / ẹde / bwaloka, okabwalẹde, / nkpi bwaloha*—"Oh, oh, oh, oh, / girls agree / tall girl, Iruka / koko yams, / sour, sour koko yams, / he goat sour". The nonsense often comes in follow-up or progressive rhymes, usually in dialogue. The sequences can be just fun but spmetimes also include a definite competitive content making up a kind of game. In the Southern Sudan the children divide into two sides, one of which asks the questions. The answer depends

on remembering the right sequence of words quickly enough, and those who get it wrong are ridiculed:

A. Who has taken my bowl?
B. Kumu has.
A Who's Kumu?
B. Kumu son of Ngeri.
A. Who's Ngeri?
B. Ngeri son of Koko.
A. Who's Koko?
B. Koko son of Lire.
A. Who's Lire?
B. Lire son of Kide.
A. Who's Kide?
B. Kide son of Langba.
A. Who's Langba?
B. Langba son of Kutu.
A. Who's Kutu?
B. (ending up fortissimo) Kutu's a sheep in the forest.

Sometimes the verbal parallelism is less exact, as in the Swazi 'children's part-song' in which the children are divided into two groups who take turns in singing a line, then join together at the end. It is not an action rhyme but depends on the words and tune alone for its attraction:

A. Ye woman beyond the river!
B. We! (responding to the call).
A. What are you dusting?
B. I am dusting a skin petticoat.
A. What is a skin petticoat?
B. It is Mgamulafecele.
A. What have they killed?

B. They have killed a skunk.

A. Where did they take it?

B. To Gojogojane.

A. Who is Gojogojane?

B. He-who-eats-cowdung-when-hungry.

A. For whom would he leave (some of) it?

B. He would leave (some) for?

A. Shishane.

A. and B. Shishane is not to blame,

 The blame is for Foloza,

 He who says he alone is handsome.

 The hoes of Mbandzeni

 They go knocking against him,

 The knocker of Njikeni.

 Magagula, Magagula keep the clod of earth tightly squeezed in your—

 [the final word is omitted in the translated text!—I leave you to guess].

Then there are catch rhymes like the Yoruba 'Blood, blood. Has a horse blood?' 'Blood, blood. Has a stone blood?' The point of the game is to try to get some child to say 'blood' after an inanimate object. A mistake results in laughter and sometimes a friendly beating (Gbadamosi and Beier, 1959, pp. 55, 67).

Many songs are enjoyed not only for their own sake but also for their usefulness in mocking other children. Thus an unwashed Baganda child may hear

 Mr. Dirty-face passed here

 And Mr. Dirtier-face followed

and a Yoruba child sing ruefully and with humour

Hunger is beating me.
The soapseller hawks her goods about.
But if I cannot wash my inside,
 How can I wash my outside?

There are also songs for games or dances, like the Dogon rhymes for counting-out rhymes or Yoruba ones for hide-and-seek. The searcher faces the wall singing his nonsense song while the others hide. When he reaches the question part of the song the others must reply in chorus, giving him a clue to their hiding-places:

Now we are playing hide and seek.
Let us play hide and seek.
Hey, tobacco seller,
This is your mother here,
Whom I am wrapping up in those leaves.
 I opened the soup pot
And caught her right inside
Stealing meat!
Who nails the root?
Chorus. The carpenter.
Who sews the dress?
Chorus. The tailor …

Other action songs are more complicated, based on imitation or on definite set dance patterns. Shona children sing an imitative song in which they circle round and round imitating an eagle catching small chickens. Hottentot action songs are based on the worldwide principles of a ring or of two rows facing each other—not, it seems, introduced by foreign missionaries (or at least not consciously) but in any case by now clearly established as the children's own. In the southern Sudan in the twentieth century

the games, mostly played by boys, happened on moonlit nights in the dry season, the singing led by one of the boys to hand-clapping, foot-thumping or the action of the game. The words themselves counted for little. The players squatted or stood in a circle. In one, the equivalent of Hunt the Slipper, the players sat in a circle with their feet under them. The leader in the middle of the ring had to find the bracelet being passed surreptitiously round the ring. He would sing, to be answered by the others as they slapped their knees in time:

Leader Bracelet of my son's wife,
Chorus I want I want now, bracelet of poor Bana,
It is lost.

repeated over and over until the leader successfully challenged one of the circle who, if caught with the bracelet, had to take the leader's place in the centre. Another was a counting-out game:

The boys sit in a circle, or, it might be, a right-angle, with their feet stuck out straight in front of them. An elder boy squats on his haunches before them and chants a queer formula, much longer than any European equivalent, tapping the feet as he chants, till the last word is said. The foot last touched is 'out' and the owner must sit on it. He goes on in this way till everybody is sitting on both his feet, i.e. practically kneeling. He then begins with the first boy of the line. There is a formula and response, and then he bows down in front of the boy with his eyes shut and his head almost touching the boy's knees. The boy has to stand up without touching the man's head with his knees. (He may use his hands to help himself, if he wishes.) If the man hears the boy's knees creak as he rises, the boy is made to stand on one side. If his knees do not creak, he stands somewhere else. Soon we have two groups—creaky and non-creaky knees. (Of course, the longer one is forced to sit on one's feet, the greater the

likelihood of creaky knees!)...The game ends with the non-creaky knees pursuing the creaky knees and punishing them.

There were also Sudanic games based on the familiar (to us too) arch or the line. In one, the boys lined up in two opposing ranks and one line advanced slowly towards the other, which retreated, both sides singing:

The foreigner
Chin of a goat
The foreigner comes striding haughtily
With his red skin.

After several repetitions, the two lines took it in turn to advance. Suddenly the pace and verse changed as those advancing now had to run stiff-legged and try to kick the others' shins, singing over and over:

Why does the stranger hurry so?
Ha! ha! hurry so.
Why does the stranger hurry so?
Ha! ha! hurry so.

—a hit at the white man. The "chin of a goat' in the first song referred cheekily to Roman Catholic missionaries' beards and the "kicking" to "the average official"'s use of his boots when angry or impatient".

Chasing and following games were also often to songs In the Acholi "Follow my leader" the boys stood in single file, holding each other's waists, and the leader took them in a closing circle to the words of the song "close in", then wormed his way out again, singing "open out". The words of the song formed the background. Finally, there were imitations of animals. Some came in chasing

games like the Shilluk Lion and Sheep, but in others the imitations seemed to be taken more seriously. In one a boy doubled himself up to look like a frog and tried to jump backwards in a circle without falling over, in time to his companions singing:

Jump up and down,
Up and down.
Jump up and down,
Up and down.
I shall jump again,
Up and down.
I shall jump again,
Up and down!

The "Bush-buck in a trap" game depended on the exactness of the leader's imitation:

The boys stand in a ring, holding hands. One boy is in the middle, and he is 'Gbodi', the bush-buck. He sings suiting his actions to the words, and the others reply, copying him. Thus, for example: Gbodi shake your head, Gbodi shake your head. Kango. Gbodi crouch down, Gbodi crouch down. Kango. Gbodi scratch your ear, Gbodi scratch your ear. Kango. Gbodi stamp your foot, Gbodi stamp your foot. Kango. Gbodi snort and snuffle, Gbodi snort and snuffle. Kango. Gbodi break away now, Gbodi break away now. Kango. At the words 'Gbodi break away now', he makes a wild dash for safety, and tries to break through the circle. If he fails, he has to act 'Gbodi' again.

By now the growing numbers of school children in contemporary Africa are likely more and more to develop their own distinct and conventional songs and games. Increasingly it is in the schools and through written correspondence and the cooperation of teachers and the creative children themselves that,

as with research in European countries, these can most easily and fruitfully be studied.

Not all children's songs are action ones however. Some express personal thought and feeling, sometimes in very moving ways. The reflective and moving Luo girls' songs have already been mentioned in an earlier chapter, but boys have songs too. In East Africa, these are sometimes while they are alone—unusual in oral poetry where an audience is generally expected, but often of great personal feeling. The boys compose these themselves as praise songs to the adored cattle they are sent to the plains to herd: long-horned, beautiful, slow- moving beasts.

And not all are for joy. There is war, disease and disaster to remember too, the dire fate afflicting children. We are forced to confront the war-torn continent of Africa, so far removed from the gentler setting, now, of most European children and their lore.Africa, and of course its children, have long been plagued by violence, famine, and both man-made and natural disasters. These experiences are only too well reflected in the serious work of children's lore. A Zambian child's song, describes a young girl returning to her village to find everyone dead. It goes on:

Go, go quickly little child.
To the village of your relatives
Find out what they need, and start doing jobs for them, chores.
They will see that you are connected to them, and they will feed you ...
Don't sleep in the chicken coop any longer.

The vivid picture is of events perhaps not directly experienced by the singers and dancers themselves but certainly within their knowledge. Unsurprisingly there are songs from and about AIDS sufferers, dying, recovering, and their orphaned state bereft of family—all dead. There are songs about slaves torn, stolen, from

their homes or born into servitude; about the victims of child trafficking, all too common throughout the world; about children left to play—and die—in the only home and playground they know, the streets.

Even more horrific because deliberately man-made is the prevalence of child soldiers in Africa—truly child and truly soldiers, some as young as five. In the 1980s and 1990s three million children have died in battle, six million been injured, some crippled for life .The worst countries have been Rwanda, Angola, Congo, Ethiopia, Eritrea and, perhaps most horrendous of all, or at least most fully documented, Sierra Leone, with its abducted, often drugged children warriors and its flow of deliberate amputations, only too visible today in the streets of the capital city, as well as in the harrowing but, in the end uplifting, personal memoirs of the children themselves. It is almost as if modern wars cannot take place without reliance on child warriors. As in the traditional bush-secluded initiations, new recruits are indoctrinated and enthused by means of song and dance. A song for instance used to train girl soldiers in Ethiopia's Tigrean Liberation Army was repeated enthusiastically by the recruits as their own song,

Tigray, my country
Do not shed tears
Do not weep
Hand me a gun through the backyard.

The children's verbal and musical arts are also of course utilised for nation-building and the forging of identity, and, most of all, creating peace, forgiveness and reconciliation. The successes of South Africa's wonderful Truth and Reconciliation Commission is well known, but few have heard of Sierra Leone's equally miraculous *fambul tok* ("family talk" in Sierra Leone's Krio lingua

franca), in which children too are actively involved.

An inspiration for us all, they adapt, amazingly, the precious local traditions of reconciliation, among villagers who have with their own eyes seen –and suffered—pillage, murder, rape, amputation (the children too, often first and foremost). They meet ritually in a circle round a sacred tree, tell each other stories, dance, confess and—are forgiven. It is a remarkably moving process that has inspired other peace processes, not least the amazing turnaround following the horrific killings in my native city of Derry.

For truth and reconciliation following hatred we learn—we must learn from Africa.

SUGGESTIONS FOR ACTION AND DISCUSSION

Introduction: Africa, what is Africa?

Do any of the opinions here match those of people you may know?
Do any of you have direct experience of, or in, Africa to draw on?
Have you come across any instances of oral (unwritten)
communication? What is it good for, and how? Is it less effective
than, or different from, written forms?

The glory of performance

Set up a performance of some kind (musical, verbal, multisensory,
whatever) and make a study of its characteristics.
Does your audience matter to you? Why? How?

The beauty of language
African languages obviously each have their own unique genius.
Might the same be said of English? If so in what ways?
The vocabulary of many African languages as collected is their
dictionaries can be huge. Is the number of words listed in such
works as the Oxford English Dictionary larger still? If so, why do
you think this might be?
Do you know of examples of tone being used to create different,
even contradictory, senses in English (think of how you use—
pronounce—the word 'No').

The power of praise
Try creating a praise name or a praise poem for your winning
football team, favourite teacher, grandmother, yourself. Does it
add anything to your perception of them?

Then how about a sarcastic, abusive of critical one too and see how the chosen 'praisee(s)' react (a good or a bad thing?) Better make up again afterwards!

The speaking of drums

What would you say might be the advantages and disadvantages if such 'speaking' was used in your own community?

Could you adapt some of the practices discussed in this chapter to something of your own on some toned percussion instrument?

The dance in music

How far do you think that such forms as jazz orrock have now become fully 'western' forms?

Make up your own lyric set to music (song); and try to list its special features.

The wisdom of proverbs

Make up a proverb of your own. What features did you introduce to make it qualify as such?

The magic of names

What does your own name mean? (you think it doesn't? It almost certainly does—try the internet).

And your friends' names? Are those with non-English backgrounds or different religions to your own more likely to be aware of their names' meanings?

Do your friends' first names in any way reflect their personalities? If so, why might this be so?

Can you detect any recurring patterns in your family's names over, say, three or four generations? Or any name that (like Kate for me) have a special meaing?

The insight of story
What are your favourite stories? Why and how?
Did you hear/read/learn any of them from your parents? Do your favourite stories have anything in common with any of the African stories here? Or with world myths?

The strength of women
Do you know any stories in any way comparable with those in this chapter?
How much do you know about the history of slavery? Where were the slaves captured in (stolen from) Africa mostly taken and with what effects?

The play, the pain and the miracle of children
Do you, or have you, known any children's games or rhymes? How far are they the same/different from those here?
Are you or other members of your family "children"? By what definition?
1s there anything to learn from this chapter about reconciliation and forgiveness?

Finally
What if anything have you learned from this book that you would like to passs on to others?

SOURCES

Chapter 1

Burton 1865: xii.

If unreferenced here, detailed sources for these and other statements in this and in several other chapters can be found in Finnegan 2012.

Chapter 2

This chapter, even more than the rest, draws on the author's personal observation.

Nketia 1955: 184.

Mofokeng 1945: 137.

Smith and Dale ii, 1920: 336.

Morris 1964: 25.

Junod 1913, ii: 198–200.

Babalola 1966: 64, 62.

Plato, Phaedrus 275 d.

Nketia 1955: 195, 245.

Andrzejewski 1965: 96.

Chapter 3

The account iin this chapter is largely based on Doke 1948, the findings of a scholar intimately acquainted with Bantu languages.

Doke 1948: 284.

Lestrade 1937: 303–4.

Madan 1911: 53.

Doke 1948: 285.

Burbridge, quoted in Doke 1948: 287

Doke 1948: 284

Dhlomo 1947: 6.

Lekgothoane 1938: 201.

Chapter 4

Gbadamosi and Beier 1959: 21–2.

Chadwick 1940, iii, 579.

Fletcher 1912: 38–9.

Heath 1962: 27, 32.

Morris 1964: 42.

Lestrade 1935: 9.
Lekgothoane 1938: 193–5.
Grant 1927: 211–3
Schapera 1965: 17.
Mofokeng 1945: 129.
Mofokeng 1945: 129.
Ellenberger 1937: 6.
Vilakazi 1945: 45.
Mofokeng 1945: 120.
Mofokeng 1945: 123, 124),
Mofokeng 1945: 123, 120.
Dhlomo 1947: 6.
Mofokeng 1945: 121.
 1927: 202.
D. Rycroft, personal communication.
Merwe 1941: 336.
Merwe 1941: 335.
Van Zyl 1941: 131.

Chapter 5
Carrington 1949b: 54.
Carrington 1949b: 58.
Carrington 1949b: 65.
Carrington 1949b: 61-2.
Carrington 1949b: 88.
Nketia 1963b: 111–2.
Nketia 1963b: 47.
Armstrong 1954: 362–3.
Laoye I [1965].
Nketia 1963b: 45.
Nketia 1963b: 147.
Nketia 1963b: 44.
Rattray 1923: 378–82.

Chapter 6
Blacking 1995.
Osadebay 1949: 154.
Knappert 1966: 130.
Cavicchi 1998 : viii

Obelkevitch 1989: 102.
Quoted in Shaw 2001: 27
Frith 1998: 128.

Chapter 7
Nketia 1958: 21
Nyembezi 1954: 44,
Cagnolo 1952: 128–9,
Smith and Dale ii, 1920: 341.
Horton 1967: 239.
Tremearne 1913: 242–3.
Njururi 1966: 86–9.
Smith and Dale ii, 1920: 334–6.
Doke 1927: xiii.
Cagnolo 1953: 129–31.

Chapter 8
Jackson 1982: 2.
Okpewho 1998
For examples see Abrahamsson 1951.

Chapter 9
Bruner 1987: 31.
See Vivan 1991.
E.g. Opie 1960.
Jordan, 1958: 103.
Mynors, 1941:206.
Englebrecht, 1930: 10-11.
Tucker 1933: 169-170.
Tucker, 1933: 183.
Tucker, 1933: 185.
Tucker, 1933: 184.
Strickland, 2006:. 63.
Beah, 2013, also Sara Terry's wonderful film of the same name.

ACKNOWLEDGEMENTS

I would like to thank Open Book and the Clarendon Press who published earlier versions (here extensively revised) of some of the material in this volume, also to *Storia della donne* (Firenze University Press) and to *The International Journal of Play* in which earlier versions appeared, respectively, of chapters 10 and 11. Many thanks too to the huge numbers of scholars and consultants both throughout the world and in Africa itself, and as ever, to my husband David, for advice and inspiration throughout. And to the great, the wonderful continent of Africa and those who live there.

FURTHER READING

General and introductory
International African Institute
—http://www.internationalafricaninstitute.org/
"African Art'—https://en.wikipedia.org/wiki/African_art/, and further references there
Karin Barber, 'A History of African Popular Culture.' Cambridge University Press.
Richard Dowden, Africa: Altered States, Ordinary Miracles.
Martin Meredith, Fortunes of Africa: A 5,000 Year History of Wealth, Greed and Endeavour.
Okpewho, Isidore and Mazrui, Ali, The African Diaspora: African Origins and New World Identities.

The glory of performance
Frances Harding (ed.), The Performance Arts in Africa.
Isidore Okpewho, African Oral Literature.

The beauty of language
Bill Bryson, The Mother Tongue: English and How It Got That Way.
Ruth Finnegan The Oral and Beyond: Doing Things with Words in Africa.
Bernd Heine, African Languages: An Introduction.

The power of praise
Karin Barber, I Could Speak until Tomorrow. Oriki [praise poetry] woen and the Past in a Yoruba Town.
Jeff Opland, The Dassie and the Hunter: A South African Journey.

The speaking of drums
J. E. Carrington, Talking Drums of Africa.
R. S. Rattray, Ashanti.

The dance of music
John Blacking, Venda Children's Songs.
Kwabena Nketia, Ethnomusicology and African Music.
Hugh Tracey, Chopi Musicians.

The wisdom of proverbs
Dura, Best Proverbs around the World.
R. S. Rattray, Ashanti Proverbs.

The insight of story
Various authors, Illustrated Myths from around the World.
John Yorke, Into the Woods: How Stories Work and Why We Tell Them.

The strength of women
Harriet Jacobs, Incidents in the Life of a Slave Girl.
Kathleen Sheldon, "Women and African history" (and further references there).

The play, the pain and the miracle of children
Ishmael Beah, A Long Way Gone: The True Story of a Child Soldier.
Peter and Iona Opie, The Lore and Language of Schoolchildren.

REFERENCES

Abrahamsson, H. *The Origin of Death: Studies in African Mythology*, 1951.

Andrzrejeski, B. W. "Poetry in Somali society", *New Society* 1/24, 1965.

Babalola, S. A. *The Content and Form of Yoruba Ijala*, 1966.

Bansisa, Y. "Music in Africa", *Uganda Journal* 4, 1936.

Barber, Karin, *A History of African Popular Culture*, 2018.

Beah, Ishmael, *A Long Way Gone: The True Story of a Child Soldier*, 2008.

Beah, Ishmael et al., *Fambul Tok* ['family talk'], 2013.

Blacking, John, *Music, Culture and Experience*, 1995.

Blacking, John, *Venda Children's Songs*, 1967.

Bruner, Jerome, *Actual Minds, Possible Worlds*, 1987.

Bryson, Bill, *The Mother Tongue: English and How It Got That Way*, 2015.

Burton, Richard, *Wit and Wisdom from West Africa*, 1865.

Cagnolo, C., "Kikuyu tales", *African Studies* 12 (1952–3).

Carrington, J. E., *A Comparative Study of Some Central African Gong Languages, Institut Royal Colonial Belge, Mémoires* 14/3 (1949b).

Carrington, J. E., *Talking Drums of Africa*, 1949a.

Cavicchi, D., *Tramps like Us: Music and Meaning among Springsteen Fans*, 1998.

Chadwick, H. M. and N. K., *The Growth of Literature*, 3 vols, 1932–40.

Chadwick N. K., "The distribution of oral literature in the old world", *Journal of the Royal Anthropological Institute* 69, 1939.

Cope, Trevor (ed.), *Izibongo: Zulu Praise Poems*, 1968.

Damane, M. and Sanders, P. B. (eds), *Lithoko: Sotho Praise Poems*, 1974.

Dhlomo, H. I. E., "Zulu folk poetry", *Native Teachers Journal* 27, 1947.

Doke, C. M., "The basis of Bantu literature", *Africa* 18, 1948.

Doke, C. M., *Lamba Folklore*, 1927.

Dowden, Richard, *Africa: Altered States, Ordinary Miracles*, 2014.

Ellenberger, V. "History of the Ba-Ga-Malete", *Transactions of the Royal Society* 5, 1937.

Englebrecht, J. A. "Swazi texts with notes", *Annals of the University of Stellenbosch* (B) 8/2 (1930).

Finnegan, Ruth, *Limba Stories and Story-Telling*, 1967.

Finnegan, Ruth, *Oral Literature in Africa*, 2nd edition, 2012 (free to read online).

Finnegan, Ruth, *The Oral and Beyond: Doing Things with Words in Africa*, 2007 .

Fletcher, R. S. *Hausa Sayings and Folklore*, 1912.

Frith, Simon, *Performing Rites: Evaluating Popular Music*, 1998.

Gbadamosi, B. and Beier, U. (eds), *The Moon Cannot Fight*, 1959.

Grant, E. W., "The *izibongo* of the Zulu chiefs", *Bantu Studies* 3, 1927.

Harding, Frances (ed.), *The Performance Arts in Africa*, 2006.

Heath, F. (ed.), *A Chronicle of Abuja*, 1962.

Heine, Bernd, *African Languages: An Introduction*, 2000.

Hodza, A. C. and G. Fortune, *Shona Praise Poetry*, 1979.

Horton, Robin "Ikaki, the torroise masquerade", *Nigerian Magazine* 94, 1967.

Huntingford, G. W. B., *The Glorious Victories of 'Amda Seyon, King of Ethiopia*, 1965.

Jackson, H. C. "Sudan proverbs", *Sudan Notes* 2, 1982.

Jacobs, Harriet, *Incidents in the Life of a Slave Girl*, reprinted 2017.

Jordan, A. C. "Towards an African literature", *Africa South* 1–3, 1958.

Junod, H. A., *The Life of a South African Tribe*, reprinted 1966.

Klaus, Anja et al., *Illustrated Myths from Around the World*, 2016.

Knappert, J. "Compound nouns in Bantu languages", *Journal of African Languages* 4, 1966.

Kunene, D. P. *Heroic Poetry of the Basotho*, 1977.

Legkothoane, S. K., "Praise of animals in northern Sotho", *Bantu Studies* 12, 1938.

Lestrade, G. P. "Bantu praise poems", *The Critic* (South Africa) 4, 1935.

Lestrade, G. P. "Traditional literature", in I.. Schapera (ed.), *The Bantu Speaking Tribes of South Africa*, 1937.

Madan, A. C., *Living Speech in Central and South Africa*, 1911.

Meredith, Martin, *Fortunes of Africa: A 5,000 Year History of Wealth, Greed and Endeavour*, 2014.

Merwe, D. F., "Hurutshe poems", *Bantu Studies* 13, 1941.

Mofokeng, S. M., *Notes and Annotations of the Praise Poems of the Southern Sotho People* (unpublished dissertation, University of the Witwatersrand, 1945.

Morris, H. F. *The Heroic Recitations of the Bahima of Ankole*, 1964.

Mynors, T. H. B. "Moru proverbs and games", *Sudan Notes* 24, 1941.

Njururi, N. *Agikuyu Folk Tales*, 1966.

Nketia, J. H. Kwabena, *Funeral Dirges of the Akan People*, 1955.

Nketia, J. H. Kwabena, *Drum Proverbs*, 1958.

Nketia, J. H. Kwabena, *Drumming in Akan Coummunities in Ghana*, 1963 (1963a).

Nketia, J. H. Kwabena, *Folk Songs of Ghana*, 1963 (1963b).

Nketia, J. H. Kwabena, *Ethnomusicology and African Music*, 2000.

Norris, H. T., *Shinqiti Folk Literature and Song*, 1968.

Nyembezi, C. L. S. *Zulu Proverbs*, 1954.

Obelkevitch, James "In search of the listener", *Journal of the Royal Musical Association* 114/1, 1989.

Okpewho, Isidore, *African Oral Literature*, 1992.

Okpewho, Isidore and Mazrui, Ali, *The African Diaspora: African Origins and New World Identities*, 1998.

Opie, Peter and Iona, *The Lore and Language of Schoolchildren*, 1980.

Opland, Jeff, *The Dassie and the Hunter: A South African Journey*. 2005.

Osadebay, D. C. et al. 'West African voices', *African Affairs* 48. 1949.

Plato, *Phaedrus* (Greek), fourth century B.C.

Rattray, R. S., *Ashanti Proverbs*, 1916.

Rattray, R. S., "The drum language of West Africa", in R. S. Rattray, *Ashanti*, 1923.

Schapera, I., *Praise Poems of Tswana Chiefs*, 1965.

Shaw, John, "Turn thrifty lectures into rich jazz recitals", *The Times Higher Education Supplement*, 21 September 2001.

Sheldon, Kathleen, "Women and African history", *African Studies*, can be read at http://dx.doi.org/10.1093/obo/9780199846733-0005/ (accessed 30 April 2017).

Strickland, B. "Children's folklore", in P. Peek and K. Yankah ed. *African Folklore. An Encyclopedia*, 2004.

Tracey, Hugh, *Chopi Musicians*, 1948.

Tremearne, A. J. N. Hausa *Superstitions and Customs*, 1913.

Tsegeye. T. "The Tigrean women in the liberation struggle its aftermath", 1999, reprinted in McIntyre, A. *Invisible Stakeholders. Children and War in Africa*, 2005.

Tucker, A. N., "Children's games and songs in the Southern Sudan", *Journal of the Royal Anthropological Institute* 63 (1933).

Van Zyl, H., "Praises in northern Sotho", *Bantu Studies* 14 (1941).

Vilakazi, B. W., *The oral and written literature in Nguni* (unpublished D.Litt thesis, University of the Witwaterrsrand, 1945).

Vivan, Itala, *Flawed Diamond: Essays on Olive Schreiner*, 1991.

Yorke, John, *Into the Woods: How Stories Work and Why We Tell Them*, 2013.

**Hearing
Others'
Voices**

Hearing Others' Voices: A transcultural and transdisciplinary book series in simple and straightforward language, to inform and engage general readers, undergraduates and, above all, sixth formers in recent advances in thought, unaccountably overlooked areas of the world, and key issues of the day.

CPSIA information can be obtained
at www.ICGtesting.com
Printed in the USA
LVHW040522200820
663617LV00005B/427

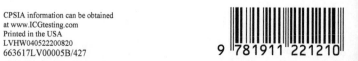